# Your Artist's Brain

**NORTH LIGHT BOOKS**
CINCINNATI, OHIO
www.artistsnetwork.com

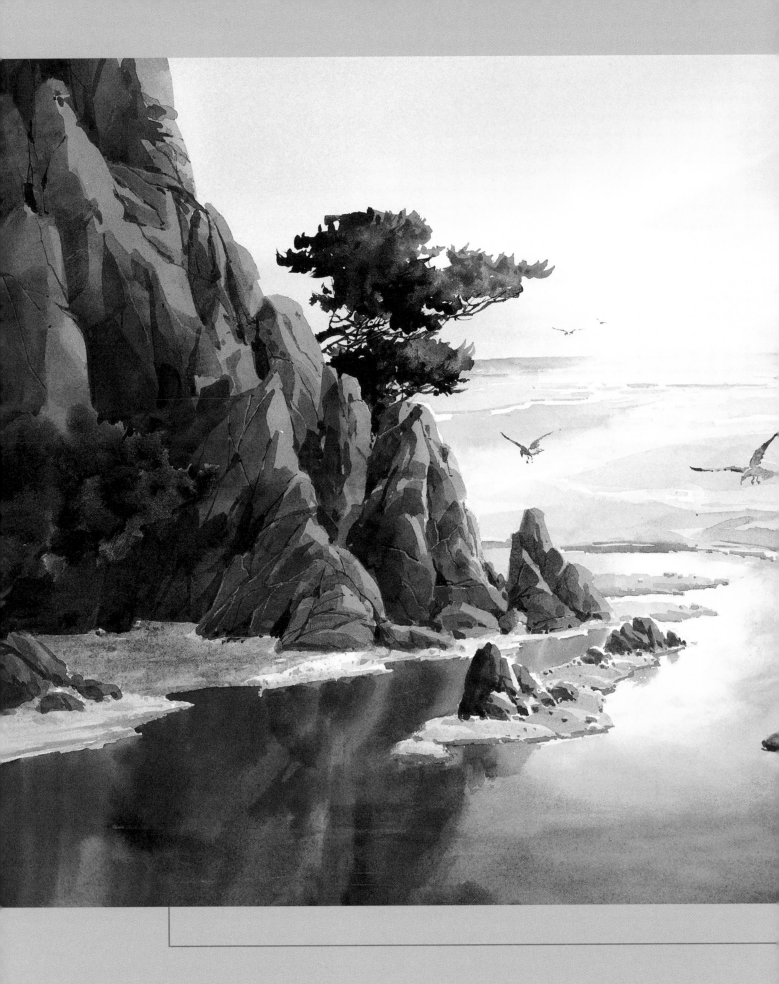

# YOUR ARTIST'S BRAIN

use the **right side of your brain**
to draw and paint what you see—
not what you *think* you see

## Carl Purcell

Other fine North Light books are available from your local bookstore, art supply store or favorite online supplier. Visit our website at **www.fwmedia.com**.

ISBN-13: 978-1-4403-0844-4

16  15  14  13      8  7  6  5

DISTRIBUTED IN CANADA BY FRASER DIRECT
100 Armstrong Avenue
Georgetown, ON, Canada L7G 5S4
Tel: (905) 877-4411

DISTRIBUTED IN THE U.K. AND EUROPE BY DAVID & CHARLES
Brunel House, Newton Abbot, Devon, TQ12 4PU, England
Tel: (+44) 1626 323200, Fax: (+44) 1626 323319
Email: postmaster@davidandcharles.co.uk

DISTRIBUTED IN AUSTRALIA BY CAPRICORN LINK
P.O. Box 704, S. Windsor NSW, 2756 Australia
Tel: (02) 4577-3555

*Art on front cover:*

**KENMORE, SCOTLAND**
Graphite pencil on bristol paper
8" × 10" (20cm × 25cm)

**AUTUMN GLOW**
Watercolor
28" × 30" (71cm × 76cm)

## Metric Conversion Chart

| TO CONVERT | TO | MULTIPLY BY |
|---|---|---|
| Inches | Centimeters | 2.54 |
| Centimeters | Inches | 0.4 |
| Feet | Centimeters | 30.5 |
| Centimeters | Feet | 0.03 |
| Yards | Meters | 0.9 |
| Meters | Yards | 1.1 |

Edited by STEFANIE LAUFERSWEILER
Designed by JENNIFER HOFFMAN
Production coordinated by MARK GRIFFIN

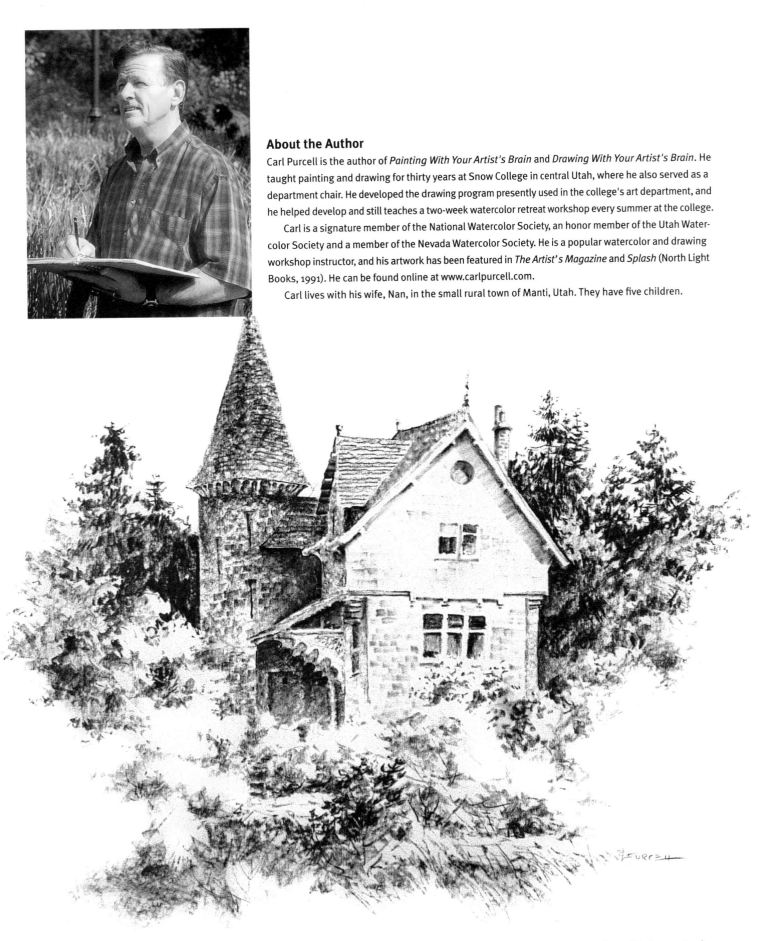

## About the Author

Carl Purcell is the author of *Painting With Your Artist's Brain* and *Drawing With Your Artist's Brain*. He taught painting and drawing for thirty years at Snow College in central Utah, where he also served as a department chair. He developed the drawing program presently used in the college's art department, and he helped develop and still teaches a two-week watercolor retreat workshop every summer at the college.

Carl is a signature member of the National Watercolor Society, an honor member of the Utah Watercolor Society and a member of the Nevada Watercolor Society. He is a popular watercolor and drawing workshop instructor, and his artwork has been featured in *The Artist's Magazine* and *Splash* (North Light Books, 1991). He can be found online at www.carlpurcell.com.

Carl lives with his wife, Nan, in the small rural town of Manti, Utah. They have five children.

**GATEHOUSE AT ARDVERIKIE ESTATE** ▸ 2B Conté on bristol paper ▸ 14" × 15" (36cm × 38cm)

# Table of Contents

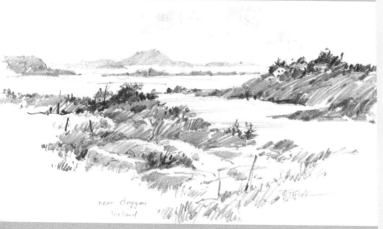

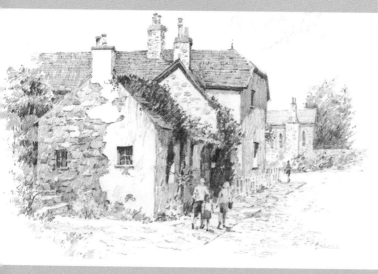

Introduction 9

CHAPTER 1

looking into your
**BRAIN'S TOOLBOX** 10

CHAPTER 2

gaining access to
**YOUR ARTIST'S BRAIN** 24

CHAPTER 3

searching for
**LINE AND FORM** 48

CHAPTER 4

seeing
**VALUE** 60

CHAPTER 5

figure and ground
**RELATIONSHIPS** 82

CHAPTER 6

organizing patterns
**OF VALUE** 94

CHAPTER 7
*technique for*
**PAINTERS** *108*

CHAPTER 8
*seeing*
**SHAPES** *124*

CHAPTER 9
*seeing the*
**SHAPE OF SPACE** *140*

CHAPTER 10
*seeing*
**SHAPES OF VALUE** *156*

CHAPTER 11
*building a painting*
**on VALUE PATTERNS** *168*

CHAPTER 12
*ensuring a strong*
**CENTER OF INTEREST** *190*

Index *204*

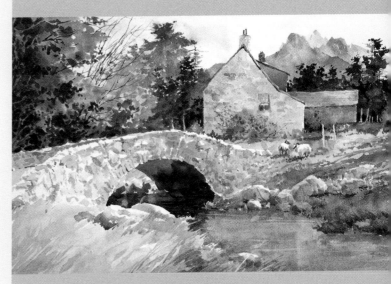

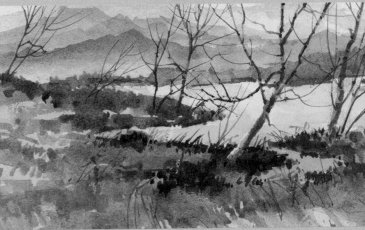

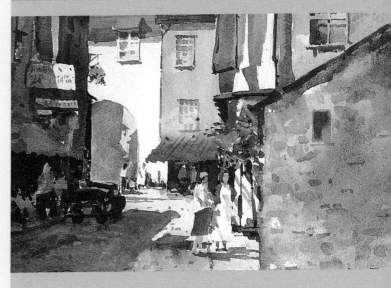

**SALISBURY WALKABOUT** ▸ Graphite on bristol paper ▸ 11" x 8½" (28cm x 22cm)

# Introduction

If you've always wanted to draw and paint but believed you didn't have the talent, don't give up. The good news is you already possess the abilities needed to do both!

Learning to draw and paint is simply a matter of training—training your brain to apply the functions it uses for other tasks to the specific tasks of drawing and painting.

The best description I have ever read of the purpose of drawing in particular was made by artist Frederick Franck in his book *The Zen of Seeing*. He said:

*It is in order to really see, to see ever deeper, ever more intensely, hence to be fully aware and alive, that I draw what the Chinese call 'The Ten Thousand Things' around me. Drawing is the discipline by which I constantly rediscover the world.*

*I have learned that what I have not drawn, I have never really seen, and that when I start drawing an ordinary thing, I realize how extraordinary it is, sheer miracle.*

**The Purpose of This Book Is:**

1. To point you to the functions of your brain that make drawing and painting possible.

2. To help you access those functions in the service of drawing and painting.

3. To make you aware of the built-in processes in your brain that hinder your ability to draw and paint.

Once you know what to train, how to train it, and what causes problems, you can learn to draw and paint well. Practice, of course, will make you better and faster.

When I first began to teach drawing at Snow College in central Utah, I used a program similar to the classes I had attended at the university. The results were terrible! I was only able to help a few students who already drew fairly well.

I reasoned that if I could learn to draw, then anyone could. We teach basic math and writing without expecting students to become mathematicians and novelists. Why couldn't we teach students basic drawing without expecting them all to become artists? People who can draw do not have an extra "talent" node on their brains.

I initiated a seven-year search to discover which functions of the brain artists use when drawing and the causes of the more common problems experienced by my students. I discovered that the right tools for drawing (and painting) are present in everyone's brains but we have other mental processes that subvert the activity of drawing. I developed a program that made students aware of what was happening in their brains when problems occurred in drawing. I then helped them to develop conscious control of their functioning spatial abilities to make drawing easier.

The results were astounding. Instead of helping a few in the class, I was able to help almost all of them. Everyone was drawing better than my most "talented" students in previous classes. My own drawing skills also improved—an added bonus!

I believe that understanding what's happening in our brains while drawing or painting is the key to developing and controlling the necessary skills and processes that cause many to have problems while doing these things.

# DRAWING AND PAINTING CAN BE AND SHOULD BE FUN!

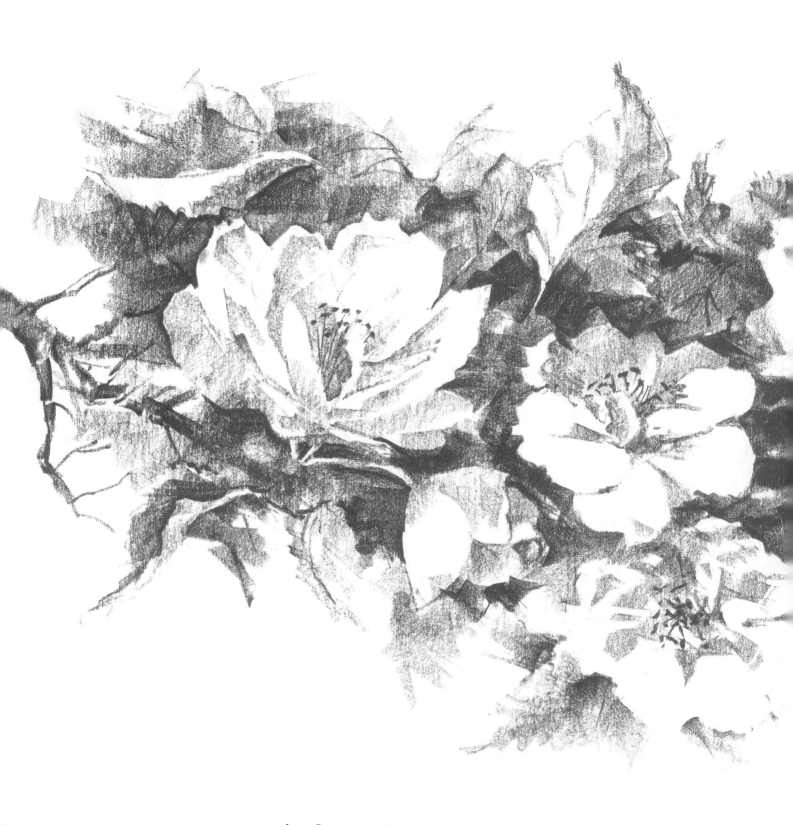

**APPLE BLOSSOMS** ▶ Sanguine Conté on acid-free foamcore board ▶ 12" x 15" (30cm x 38cm)

# looking into your
# BRain's TOOLBOX

Drawing is fun! Why, then, does drawing seem to be so difficult for most people, even art students? Why should it be? All the information is right in front of you. It's like taking a test with all the answers on the board. Yet for some reason, you struggle to transfer that information to your paper. Drawing shouldn't be a frustrating process for anyone. Let's find out why it so often is.

Like most people, I used to think that learning to draw was simply a matter of developing drawing skills. This is only partly true. Developing these skills requires you to know your problems, and know them well. This chapter will do just that by explaining the sources of the most common problems you will encounter in drawing. You've probably already encountered these problems and considered them as evidence of inability. This is simply not true!

Everyone who attempts drawing must, in one way or another, overcome the problems discussed in this chapter. It may be easier for some more than others. When I was learning, I was in the middle. It wasn't easy, but it was easy enough that I was encouraged to work hard and keep practicing. Knowing what causes your problems will make it easier to overcome them, and you need look no further for the source of these problems than inside your brain.

If you're frustrated with drawing, it's because you're using the wrong mental tools for the job. Can you see what you want to draw, but when you try to draw what you see, it comes out wrong? Let's discover what your own brain is doing wrong and why.

# The two information-processing tools of your brain

Your brain processes visual information entering through your eyes in two distinctly different ways: spatially (or visually), and intellectually. The first and faster is the spatial process. Its primary function is to keep you informed about the constantly changing space around you by recording where and how big things are. It perceives shapes and spaces, dark and light patterns, vertical and horizontal orientation, size relationships and the relative locations of shapes.

The spatial part of your brain does not identify these as trees, cars and people; that kind of identification comes later. All of this is done on autopilot, just at the threshold of your consciousness. When you parallel park a car or walk through a crowded mall, you use this spatial tool. Its primary job is to navigate you through space safely.

The analytical or intellectual portion of the brain processes the spatial information not as visual images, but as data. When you identify the shapes you are seeing as trees, cars, people and so on, you are using the intellectual brain. This is the right tool for just about every other conscious activity of your life. But when you use this part of your brain to draw, the results are disastrous. It first translates the visual information it has received from the spatial brain into data, then creates a simplified visual symbol to stand for the information.

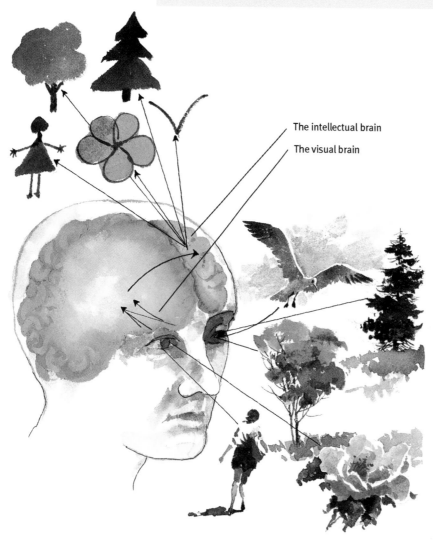

The intellectual brain

The visual brain

## How Your Brain Processes What It Sees

Complex shapes enter the brain through the eyes and are simplified by your intellectual brain into symbols that merely represent the original item. These symbols are recalled when you try to paint what you see. Additional information about these things is added to the perceived information. As a result, you may paint a person, animal or object as you think it should look instead of how it actually appears.

There are four ways in which the intellectual brain distorts information needed for drawing, thus causing the most common problems.

1. It interjects previously stored data about the object into the activity of drawing.

2. It calls up early symbols created to stand for (not look like) the complex visual information it receives.

3. It creates new symbols and generalizes information to make it easier to store.

4. It focuses on surface details for which it has a name and ignores information that explains the structure of forms.

# How your intellectual brain interferes

**FROM THE ARTIST'S BRAIN**
Drawing problems arise when we attempt to do the job with the wrong tool.

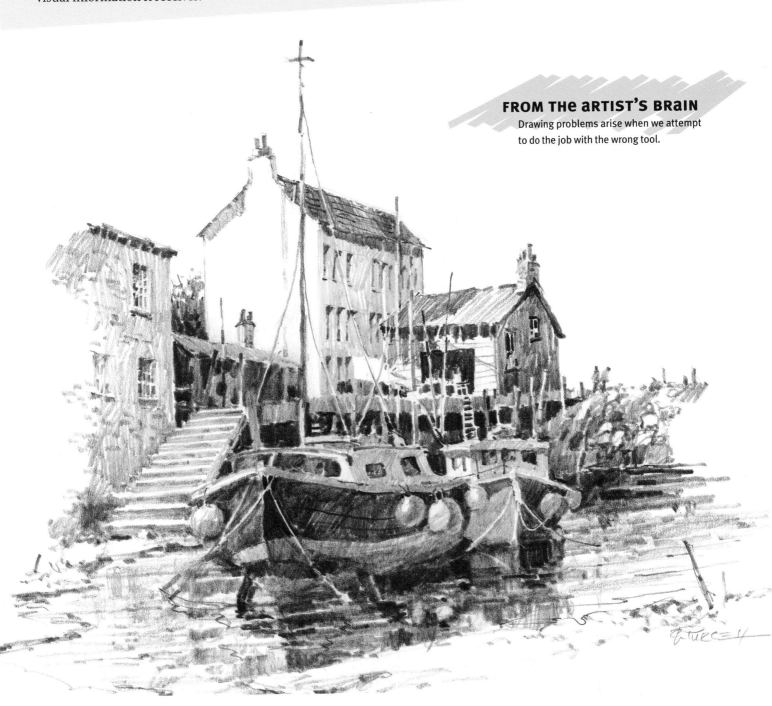

**POLPERRO HARBOR** ▸ Graphite pencil on bristol board ▸ 9" x 10½" (23cm x 27cm)

# The intellectual brain imposes previously stored data into the drawing.

This problem is evident when you start to draw a simple object like a box. The conflict between what you know (analytical, intellectual) and what you see (visual, spatial) is very clear.

You want to draw the box, but you're faced with a dilemma: The visual information does not match the intellectual information. Is the object made up of rectangles or of these odd geometric shapes perceived by the visual brain?

**The Dilemma**
Does trying to resolve the conflict between visual and intellectual processing make you feel like this?

**Perspective Is Not the Problem**
Most people complain that they don't understand perspective and that this lack of knowledge makes it difficult to draw a simple box. It is not lack of knowledge that causes the problem.

**What's Really There**
These are the shapes the visual brain records. It sees an object with three planes, each having a different shape. And not one of these shapes has a 90-degree angle!

**What Your Smarts Say**
Your intellectual brain says, "Oh yes, that is a box. I can see three of its planes." And what does it know about those planes? It knows that the planes are composed of rectangles, four-sided geometric shapes with four right angles, especially with adjacent sides of unequal length.

## The Answer

Both sets of information are true! One is a visual truth about the shapes as they are seen, and the other is an intellectual truth about what the shapes mean. If you want to build a similar box, measure it and use the intellectual data. If you want to draw it, ignore that data and focus on the shapes you see.

However, since the analytical part of your brain controls the conscious activities of your life, it naturally thinks it should also control the act of drawing. And this is the cause of the problem. You are trying to draw the box, but your brain is sending two conflicting messages. What do you do? Compromise?

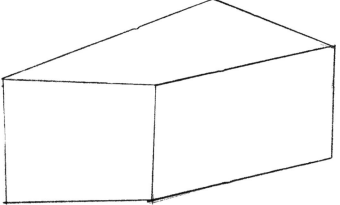

## Is Compromise Possible?

We're civilized people, can we meet halfway between true visual information and intellectual truth?

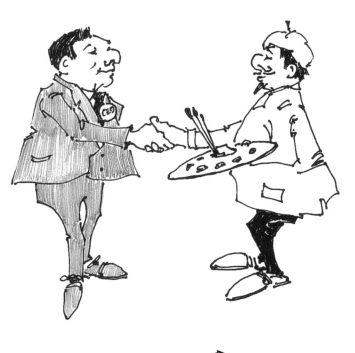

## The Sad Truth

Compromises in drawing do not work. This is the kind commonly reached; it contains elements from both bodies of information.

Your intellectual brain compromises by admitting that the angles you see are not the 90-degree angles it knows are there, but it is unwilling to find out exactly what they really are. It tells your hand to put in any angle that is somewhat close. Your task in drawing is to turn off the analytical information and focus only on the visual.

### FROM THE aRTIST'S BRaIN

For most people, drawing is a fight with the intellectual brain to adjust the drawing bit by bit toward the visual truth of what they see.

## Problem 1 in Action

A container with a round opening presents another example of this classic conflict between the visual information supplied by the eyes and the analytical data supplied by your intellectual brain.

I know this mistake is the result of a compromise and not an error of perception: In thirty years of teaching, I've never seen a student observe a narrow elliptical opening and draw an even narrower ellipse. Invariably, students draw the opening wider than they see it. If it were only a mistake in observation, some students would draw a too-narrow version of the shape. This was my first clue that something happened to the observed information after it entered the student's brain, distorting it on a consistent basis.

I find that making you aware of the mental conflicts you will encounter makes you look twice before putting pencil to paper. And that second look gives you the information you need in order to draw it right the first time. As a result, you're able to draw faster and more accurately.

### Not Just Boxes
Do you have problems drawing simple containers like this one?

What we see

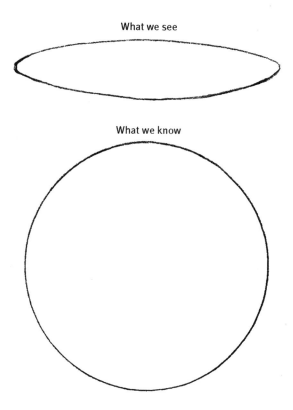

What we know

The compromise drawing of the opening will be somewhere between the narrow ellipse seen and the circle the intellect knows it to be.

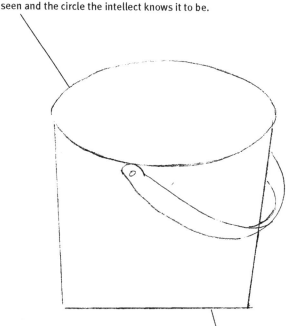

### Seeing vs. Knowing
What we see of any circular opening is a foreshortened view, an elliptical shape. We know it is a circular opening, and we know what a circle looks like.

### Why We Can't Just Get Along
This is what the compromise drawing might look like.

I often saw students do this. Why? At first I chalked it up to mistaken perception, but it happened too often to be the case. Now I know! Their intellectual brains told them that the bottom was flat because it's sitting on a flat surface.

16

# The intellectual brain creates symbols intended to stand for (not look like) the visual information before you.

We create symbols for everything. It is a method for compressing large amounts of information into smaller packages. The digit "5" is a symbol for a given quantity. The Yin-Yang symbol stands for a complex cultural concept.

The brain also creates symbols for the things we see, acting as shorthand versions. They are not meant to be a likeness of the item. For example, the common symbol for mountains -^^^- is not meant to resemble a particular mountain, but to stand for all mountains.

For a child, creating symbols is a method of communicating feelings. You will find that children spend much more time creating symbols on blank paper than they will spend with coloring books. The paper gives them a world in which to express themselves. At some point, most people become dissatisfied with these symbols and try to shift towards making their creations appear more like the individual items they see. We call these people artists.

Most people encounter difficulties and give up. For them, the intellectual brain (which has received all the attention in school and at home) is dominant.

Drawing is based entirely on the visual information supplied by the visual brain. Drawings are the product of intense observation, not intellectual interpretation.

**The Symbols We Make**

**Art That Stands for Something**
No child thinks this is how Mommy really looks. In fact, when asked they say, "This is Mommy," not, "This is what Mommy looks like."

**Building Your Symbol Collection**
Between the ages of three and ten we create a host of symbols to represent the things around us. These symbols become more complex as we age, and new symbols are created for all the details.

## Problem 2 in Action

I often see people who are looking directly at a pine tree draw a version of their childhood pine-tree symbol. How does this happen?

The intellectual brain is trying to control the drawing process. It recalls the childhood symbol, and it compromises by changing the symbol a little. Intense observation would reveal information about the tree's shape and edges, but this not only takes time, it also puts you in a visual mode that shuts the intellectual brain out. Ouch!

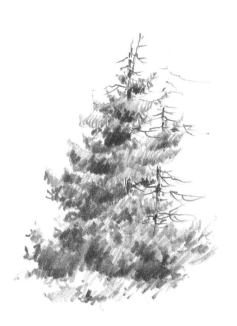

A person sees something like this.

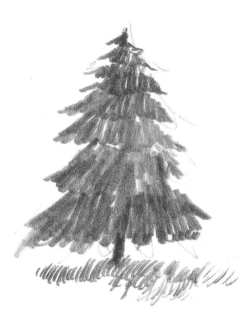

The intellectual brain recalls a childhood symbol for "pine tree."

Seeing this symbol work as well as it did in the third grade, a compromise is reached in which some of the observed features are grafted onto the childhood symbol to create a new symbol.

### From Seeing to Remembering

The image in front of a person goes through a transformation from what is *seen* to what is *remembered*, resulting in a disastrous compromise.

# The intellectual brain creates new symbols and generalizes for better storage and retrieval.

Accurate drawing requires intense observation. You can assume nothing about the object: Approach with a blank page and the willingness to see it as it really is. That is far different than simplifying and generalizing the information for easy storage. The two tasks are simply not compatible.

There is nothing wrong with the generalizing mode of the intellectual brain. It protects us from sensory overload. We can't go through each day taking note of every little detail. We would soon burn out. So we create broad generalities that do not bother with the specific variations. Roses are red. Bananas are yellow.

Symbol-making is one way of simplifying and generalizing visual information. However, when it insinuates its symbols into the drawing process, a process that requires the recording of specific, unique information, it becomes a problem.

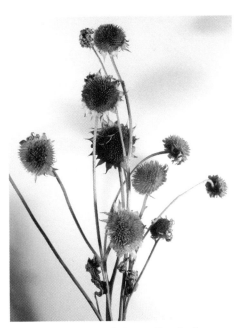

### The Beginnings of a New Symbol

When you look at these dried sunflowers, you identify them, store the information in case you have to identify them again, and move on. If asked about their color, they are brown and dark. Period!

However, if I tell you to draw them, your response might be different. "What? That's too difficult! They're too complex!" To help you, the intellectual brain will create some new symbols to simplify the task. Not so good of a friend!

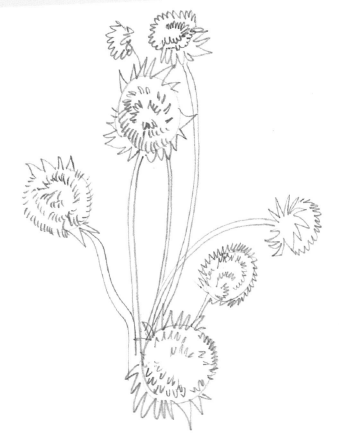

### What Your Intellectual Brain Creates

This symbol represents the essential information concerning the dried sunflowers without intense observation. It records the generally prickly nature, the curve of the stems and the fact that there are larger, triangle-shaped objects around their perimeter. This drawing doesn't even mention the leaves. It seeks general information that can stand for all dried sunflowers.

Typically, the intellectual brain does not care about the relationship of each flower to the next one or about the peculiar twist in the dried petals or the specific curve of each stem. It simply asks, "Where are they?" and answers, "At the end of curved stems." It seeks a symbol for all petals. Likewise, it creates a symbol to stand for all the prickly centers and selects one curved stem to stand for all stems.

## Problem 3 in Action

Doing a drawing that actually looks like these sunflowers will require you to create marks that convey the actual quality of the sunflowers, and that you place all the parts in the same spatial relationships that exist in the original forms.

Don't fall into the trap of letting the intellectual brain give you the "Tarzan approach" to your drawing. "Me Tarzan, you Jane!" "Sky blue!" "Grass green!" "Sunflower prickly!" "Stems curved!" You can do a faithful drawing of these sunflowers only if you turn off the symbol-making analytical brain and allow your more artistic, visual brain to handle the job. Your visual brain enjoys the complexities of the image.

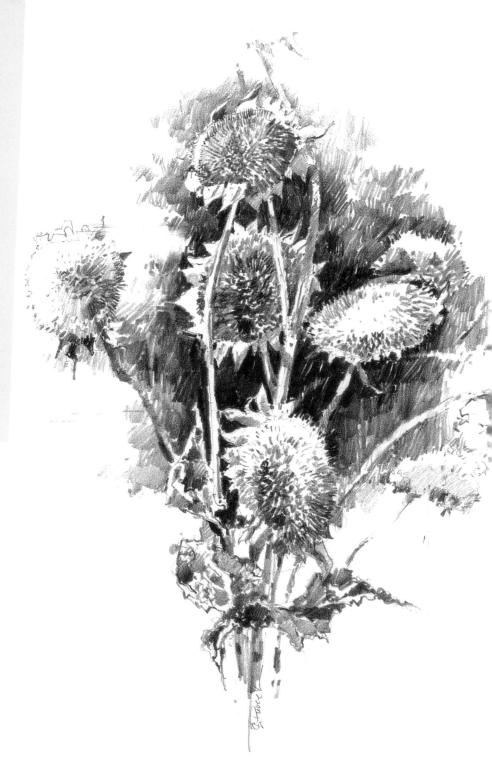

### Drawing as a Means of Discovery

This drawing discovers the complexities of the forms, the brittleness of the leaves, the prickly quality of the centers, and the lights and darks as they reveal an edge in some places and dissolve it in others. Unlike the intellectual symbols, this drawing cannot be repeated. Another drawing of the same subject would yield a different result. Even a slightly different view would produce a completely new set of relationships to explore.

**SUNFLOWERS** ▸ Graphite pencil on bristol paper ▸ 9" x 7" (23cm x 18cm)

# The intellectual brain focuses on the surface details it can identify, ignoring information that explains the form.

A common statement by adults who claim not to be able to draw is, "I can't even draw stick figures." That, of course, is not true. What they mean is, "I can't make my stick figures look realistic." Well, of course they can't—people don't look like stick figures!

It's odd that in our culture we assume that everyone can (and should) learn basic language skills although only a small percentage will become authors. We also assume that everyone can learn math while only a few will become mathematicians. However, we assume that drawing requires some special talent possessed by only a few and the rest need not try.

When I first started teaching drawing, I had no idea where these symbol images came from. Students looked at a subject right in front of them, but their drawings seemed to come from another world. And in a sense, they were. The subject for the drawing was in the visual world, but the symbol that materialized on the paper came from a world of data storage. Drawing ability was overshadowed by conscious symbol-making.

Discovering your hidden talent doesn't have to take years.

Drawing well requires you to reject the symbol proposed by your intellectual brain and ask yourself, "What do I actually see?" There are no shortcuts. The information cannot be generalized or memorized. It must be savored and enjoyed.

Like a good meal, an honest search for visual information in a subject is enjoyable and satisfying. Only your intellectual brain thinks it's tedious.

**Photo Reference**
This gentleman in England was kind enough to allow me to photograph him for a drawing.

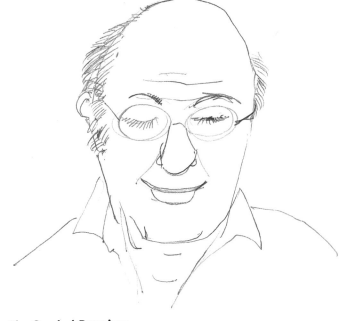

**The Symbol Drawing**
This is a typical symbol approach to drawing a head. Notice the attention placed on nameable details like glasses, lips and hair. But it pays no attention to their shapes. Glasses are glasses; why bother to get the actual shape when a symbol will do? The intellectual brain does not notice the hair is dark (in shadow) on one side and white on the other. Also, the intellectual brain doesn't care about the actual tilt of the head, but includes details such as eyelashes although it can't see them. It only knows they are there.

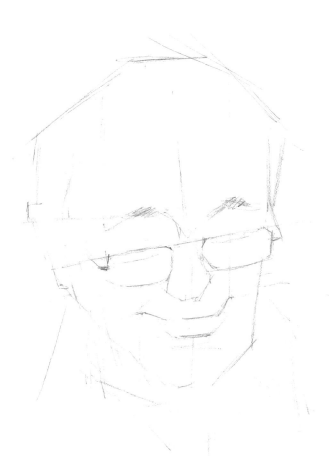

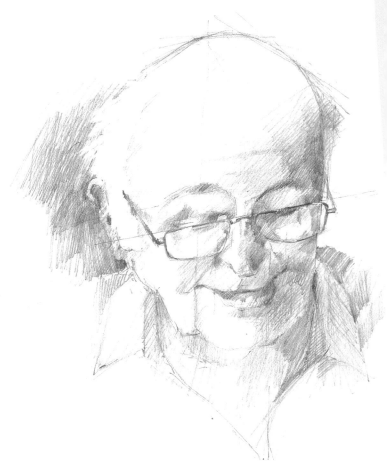

## Beginning to See

This, on the other hand, is the beginning of a real search for observational details. Notice the sighting lines that explore the vertical and horizontal relationship of the hairline to the glasses, the eyebrow to the ear.

This kind of search produces a likeness. The search narrows until it includes the small angles of the shadows around the eyes, the spots of light on the glasses' rims, and so on.

## An Almost Completed Search

Here the search has progressed to a more complete stage. I would finish this drawing by pushing the values (the lights and darks) and deciding what I wanted to emphasize about him.

## POINTS TO REMEMBER

▸ Your intellectual brain can't draw—it sacrifices all the wonderful information that makes beautiful drawings. It interjects, symbolizes, generalizes and focuses on details. Work around it to see only shapes.

▸ Pay attention to shadows. When the symbol creation of your intellectual brain is unsatisfactory, it tries to remedy the problem by adding details. Its theory is that if there is a problem, more details will solve it. Of course, it focuses on the details for which it has names: eyelashes, stains, bumps, holes, scratches, etc. It will ignore shadows that explain how the form turns in space.

## Problem 4 in Action

This old gas can is a good example of different kinds of detail. It has decorative details that may enhance the visual interest of the piece but do not explain its form. But, it does have structural details that help us understand its form, structure and three-dimensionality. Can you see the difference?

Colorful rust spots. Another detail that the intellectual brain can identify, but which adds nothing to our understanding of the form.

Bullet holes. These are decorative and nameable, but do not add to our understanding of the planes or volume. Your intellectual brain loves these.

The harder edge of the shadow shape at these two points explains the dented surface. The intellectual brain, having no name for this, often ignores it.

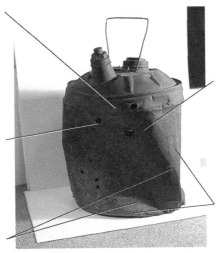

Shadow shapes. This detail is essential to our understanding of the form, the nature of the dented surface and the volume. This is visual information.

The gradual change of values in these two areas tells us that the surface is more rounded. The visual brain sees this and interprets it, but the intellectual brain cannot.

**What Makes the Shape?**

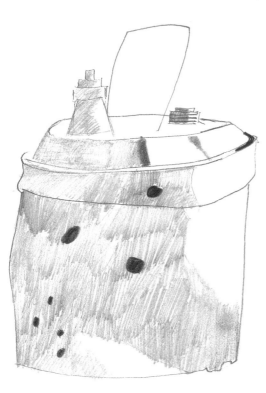

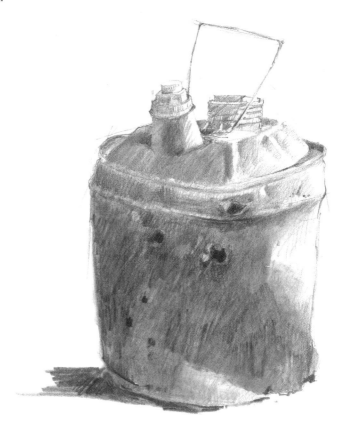

### Ignoring Form and Latching Onto Details

Look familiar? This is a typical beginner's response to drawing and shading the can. You can tell the intellectual brain controlled the process. Notice the proportions: It's too wide for its height; the spout and lid are too small and too far apart. The bottom is not fully rounded, and the shadowed area is not dark enough. These characteristics were ignored by the intellectual brain as it jumped into the drawing and headed right for the bullet holes.

Check out those dark bullet holes! You can't help but notice them, can you? Why are they so pronounced? It's because the intellectual brain could identify them and put a name to them. You can almost hear it say, "Hey, bullet holes! I can draw those. They're just black dots. That's easy!" It doesn't notice that the holes are only a little darker than the shadowed can.

### Drawing Like It Is

In this drawing, I have rendered the shadow almost as dark as the bullet holes. This is the correct value relationship. I have also drawn the height to width and other size relationships correctly. I checked the angles and the positional relationships of the handle, the spout and the lid. A visual likeness is created by these relationships, not by the accumulation of details.

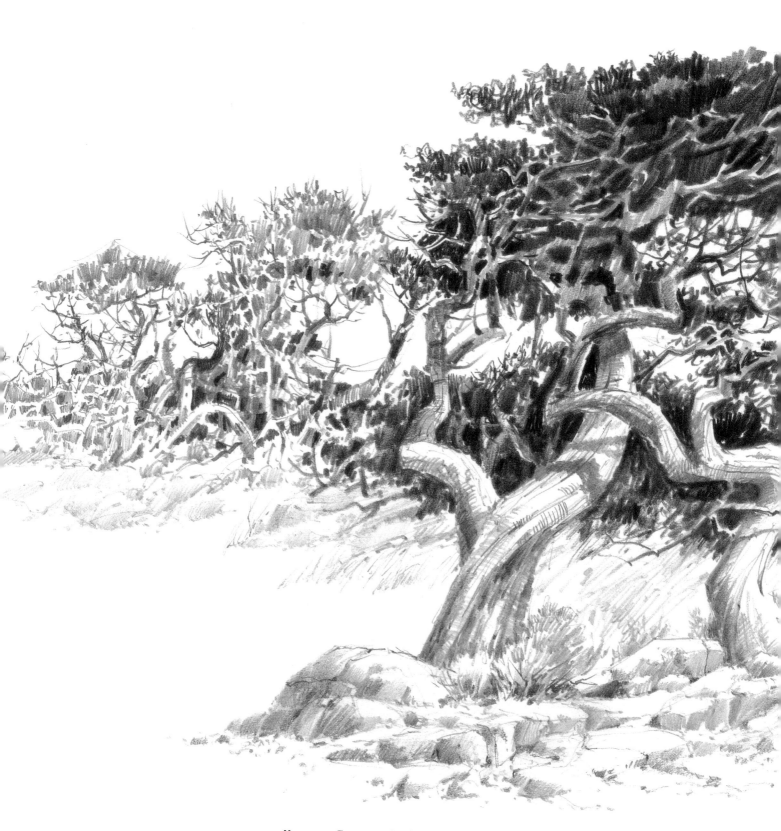

**MONTEREY TANGLE** ► Graphite on bristol paper ► 9" x 12" (23cm x 30cm)

# *gaining access to*
# YOUR ARTIST'S BRAIN

Now that you know the causes of your most common problems, you're ready to become acquainted with the abilities in your brain that make drawing easier and more fun. These are abilities you already possess and use every day! You have used them until now on a subconscious level, hardly aware of it. The exercises in this chapter are designed to apply your natural abilities to compare sizes and angles, and to see positional relationships in the act of drawing. Your hand is the physical extension of your mental operations, and as such, can do only what your brain tells it to do. When your brain shifts from naming items to perceiving visual relationships, it will send the information right to your hand. The hand will then record the information in your drawing.

# The drawing tools you possess

There are four mental abilities that you and I possess and use every day of our lives that facilitate the act of drawing. Every artist has a different name for them and trains them whether they realize it or not:

1. The ability to see relationships of angle.

2. The ability to see relationships of size.

3. The ability to see relationships of position in space.

4. The ability to see relationships of value (relative darkness and lightness).

These are not abilities possessed by only a few "gifted" people—everybody uses them all the time. If you focus your attention on searching for these relationships, better drawings happen naturally.

The exercises in this chapter will result in your artistic freedom. Like the study of piano, a disciplined approach to learning the scales and chords that form the structure of all music leads to the freedom to play anything. Similarly, seeing in the right way will create good habits and drawing will become easier and more enjoyable.

**Isn't It Obvious?**
You're already in possession of all the tools you need to draw well.

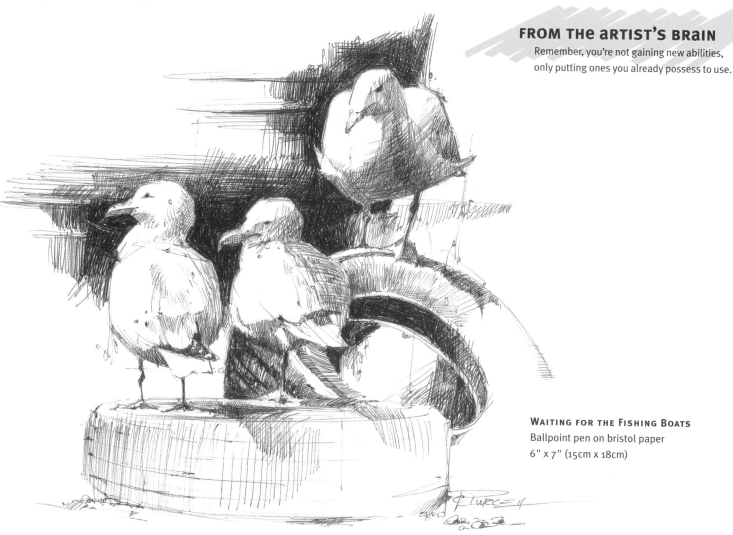

## FROM THE ARTIST'S BRAIN
Remember, you're not gaining new abilities, only putting ones you already possess to use.

**WAITING FOR THE FISHING BOATS**
Ballpoint pen on bristol paper
6" x 7" (15cm x 18cm)

## 1 Your Ability to See Angle Relationships

When you straighten a picture on the wall, you are using your ability to compare angles. You look at the edge and compare it to the closest vertical line you can find: the door frame, a window or another picture. When they are parallel, you are satisfied. Lining up pencils and paper parallel on the desk uses this ability. When you parallel park your car, you are matching the angle of your car to the angle of the curb.

Every day in hundreds of ways, you use this spatial ability to see, compare and project angles in space. In most of these instances, you compare an angle with what you know to be vertical or horizontal, for which you have a built-in sense. This is an artistic ability.

## 2 Your Ability to See Size Relationships

When you pick up a can of beans and open the cupboard to put it away, you look for a space that is at least the same size as the can. Do you measure the can first? Of course not! You mentally memorize its size and scan the shelf for a similarly sized space. When you decide that a parking space is large enough for your car, you don't have to block traffic while you measure both the space and your car. You can look at a drawing of a head and tell if the ears are too big because you are accustomed to seeing a certain size relationship in people. At a glance, you can look at a group of paintings on a wall and tell which is the largest, which is the smallest and which two are hanging the closest to each other. You perform these kinds of size relationship comparisons every day. Now you will consciously use this as a drawing skill.

## 3 Your Ability to See Positional Relationships

When you describe something as being at "about eye level," you project an imaginary horizontal line in space equal with your eye. Instead of using actual measurements, we often say things like "the dog comes up to my knees." When we read that the man was "standing just to the left of the door and directly below a carved waterspout," we can mentally position him in space.

Maps are simply two-dimensional representations of where cities and towns are located in relation to each other in real space. On a map, vertical represents north and south, and horizontal represents east and west. An essential part of drawing is "mapping" the location of key points in relation to each other. Vertical and horizontal alignments are something we all understand. They are used constantly in drawing.

## 4 Your Ability to See Value Relationships

We are able to distinguish one shape from another because of variations of light and dark. We also understand volume because of the way light falls on an object. As children, we learned that if a shadow on an object ended sharply, there was a sudden change in plane, and if it changed gradually, the form was rounded. Light and shadow are how we read shape and form, but we do so without thinking. In drawing, you will pay close attention to those changes and how they affect your perception. Recording value relationships is a skill that must be developed.

### FROM THE ARTIST'S BRAIN

In drawing, three-dimensionality, depth or volume all have to do with the same thing: the relationships of value.

# Achieving a likeness

To achieve a likeness in drawing, you must use visual solutions. A likeness is only found in correct visual relationships. The only errors possible are as follows:

1. You have drawn an edge or line at the wrong angle.

2. You have drawn a line too short or too long compared to another.

3. You have drawn something in the wrong place in relation to the things around it.

4. You have made the value of an area too light or too dark in relation to its adjacent values.

There isn't a right way to draw noses, a right way to draw eyes and another way to draw trees. Everything in the visual world can only be drawn as shapes on a two-dimensional sheet of paper. You can draw the angle correctly or not, make a shape too large or too small, put the shape in the wrong place or draw too light or dark. That's it!

Everything is made up of shapes, and those shapes have a particular configuration because of the relationship of angles, size, position in space, and value. Build a habit of searching for these relationships and you can draw anything.

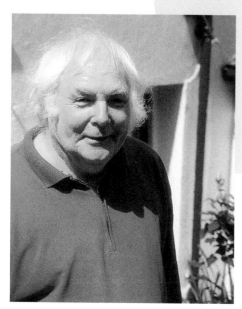

**Reference Photo**
This gentleman was nice enough to let me photograph him. People expect artists to be a little weird, so you can get away with asking perfect strangers to do this!

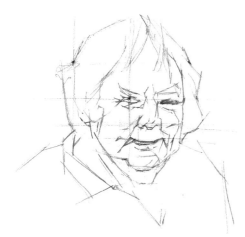

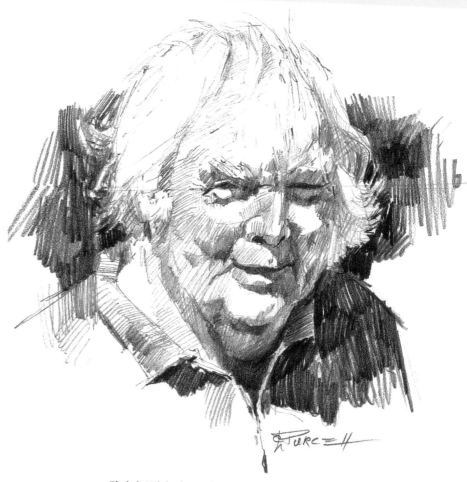

**Searching for the Visual Relationships**
This sketch is a record of a search for relationships. There are no details; everything has been reduced to angles. Curves have been converted to a series of straight lines so the angles can be seen. Sighting lines help locate points on the head that are horizontally or vertically aligned. This search captures the likeness, but no nameable items have been outlined.

**Finish With the Values**
Here the values have been added and the sighting lines have been mostly covered. The values provide the sense of three-dimensionality, or volume. No amount of shading, however, can correct errors of placement, size or angle. Lavish your time on the first stage of the drawing, not on the details.

**AN ENGLISH GENTLEMAN**
Graphite pencil on bristol paper
5" x 4" (13cm x 10cm)

The following is what such a search looks like.

## The Strategy of Search

Our strategy in the remainder of this chapter is to focus attention on three relationships—namely of angle, size and position. Put aside common notions of drawing and replace them with this:

*Drawing is a process of searching: It's a search for the spatial and visual relationships of angle, size and position, followed by values. My drawing is the record of my search. The more focused my search, the finer the drawing.*

Make a sign of the previous statement and hang it where you do your drawing. Remind yourself of it daily. If you stay focused on these relationships, your intellectual brain will not be able to intrude. You will discover that drawing is easier and more fun.

### One Relationship at a Time

Good drawing habits are a matter of noting a relationship, recording it, then moving on. Even the most complex subjects are handled one relationship at a time.

### Catch the Spirit

My drawings of the places I visit capture much more of the spirit of the place than the photos I take. I still take my camera along, however, because some things go by too fast.

**DORNOCH, SCOTLAND** ▸ 6B graphite pencil on bristol paper ▸ 5" x 8" (13cm x 20cm)

# Seeing shapes instead of things

Everything in the visual world is made up of irregular shapes that vary in complexity. You don't have to learn to draw shirts, rocks, eyes, etc. You only have to learn to draw shapes. Take comfort in this, for there are millions of different things out there. Anything you draw must be taken just as you see it at that moment, from that vantage point. If you move over one foot, the shape, the angles, the width in relation to height and the relative position of points in space will change.

How do you get the angles and size relationships right on all these different shapes? One of the most useful tools for checking these relationships is the one in your hand: your pencil.

### Using Your Pencil to Find Angles

Before you begin to draw this pear, look at it not as fruit, but as a shape. Look at the angles of its edges, the angle of the stem, its height and width, and where the stem is in relation to its sides. Use the pencil to check. Prop the book up in front of you.

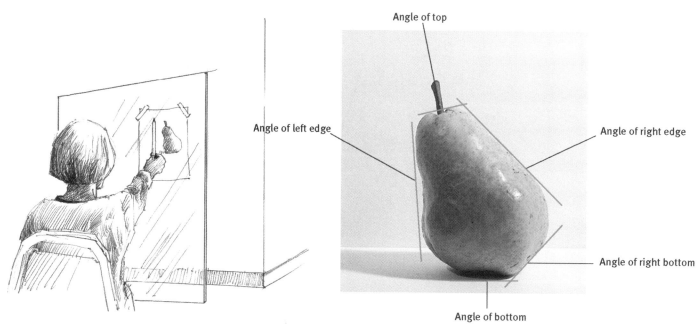

Angle of top

Angle of left edge

Angle of right edge

Angle of right bottom

Angle of bottom

### Seeing Your Subject in Two Dimensions

Imagine a sheet of glass between you and the subject. If you were to close one eye and draw with a marker on the glass exactly what you see, you would duplicate what you see on your paper—converting three-dimensional material into flat shapes on a flat surface.

### Determining the Angles of the Edges

These are the angles you should see.

# using a pencil to measure

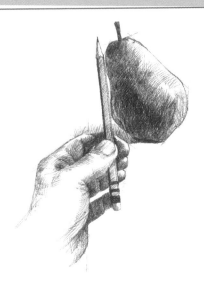

### 1 Measure the Left Edge
Begin by drawing a line representing the left edge of the pear. Don't worry about the small undulations; focus on the angle of the whole edge. Now hold your pencil out as though placing it flat on a window. Keeping one eye closed, tilt the pencil until it corresponds to the angle of the left edge of the pear. With both eyes, look back and forth from the pencil to the line. The pencil is at the same angle as the edge of the pear.

### 2 Establish the Size
The size is arbitrary—this first line determines the size of everything else; the rest will be in relation to this line. Mark where the first angle near the top changes direction and at the bottom where it turns.

Next, I usually add an adjacent angle; in this case, the angle along the top edge of the shape. Don't bother with the curve until the proper angle is established. If you establish the direction first, the variations of contour along the angle can be put in with confidence. Look at the angle of the right side of the pear, visualize it already drawn, then draw it. Hold up your pencil along that angle, look at your pencil's angle, look at your line, and adjust it as necessary. The most important thing is angle, size and placement.

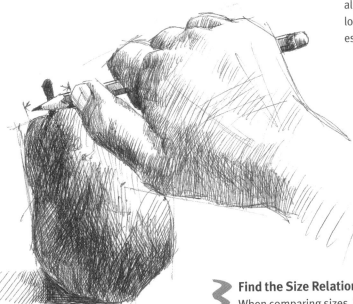

### 3 Find the Size Relationships
When comparing sizes, it's absolutely necessary to keep your arm extended and locked into place. Any change in the distance between your pencil and your eye will invalidate the comparison. Place the tip of your pencil at the point where the angle of the top edge changes direction and curves down toward the left side. Move your thumb along the shaft of the pencil until it is marking the right end of the angle.

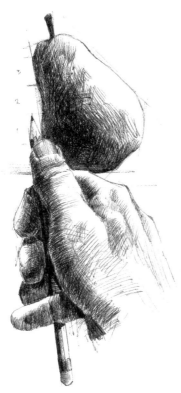

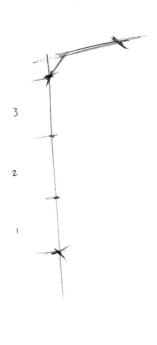

## Compare Sizes

Keep your arm rigid while your thumb marks the length on your pencil, then rotate your hand until the pencil is parallel with the left side, and the tip of your thumb is at the bottom of the first edge you drew. See where the tip of your pencil comes to on the pear. Move your hand and pencil up until the tip of your thumb is at that point. Note where the tip of the pencil comes again and move your thumb up to that point. The length you marked off on the pencil with your thumb is one-third of the first edge.

## Correct the Size Relationship

Go to your drawing and divide the first line you drew, the one representing the left side, into thirds. You now know the length of the top angle. No matter how long you made that first line, the second line is one third as long. You are using the pencil to get the same size relationship in your drawing—not an actual measurement, but a comparison.

## Check Sizes and Angles

Use your pencil to see the angle of the right edge of the pear as before. Draw the line, then hold your pencil back up to the subject and repeat the process, looking back and forth from your pencil to your drawn line. When you are satisfied, check its length with the first edge. The first one is a little longer. Make this one a little shorter than your first and go to the angle of the next edge. Compare the widest width with the length of your first edge.

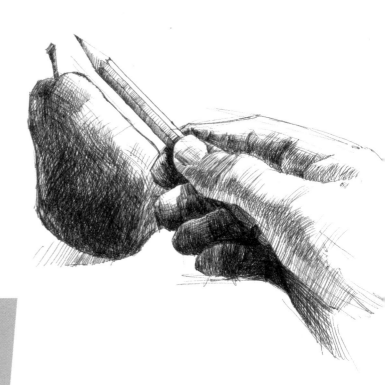

## Angle, Edge or Line?

Most of the time in this chapter when I speak about an angle, I will be referring to the angle of an edge on a shape. Your ability to recognize these angles will help you draw every line as it relates vertically or horizontally to the drawing.

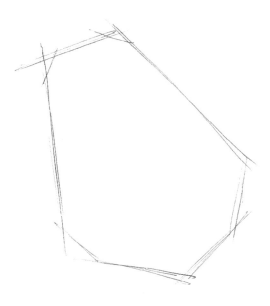

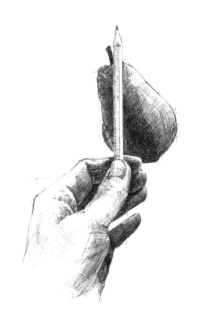

### 7 Find Positional Relationship

When you complete the shape, your rough drawing contains the essential elements—the proper width to height, the attitude or general tilt of the shape (often called "gesture"), and the way it sits on the surface. Now let's add the stem.

### 8 Measure the Stem

Hold your pencil in front of you vertically. Move the pencil over slowly until it touches the right side of the stem. Sight along your pencil to see where that line touches the edge of the shape near the bottom. Mark that point and draw a light line vertically up through the shape. You now have the location of the stem and also know that it leans slightly left from vertical. This time you used the pencil as a plumb line to check vertical alignment. You can also hold it horizontally to sight and find horizontal alignments.

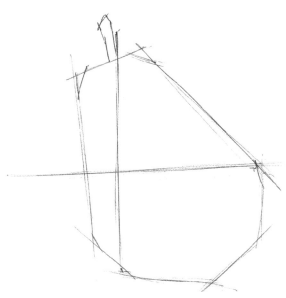

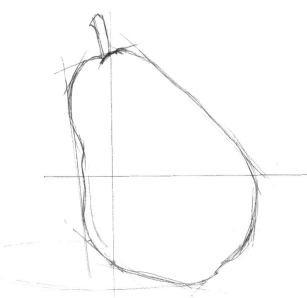

### 9 Add a Sighting Line

Hold your pencil horizontally and bring it up until it's touching the widest point on the right side of the pear. Sight along the pencil and see what's on the left side. The line goes right through the middle of the first edge. Draw that sighting line; it will be helpful in refining the shape.

### 10 Refine the Shape

Round out the curves where the general angles meet. Can you see how important the angles are? The curves fall into place if the angles are correct. Note the more subtle curves and directions of the contour.

The addition of values will eliminate most of your angle lines and sighting lines. Those that remain are evidence of an honest search and, in most cases, only add to the drawing's integrity.

# Strengthening your search muscles

Athletes do push-ups to strengthen their muscles. Likewise, you can do exercises to train your mind to see and respond to these spatial and angular relationships. I've heard it takes twenty-one days to create a new habit. So get ready to exercise. If you practice these exercises once every six months, don't expect much to happen. If you practice them for half an hour each day for twenty-one days, you'll impact your drawing skills forever.

When drawing the edge of a shape, scan the subject quickly for other edges that are the same angle. Parallel lines are the easiest relationships to see. Look at an edge until you see it as an angled line in space, then look around the subject to spot other edges at the same angle.

**Let's Get Physical**
Like an athlete or musician, you'll only get better at your craft with practice and exercise.

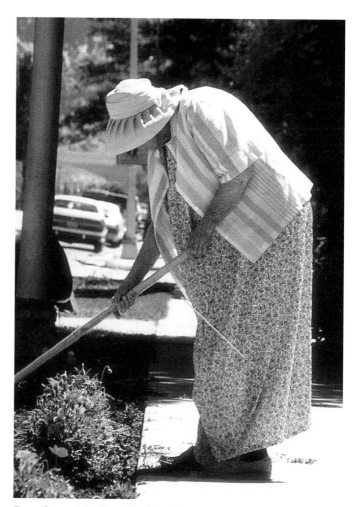

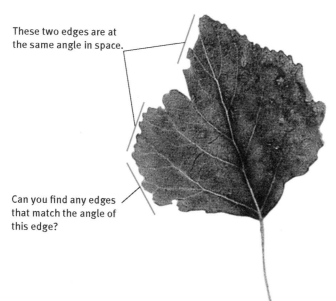

These two edges are at the same angle in space.

Can you find any edges that match the angle of this edge?

## Exercise 1: Finding Similar Angles Within a Shape

I have marked two edges that share a similar angle. You may find several. Seeing them develops your search muscles. Practice on magazine photos. Get in the habit of looking for angle relationships. You will eventually spot them immediately.

## Exercise 2: Finding Similar Sizes

See how many edges and distances you can find in this figure that are the same length as the angle I have marked. I have indicated one to get you started. There are at least eight more. It's best to scan first, then check to verify. This will train you to see these similarities.

## Points of Reference

We use points of reference all the time when giving directions. In drawing, the easiest points to locate are in horizontal and vertical relationships. Some artists refer to these as landmarks. They are places where:

1. An edge changes direction

2. Two edges overlap

3. A small but significant object (an eye, for example) is located

4. An object terminates, e.g. the end of a pole or shoe

When I draw the contours of an object, I bear down a little on the pencil at those intersections to fix them in my mind and make me pause. Then I see where that point is in relation to other fixed points, especially horizontally and vertically.

The easiest size relationship to see is two things of the same size. The length of one edge may be the same as the width of the subject, or the distance between two points may be equal to the length of an edge. Look at yourself in the mirror. Notice that the space between your eyes is the same width as one of your eyes.

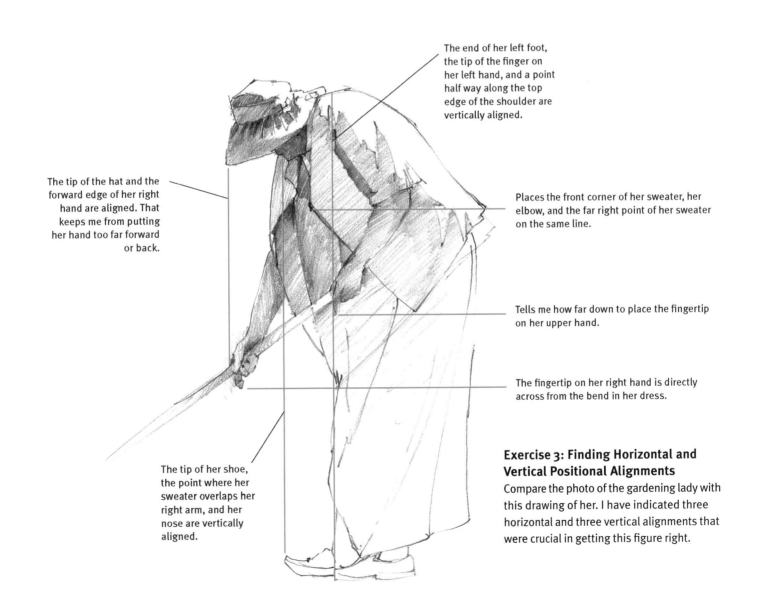

The end of her left foot, the tip of the finger on her left hand, and a point half way along the top edge of the shoulder are vertically aligned.

The tip of the hat and the forward edge of her right hand are aligned. That keeps me from putting her hand too far forward or back.

Places the front corner of her sweater, her elbow, and the far right point of her sweater on the same line.

Tells me how far down to place the fingertip on her upper hand.

The fingertip on her right hand is directly across from the bend in her dress.

The tip of her shoe, the point where her sweater overlaps her right arm, and her nose are vertically aligned.

### Exercise 3: Finding Horizontal and Vertical Positional Alignments

Compare the photo of the gardening lady with this drawing of her. I have indicated three horizontal and three vertical alignments that were crucial in getting this figure right.

35

# Four methods of search

## Comparing Shapes to Find Relationships

To get a likeness of any subject, the edges of the shapes must be at the correct angle, the proportions must be right, and everything must be in the right location (positional relationships). Let's look at four of the most common approaches artists use to apply these rules.

All of the following approaches develop an understanding of the form's inherent structure, eliminate superfluous details, and finally, use line not as a means of outlining shapes, but to probe and define structural and spatial relationships.

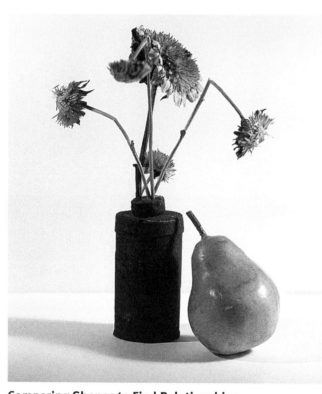

## Comparing Shapes to Find Relationships

I set up this still life specifically because all the stems bend at odd angles. Before you follow this demonstration, take a moment to scan the subject for any lines that are at the same angle as each other. See the flower stem at the right and the stem of the pear? Now look at the lower part of that flower stem and notice that the little one at the top is bent the other way but parallel with this one. Is there any part of a stem that is parallel with the edge of the can? Is part of the pear's edge parallel with the edge of the can? If you notice some of these similar angles before you start, you will be ready for them in the drawing. Look for some similar sizes also.

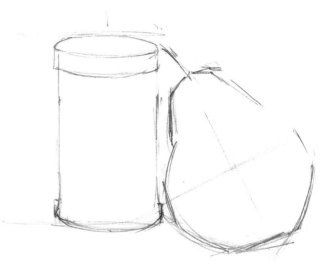

## Rough In the Biggest Shapes

It's easier to relate a small shape to a bigger one. So let's start with the two biggest shapes: the can and the pear. Begin the can with two vertical lines. Decide how tall you want to make it, then see how wide it is compared to the height. I found the body of the can to be twice as tall as it is wide.

Where is the top of the pear in relation to the can? The stem is as close to the can as it can be without touching it. Now you can check the length of the pear against the can. Find the width of the pear and you can block in the contours with straight lines.

### FROM THE ARTIST'S BRAIN

Every time you draw a line, mark its end point and glance to see if anything you have already drawn is directly across from it, then glance up or down to see if it is directly above or below something. Moving the point at this time is much easier than moving an entire section of the drawing later. This simple check can save many a blunder.

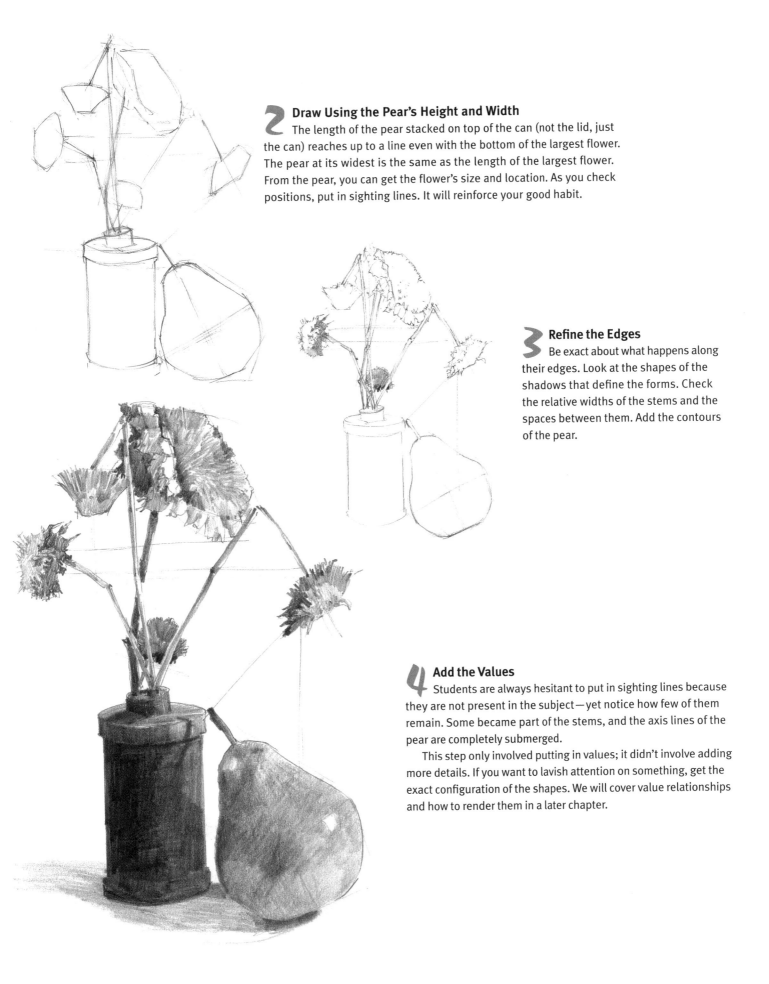

## Draw Using the Pear's Height and Width

The length of the pear stacked on top of the can (not the lid, just the can) reaches up to a line even with the bottom of the largest flower. The pear at its widest is the same as the length of the largest flower. From the pear, you can get the flower's size and location. As you check positions, put in sighting lines. It will reinforce your good habit.

## Refine the Edges

Be exact about what happens along their edges. Look at the shapes of the shadows that define the forms. Check the relative widths of the stems and the spaces between them. Add the contours of the pear.

## Add the Values

Students are always hesitant to put in sighting lines because they are not present in the subject—yet notice how few of them remain. Some became part of the stems, and the axis lines of the pear are completely submerged.

This step only involved putting in values; it didn't involve adding more details. If you want to lavish attention on something, get the exact configuration of the shapes. We will cover value relationships and how to render them in a later chapter.

# Four methods of search

## METHOD 2

### Simplifying, Then Refining Shapes

This has been a standard approach in figure drawing classes for many years. If you have to draw the head as a sphere with attached three-dimensional triangle forms for the nose and jaw, you won't become ensnared by eyelashes and lips. This approach neatly sidesteps the interference of the intellectual brain.

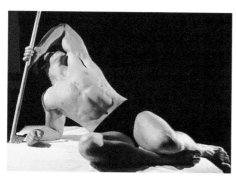

**Reference Photo**
It's easy to get absorbed in the details and lose the form. I've seen this happen so many times in figure drawing sessions that I believe it to be the norm rather than the exception.

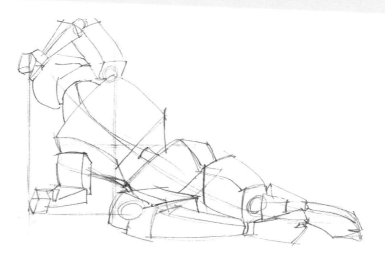

**1 Reduce the Figure to Geometric Shapes**
Visualize the major portions of the body as geometric shapes that are linked together. By forcing the attention on volume and structure, the details will be ignored. This planar structure is essential if the details on the surface of those planes are to make sense.

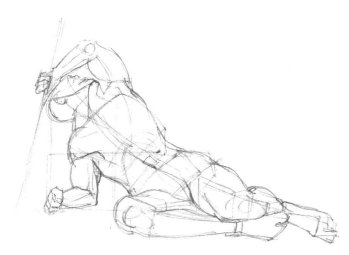

**2 Define the Contours**
Like the first approach, this method moves from a general statement of form toward a more specific description, introducing the surface details at the very end.

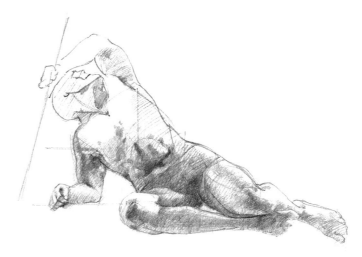

**3 Add the Values**
Any addition of value, whatever the technique, must be preceded by an understanding of the volume, size relationships, positional relationships and the angles of the forms in space. Anything short of a dedicated search will result in a faulty construction that no amount of shading and surface details will ever resolve.

## Method 2: Ellipses

Note that in each case, you will still see the plumb lines and horizontal sighting lines that ensure everything is where it should be.

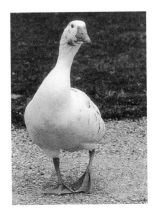

**Reference Photo**
This goose is an excellent subject to practice converting forms into ellipses and geometric constructions.

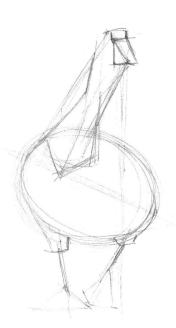

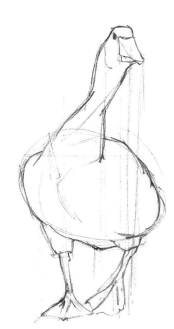

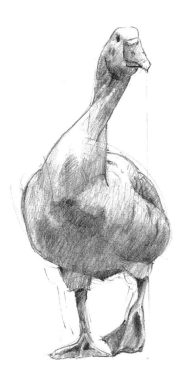

### 1 Draw the Geometric Shapes
Draw the long axis of the ellipse at the proper angle. Next add the angle of the neck, then break it down into a couple of triangular forms, the top one inverted. Notice how the base of the lower triangle extends down into the ellipse. Add the triangular block that forms the beak and drop a plumb line from its tip to see where the feet are in relation to that point. Finally, the legs can be seen as two angled lines with triangular forms at the ends. Pay attention to where the points of the triangles are in relation to each other.

### 2 Define the Contours
With the structure analyzed, it's time to pay attention to the contours and to place the eye and get the right angles. Isn't it funny that the goose fits so nicely into the shape of one of its eggs?

### 3 Check Your Angles
Never stop checking the three big relationships. You can see the vestiges of the initial angles, my pentimento lines. I double-checked the angle by looking closely at the plumb line from the tip of the beak. It comes very close to the outer edge of the left foot. I also dropped a plumb line from the eye and confirmed that the foot should be moved to the right. It pays to check rather than assume.

### FROM THE ARTIST'S BRAIN
Like all drawing, this method requires you to look for positional relationships by dropping plumb lines from key locations to ensure that things are vertically aligned. Also, check by sighting along horizontal lines from key points like the hand or shoulder. Do not ignore size relationships. If you don't also search these out, you may analyze the structure of the form but have it in the wrong place at the wrong size.

## Method 2: Analysis

It doesn't matter whether you analyze the structure as geometric forms or a group of circles. The important thing is that you begin with such an analysis. Any method that shifts your focus from details to relationships is good. You will find yourself gravitating to the method that suits your personality.

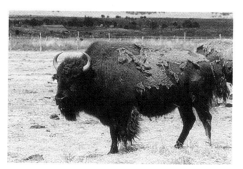

**Reference Photo**

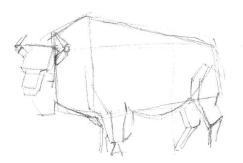

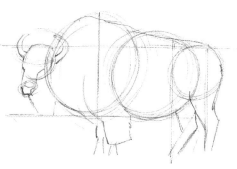

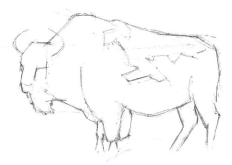

**Geometric Blocks**

This is an analysis of the form as geometric blocks. It emphasizes the solidity of the forms and the planes.

**Overlapping Circles**

This approach builds the form upon overlapping circles to represent the major parts of the animal: the hindquarters, the midsection, the massive shoulder and chest area and the head. The legs are added to these basic shapes.

**Angular Construction**

This is my usual approach, one based on the basic angular construction of the major shape. I see the form as one large shape whose edges are represented with lines at the proper angle, the right length and in the right place.

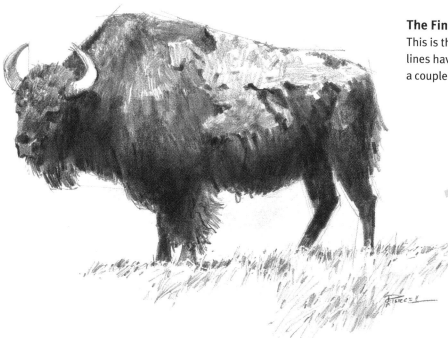

**The Finished Product**

This is the final stage of adding the values. Most of the sighting lines have disappeared, but slight vestiges of the angle lines and a couple of sighting lines remain as evidence of the search.

### FROM THE ARTIST'S BRAIN

Keep asking yourself the important questions. (And I don't mean "Why am I doing this?") Questions like, "How close is the angle of this object to vertical?" "Are any of the subject's dimensions the same?" "Where is this in relation to that?" Everything is a relationship of size, position or angle. If something looks wrong, the problem and solution lies in one of these relationships.

### Fitting the Subject Into One Shape

All of these methods simplify the subject matter and organize it into manageable parcels. Think of it as similar to creating an outline for a written article. The outline does not present any of the supporting details, but it organizes the main ideas to best support the thesis. Like an outline, these methods organize the task of drawing and present a framework on which to hang the supporting details.

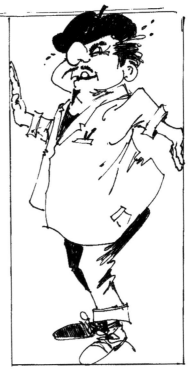

**See It Simply**
Anything can be made to fit into a simpler shape!

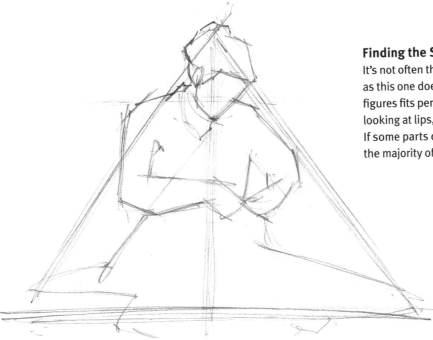

**Reference Photo**
Sometimes a single figure fits nicely into an easily defined shape. This shape then provides a framework for the whole. Can you see the shape that this figure fits into?

**Finding the Shape**
It's not often that a figure fits so nicely into an equilateral triangle, as this one does. But be aware, often a complex figure or group of figures fits perfectly into a rectangle, triangle or square. If you are looking at lips, jewelry or hair styles, you will not see these shapes. If some parts don't fit perfectly at this stage, don't worry. At least the majority of the figure is organized for you.

## Method 3: Subject as a Triangle

In typical Renaissance tradition this bear trio formed into a stable triangle shape. We can use that shape to begin our search for important relationships. Raphael would have loved this!

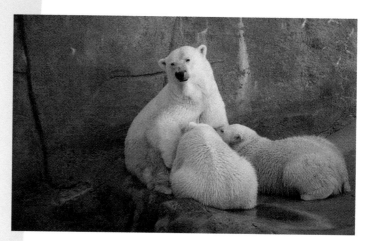

**Reference Photo**
I was fortunate to be at the zoo one day when a proud polar bear mother was striking a classic Madonna and child pose—except this Madonna had twins.

### 1 Record the Shape
Record the triangle shape that encompasses most of the grouping. This is a scalene triangle; it has no congruent sides.

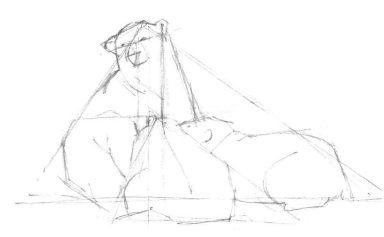

### 2 Fit the Figures Into the Shapes
Note where each of the figures extends beyond the boundaries of the triangle. If we drop a plumb line from the apex, it passes the cub's ear and touches the ground where his haunches fit over the rock. Draw the angle of the line for the mother's eyes. If you extend the line, it positions the ears. Do you see how the little cub nearest to us fits into an almost identical but smaller triangle? Check for similarly angled edges and similar size relationships. All this is part of the search.

### 3 Add the Values
When you are satisfied that the shapes and angle of the edges are right, and the sizes are correct in relationship to each other, then you can begin adding the values. If any of the above is wrong and you add darker values, it's a lot of work to erase. I promise we will get to values later. Just hang on for now.

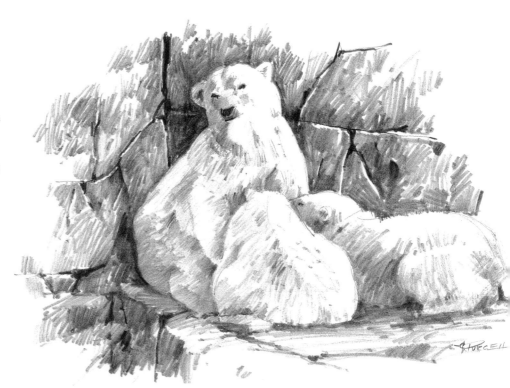

## Reference Photo

If you try to draw these lilies petal by petal you will probably get frustrated. I would! Let's simplify the process into more bite-sized steps. See how neatly these blooms fit into a rectangle? Determine its height-to-width ratio. Hint: the length is one and two-thirds times the height. Tilt the right side downward.

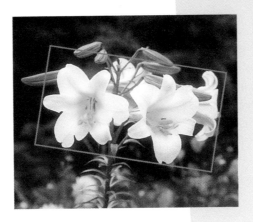

## Method 3: Subject as a Rectangle

Remember, these methods are organizational tools. Use them as a framework for your drawings and get a feel for the shapes. Eventually, you won't even notice the details at first.

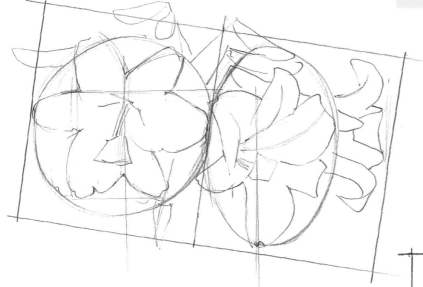

### Filling the Rectangle

Now divide the rectangle in half and notice that the left bloom fits into a circle that takes up the first half of the rectangle. The second bloom fits into an ellipse, with the third bloom filling in the remainder of the rectangle's length.

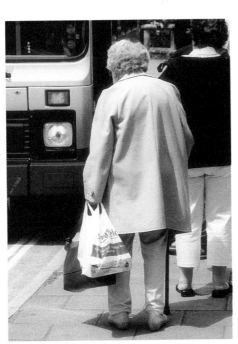

### Make 'Em Fit

Visualize this lady fitting into a shape. What does it look like?

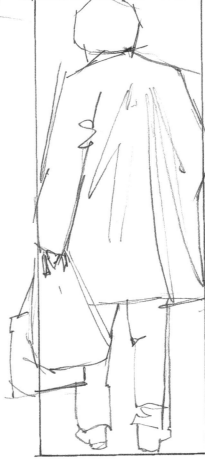

### Identifying the Shape

See how well she fits into a rectangle that is just a little over three times as high as it is wide?

# A word of caution

One caution I would give in using the first three approaches: Don't look for a magic formula that results in a great drawing every time. You can't memorize a set of relationships because these variables change. You can't memorize, period. Every time we move a fraction of an inch, the relationships of all objects to one another change.

Some subjects present a general overall shape that makes it easier to see the whole. In that case, Method 3 is an ideal way to begin. Other subjects may be more easily mastered by seeing their geometric construction as in Method 2. Some subjects have no overall shape, so you'll need to compare one shape with the others as in Method 1. Become familiar with all the methods in case the need arises, which it will.

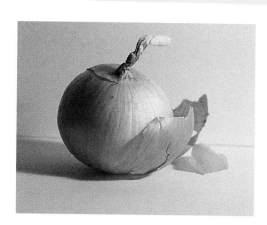

## Why All These Steps?

After years of drawing, I asked myself, "If I can draw a shape generally, then adjust it until it is correct, why can't I just draw it right the first time and skip the general stage?" I tried and it worked.

My wife gave me a wonderful Christmas present a couple of years ago. It was the book *Alla Prima* by the great oil painter Richard Schmid. He had come to the same conclusion. He writes, "If I could see the colors and shapes of a subject well enough to correct them, then I could also get them right the first time, and thus eliminate the almost-right stage! All I had to do was be very picky about how I looked at my subject, and what went on my canvas."

However, this accuracy from the get-go requires discipline—assume nothing about the subject.

### Use What You've Got

All around your own home, there are hundreds of wonderful things you can use to practice drawing skills. Try a pair of scissors, a tape dispenser, the telephone or a paper bag, and don't neglect the refrigerator. This onion is perfect!

### 1 Get the General Shape

This subject has a circular shape that will help us if we get it correct. But before you draw the circle, determine if it's a full circle, more elliptical, straight or tilted. Then draw it, but not with a dark line pressed deeply into the paper. Hold the pencil lightly, and with a full arm movement, lightly block in the shape. I go around a number of times until it evolves into the shape I want. This circle is about as wide as it is tall, and its axis is tilted to the right. It is more like an ellipse with a little added to the top.

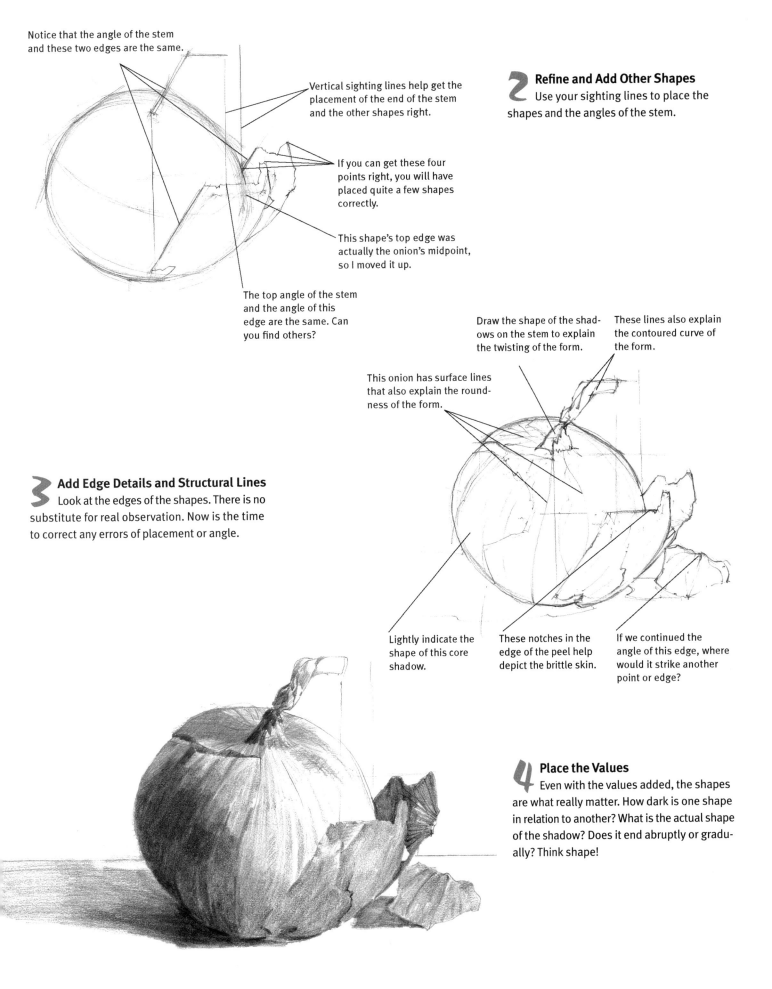

Notice that the angle of the stem and these two edges are the same.

Vertical sighting lines help get the placement of the end of the stem and the other shapes right.

If you can get these four points right, you will have placed quite a few shapes correctly.

This shape's top edge was actually the onion's midpoint, so I moved it up.

The top angle of the stem and the angle of this edge are the same. Can you find others?

## 2 Refine and Add Other Shapes
Use your sighting lines to place the shapes and the angles of the stem.

Draw the shape of the shadows on the stem to explain the twisting of the form.

These lines also explain the contoured curve of the form.

This onion has surface lines that also explain the roundness of the form.

## 3 Add Edge Details and Structural Lines
Look at the edges of the shapes. There is no substitute for real observation. Now is the time to correct any errors of placement or angle.

Lightly indicate the shape of this core shadow.

These notches in the edge of the peel help depict the brittle skin.

If we continued the angle of this edge, where would it strike another point or edge?

## 4 Place the Values
Even with the values added, the shapes are what really matter. How dark is one shape in relation to another? What is the actual shape of the shadow? Does it end abruptly or gradually? Think shape!

45

# Four methods of search

## Drawing Adjacent Shapes

You may want to try this last method after you have mastered drawing shapes. It requires you to begin with one shape correctly drawn then move to an adjacent shape, draw it correctly, and so on until the last shape is drawn. It's like putting a puzzle together piece by piece.

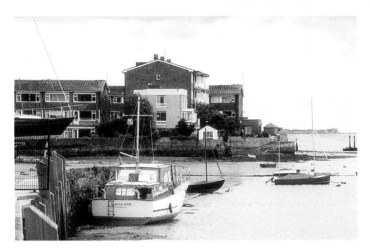

### Reference Photo

The temptation would be to start with the boat. But look again—the boat is not an easy shape to see. It's made up of many little shapes, and your intellectual brain will try to insert information about lengths and proportions. The near end of the dark building at the top is a better place to start. That's a shape even I can handle.

### 1 Get One Shape Down Right

Visualize the completed drawing on your paper. Place the all-important first shape somewhere near the top. Draw the right edge of the shape the size you want it. This is the easiest line in the drawing because you get to decide how long it will be, and the angle is vertical. Measure on the photograph and you will see that three more of those lengths will take you to the bottom of the boat.

Check the length of the edge of the roof. If you don't count the part that sticks beyond the edge of the wall, it's the same length as the first line. The width of the shape is a little more than twice the length of the edge.

### 2 Proceed to the Adjacent Shapes

Take each shape and relate its size and position to the first shape. If you check, you will usually find that a size repeats. The height of the gray building minus its white cap is the same length as the first line drawn and the roof angle, as is the length of the roof ridge and the height of the right edge.

When you put your pencil point on the paper, pause to see if you are in the right place. You wouldn't swing a hammer and then check to see where the nail is.

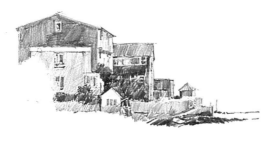

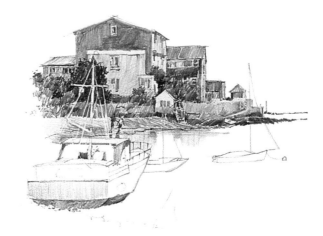

### 3 Finish the Buildings

Each shape has to be seen in relation to every other shape, whether drawing a scene or a portrait. Also, each shape has its own specific dimensions and configurations. Don't guess! Drawing from life is about accurate observation.

### 4 Build the Foreground

The very first line you drew will help you to position the large boat and get its size correct. And the width of that first shape will give you the size. No guesswork!

Also, decide what not to include. The apartment building isn't needed. Lower the connecting building, extend it a bit, then drop it into some trees. The shape of the land will expand as it moves into the picture.

### 5 Finish the Drawing

Keep thinking shape: How does the major dark shape of land end? Can you make it better? If you include people, it always adds interest to a landscape.

Look for any flaws in the composition. Your eye movement along the upper buildings toward the right side is checked and redirected downward by the mast of the small boat. The post and ground pick up that downward movement and direct it back to the left toward the large boat.

**BUDLEIGH SALTERTON HARBOR**
6B graphite pencil on bristol paper
8½" x 10" (22cm x 25cm)

## POINTS TO REMEMBER

▸ Visualize the subject as a drawing. You don't have to see all the details, but translate it from an object into a drawing. What will it look like?

▸ Ask critical questions to help you draw well: Is there a general, overall shape that will help me relate all the parts? Are there any edges or lines that are parallel? At what angle? What is the general attitude of the subject? Is it vertical or tilted at an angle? If so, what angle? Are there any key points directly across from each other? What is the vertical alignment?

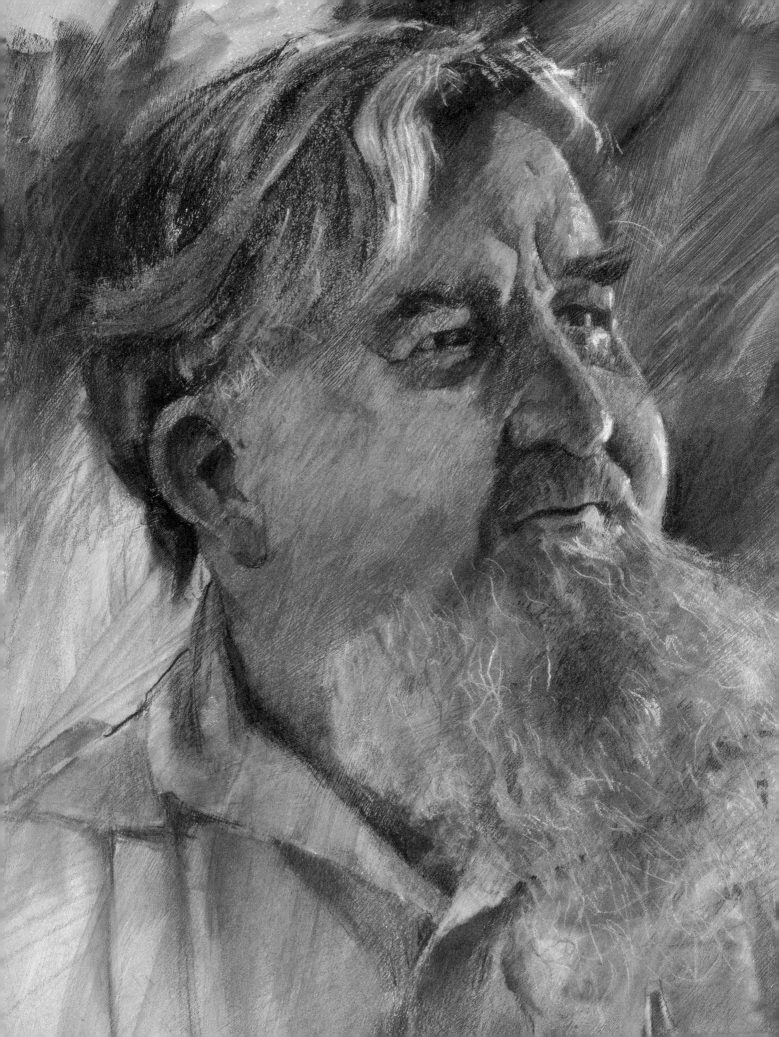

# *searching for*
# Line and Form

The process of search is the same for every subject. Like many artists, you may have avoided some subjects because they seemed too complex. However, the search required to draw a pear accurately is the same as the search to draw the human figure accurately. Develop the habit of searching for relationships of angle, size and position and your progress will amaze you.

At this point, we need to address the edges or contours of forms and the quality of line we use to define them. Complex forms provide us with overlapping edges that make the form appear to turn in space. As we refine the search for relationships, we will want to firmly state these overlapping edges through contoured lines. This chapter introduces the contour line as an expressive tool for defining edges and eventually applies this to the complex form of the human figure.

Remember that all forms are made up of simple shapes. Complex forms just have more shapes. When drawing these forms, the journey may be longer, but you can still only travel one segment at a time. Drawing the contour lines of these forms is a decision to slow down and savor the scenery.

Ed ► Acrylic, Conté crayon and pastel ► 17" x 13" (43cm x 33cm)

# Contour line drawing

## The Essence of Line

In nature we don't see lines, only edges of forms. Line is the convention artists use to describe these edges on a two-dimensional surface. But apart from its role in describing edges, the line has character of its own. It can be bold or delicate, energetic or graceful. Lines can be very expressive, both of the subject being drawn and of the person drawing.

Most people starting out in art are unsure of themselves and fearful about the lines they put down. Knowing they are going to make mistakes, they minimize errors by only committing to short line segments. The result is that sketchy line so common in beginning drawings. If drawing a fur ball, this line would actually be effective, but when drawing solid objects with clearly defined edges, these lines look hesitant and timid. Practicing contour line drawing will develop your drawing confidence, allowing your lines to be deliberate and correct, even beautiful.

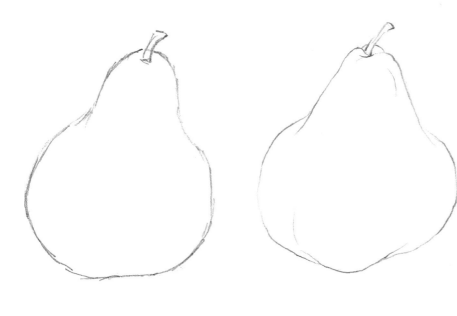

## Be Confident

Even if the shape is accurate, as it is in the first pear, the lines say more about the artist's hesitation than they do about the edge of the object. In the second drawing, the lines define the contours of the pear and suggest the fullness of its form. In addition, each line looks deliberate, as if placed exactly where intended. Even if the shape is a bit inaccurate, we assume it is right because of the sureness of the lines.

## Express Mood and Energy

Pay attention to the energy behind each stroke. The top lines convey a flowing, graceful movement. The second row is more explosive, like a bolt of electricity. You cannot make lines like this carefully. The third row combines delicate and bold lines. Imagine the variety of subjects these different lines can express.

## What Is Contour?

Contour moves with the edge of a form, defining where a plane changes direction, or where one part overlaps another. It's not confined solely to the edge where shape meets space, but often moves into the interior of the form. An outline, however, is the outside edge of a form, the edge that would be defined in a silhouette.

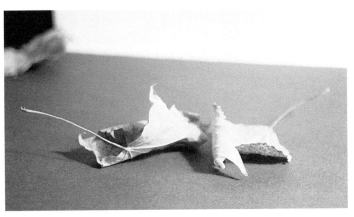

**Reference Photo**
Organic shapes like this make excellent subjects for contour line drawing because they have edges or contours that overlap and move from the outer edge into the interior.

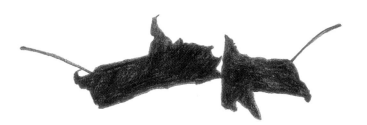

**Silhouette**
A silhouette defines where the entire form meets space.

**Outline**
Like the silhouette, an outline only defines the outside edge of the form.

**Contour Line**
The contour lines here follow the edges of the forms as they move through space. These lines are sharp and crisp, just like the brittle edges of the leaves.

# Point-to-point contour

Contour line drawing is a slower, more deliberate kind of drawing that emphasizes hand-eye coordination and empathy with the drawn forms.

My preferred method is called point-to-point contour. First, place the tip of your pencil at a given point on your paper where a contour will begin. Then, look at the subject to determine the point where the contour changes direction or overlaps another contour. Picture that point on your paper, then pull the pencil line along the contour, matching each bump and change with a corresponding shift in the line. Pause when you reach the point. With the pencil still in contact with the paper, find the next point and continue the contour. Lift your pencil only when you reach the end of a contour. Find the beginning of the next contour and do the same.

## Exercise: Pulling a Line

Tape down a piece of paper so it won't move. Place a number of random dots on the page. Then, using a 4B or 6B pencil held between your thumb and forefinger, pull a line between two of the dots, pause, locate the next point, and pull the line to that point. Try varying the line between points by twisting the pencil as it moves, or changing the pressure.

Don't hold the pencil as if you were writing. Writing is composed of short lines created by the movement of the fingers. You want longer, more fluid lines created by the movement of your whole arm. Draw from the shoulder.

## Pay Attention to Your Line

Emphasize the point of directional change with a slightly heavier pressure. You are striving for beauty of line. Use your arm instead of your fingertips. You use your whole body when you dance, not just your feet. The same is true here. Practice pulling lines with sudden changes in line density as shown here on the left. Discover the line varieties that are possible by twisting the pencil, laying it down to pull sideways, and pressing down to pull up the tip.

A number of subjects are good for contour drawing. Organic objects usually provide a lot of contours and make an interesting drawing. However, don't overlook your household items. Tools and toys make excellent subjects, as well as eggbeaters and old shoes.

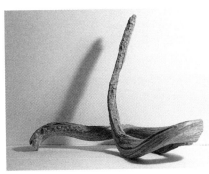

### Reference Photo
Subjects like this twisted piece of wood are excellent because contours emerge only to disappear behind other contours. Outside edges become inside contours. Some outside contours move through the form and emerge on the opposite side.

### Using Line to Explain the Form
This drawing emphasizes the contours of the twisted wood and is complete without the addition of values. The line alone explains the turning of form in space.

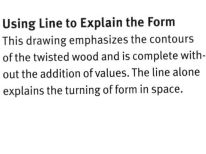

### POINTS TO REMEMBER

- Be confident. It will show in your contour drawing (actually, any drawing).

- Imagine your pencil point is in contact with the contour of the subject.

- Go slow. Don't let your eye get ahead of your line.

- Let the movement come from your arm.

- Do not lift the pencil until you have reached the end of a contour.

- Between points, look only at the subject. Don't watch your pencil draw the line.

- Erasing intensifies error. Draw the line again if you want, without erasing.

### Folds of Fabric
Clothing makes an excellent subject for contour line studies because, like the twisted wood, it features edges that begin in the interior, move to the exterior, then disappear behind another contour.

# Capturing an edge
## WITH CONTOUR LINE

*There are two ways to define the edge of any form: with value changes or with line. Whenever you create a drawing that utilizes both line and value, you will have to decide which will be dominant. I am primarily a value artist, but I love the beautiful linework of such masters as Rico Lebrun and Katsushika Hokusai. I utilize contour drawing in two instances: to define some of the edges where figure and ground are the same value, and when I don't have time for a complete value drawing of a scene—in which case, I do a contour line drawing of all the shapes involved and fill in the values later. The most difficult part is knowing when to stop. I could use someone to snatch my pencil away.*

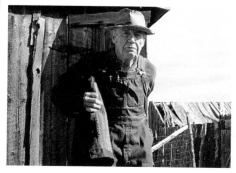

**Reference Photo**
I like the way shapes of shadow define Alma Larson's face and hand.

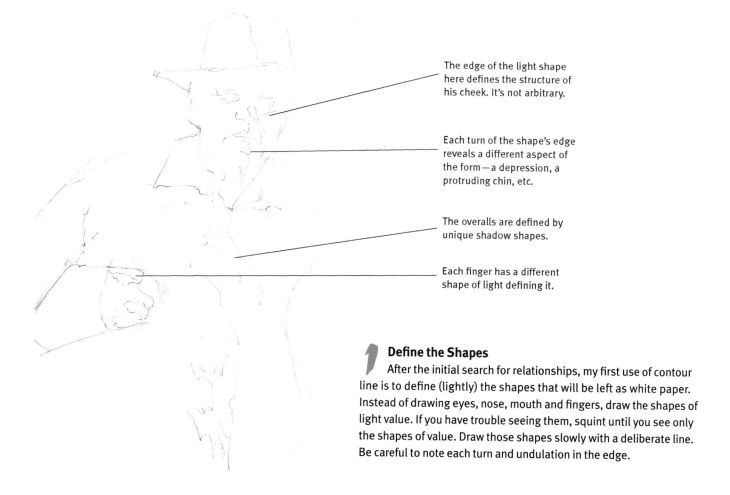

The edge of the light shape here defines the structure of his cheek. It's not arbitrary.

Each turn of the shape's edge reveals a different aspect of the form—a depression, a protruding chin, etc.

The overalls are defined by unique shadow shapes.

Each finger has a different shape of light defining it.

**Define the Shapes**
After the initial search for relationships, my first use of contour line is to define (lightly) the shapes that will be left as white paper. Instead of drawing eyes, nose, mouth and fingers, draw the shapes of light value. If you have trouble seeing them, squint until you see only the shapes of value. Draw those shapes slowly with a deliberate line. Be careful to note each turn and undulation in the edge.

Define the light edge of the hat with some dark in the background.

Merge the dark figure and the dark background in a single value. If you define this edge, you rob the viewer of figuring it out.

Lose the edge of the hat here as it merges with the light.

Put in the gray, leave the light shapes.

Carve out the lights by placing darks next to them.

These lines along the shoulder were pulled with a 6B pencil.

The pencil can be alternately dragged sideways to produce broad lines, then lifted for more delicate lines.

One careful line can give all the necessary information about the zipper flap.

Start near the center of interest—his face. Define a few contours with deliberate, carefully pulled lines.

## Lay In the Values and Define the Edges

The idea here is to have the figure emerge from the dark shadows behind him. Put in the value and let the light shapes pop out. Apply powdered graphite using a piece of thick piano felt as a brush. Lay in the background dark and carry it across and into the figure. It does not have to be recognizable, just dark. Don't let the photo tell you what to do. Define the intricate edges with a blending stump. Lift out small pieces of light such as the edge of the hat brim and the brass button with a kneaded eraser. Some edges will be lost.

## Select Areas to Be Defined

Too much contour line would ruin this drawing. To keep the dominance on value contrasts, carefully select the areas to be defined by line. Resist the temptation to define everything. Leave in lost edges, choosing the contours that best describe the form.

**ALMA LARSON**
Powdered graphite and graphite pencil
16" x 12" (41cm x 30cm)

# Using line to
# FIGURE OUT A FIGURE

When I ask workshop classes what their most challenging subject is, the most common answer by far is "people." As children, we developed an extensive repertoire of symbols about people. Later, when we attempted to draw them, the symbols were substituted in place of observation. Even though we are very familiar with the figure, we never had to create one. In order to reconstruct it, we need to forget about the hair, nose and other specific features and focus instead on shapes and their relationships.

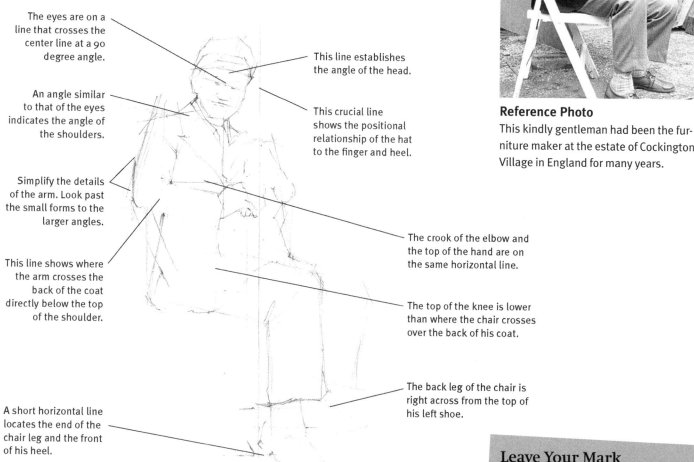

**Reference Photo**
This kindly gentleman had been the furniture maker at the estate of Cockington Village in England for many years.

The eyes are on a line that crosses the center line at a 90 degree angle.

This line establishes the angle of the head.

An angle similar to that of the eyes indicates the angle of the shoulders.

This crucial line shows the positional relationship of the hat to the finger and heel.

Simplify the details of the arm. Look past the small forms to the larger angles.

The crook of the elbow and the top of the hand are on the same horizontal line.

This line shows where the arm crosses the back of the coat directly below the top of the shoulder.

The top of the knee is lower than where the chair crosses over the back of his coat.

The back leg of the chair is right across from the top of his left shoe.

A short horizontal line locates the end of the chair leg and the front of his heel.

## Begin Your Search
Begin your search with a simple vertical line. This gives you the correct tilt of the head (it's an angle relationship to your vertical line). Follow with lines for the angles of the eyes and mouth. Then set up the width and height of the head, which will become the size comparison for everything else. (Example: The heel of his shoe and the bottom of the chair are four head-lengths down from his face.)

This stage in the search is about getting the correct tilt or angle to the shapes, locating landmark points and getting the right sizes. It is not about eyeballs, wrinkles and such.

## Leave Your Mark

I firmly believe that a drawing should look like a drawing. If I want a photograph, I will take one with my camera. Drawings go beyond photos, capturing not only a likeness, but also the response of the artist to the subject. It is that intangible bit of the artist in the work that makes it art and gives it life. In the end, the art stands apart from what the subject was.

Break down the
angles into the correct
texture of the edges.

The dots show where
the eyes are. Look
at the exact shapes.
What is the shape of
the eyebrow? What
are the eye shapes?
How do they differ?

Break up the angles
of the arm into
smaller shapes of
the folds.

The shadow shape on the side of the nose
defines the planes. How steep are the nostril
angles?

Mark the corners of the mouth. Where are they
in relation to the eyes? What is its exact shape?

Squint to see the light on the dog. Don't get
tied up in the fur. Get the shape right.

What is the shape that defines the dog's leg? If
these shapes are right, the dog will materialize.

## 2 Refine the Shapes

This second step is like the first: a search for the relationships
of shapes. The only difference is now you narrow the search to smaller
shapes within the large shapes you developed in step one. The empha-
sis is not on final appearance but on drawing shapes at the correct size,
set at the correct angle and in the correct place.

## 3 The Final Stage

Focus on what the drawing is about—the man's face and the dog
looking up at him. Make certain that the values in these areas look right.
As you move further from this focal area, ask yourself if certain shapes
need more detail to make the drawing complete, and if not, don't add
them. Notice how the shoes were left almost as they were first laid out.

You may want to add a suggestion of the stone wall. It gives a sense
of space and location and a value contrast for the light area of the dog.
Leave the sighting lines—they are part of the process. A drawing has
its own life. In the end, it has to live as a drawing, not as a copy of the
subject. These lines are a personal part of the artist's response and are
as much a part of the drawing as anything.

THE FURNITURE MAKER ▸ Graphite pencil on bristol paper ▸ 12" x 9" (30cm x 23cm)

# DRAWING a PORTRAIT

*Discipline yourself to conduct an honest and thorough search for relationships and no subject will be beyond you. You will be free to draw anything.*

**Reference Photo**
In England, we took a small boat ride from the pier in Dartmouth Harbour to the castle at the harbor's mouth. This man was the boat's captain.

## 1 Complete the Initial Search
Begin with a curved line indicating the line through the center of the subject's forehead and curving down to his chin. Use a second line to find the angle from one eye to the other. Establish the relationship of his chin, the bridge of his nose and where his forehead meets his hairline with a third line.

Mark the center of the eye to the hairline. This distance repeats itself numerous times.

Describe the hair's shape by its edges with straight lines at the proper angles. Note the points of directional change. The uppermost point is above the outer corner of the eye, and the back point is across from where his hair meets his forehead.

Draw a line through the eyes to determine where they are in relation to each other.

This line shows the tilt of his head and his general attitude— a lot for one line.

Locate the point where his collar meets his hair across from the top of his lip.

Get the ear shape, especially the location of the ear lobe relative to the top of the ear.

Nail down additional landmarks like the outer corner of the eye, where the neck meets the jaw and the bottom of the ear.

Draw a vertical line up from his chin. It passes halfway between the bridge of his nose and the corner of his eye.

## 2 Refine the Search
Refine as needed, but don't define small characteristics such as teeth or the iris. Resist the urge to get into details. They call to you so seductively: "Oh, look at me, I am so beautiful. Please put me in your drawing." Ignore them! Focus on the search.

Establish key angles such as the angle of the far cheek, under the chin, the neck and the hair.

DRAWING DEMONSTRATION

58

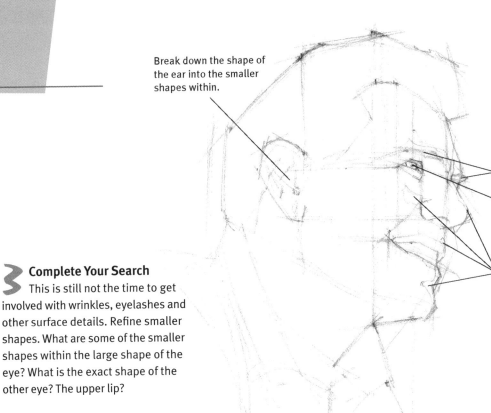

Break down the shape of the ear into the smaller shapes within.

Draw the shape of the eyebrow.

You certainly don't see a round iris. Draw the exact shape of the darkness you see.

Indicate the shapes of light that will be left as white paper. The teeth are not these. (Squint and you will see that they are actually darker than the light on his lip.)

## 3 Complete Your Search

This is still not the time to get involved with wrinkles, eyelashes and other surface details. Refine smaller shapes. What are some of the smaller shapes within the large shape of the eye? What is the exact shape of the other eye? The upper lip?

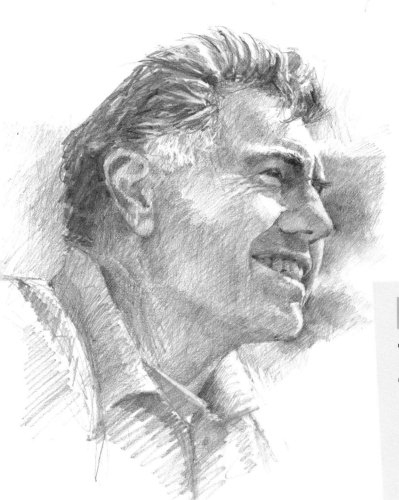

## 4 Add Refinements and Values

Define the value relationships, as well as the smaller shapes within the larger ones: the small shapes of dark and light within the hair, the shapes that define the teeth (not an outline of them), the shape of stray hair that crosses the forehead. These aren't details, but refinements. If your search has been thorough, the result will be a realistic drawing.

**HAVING A GOOD DAY**
Graphite pencil on acid-free foamcore board
14" x 12" (36cm x 30cm)

## POINTS TO REMEMBER

- Make every drawing a search for relationships.

- The only thing you can really draw is a shape, and the only way to get the shape right is to faithfully record the angle of its edges, its size relative to other shapes, and the position of its key points in relation to other points.

- Your intellectual brain will try to substitute previously stored data in place of a search. Don't let it control the process.

- No amount of detail will correct underlying problems.

- It's OK to leave your search lines as they are—a record of you, the artist.

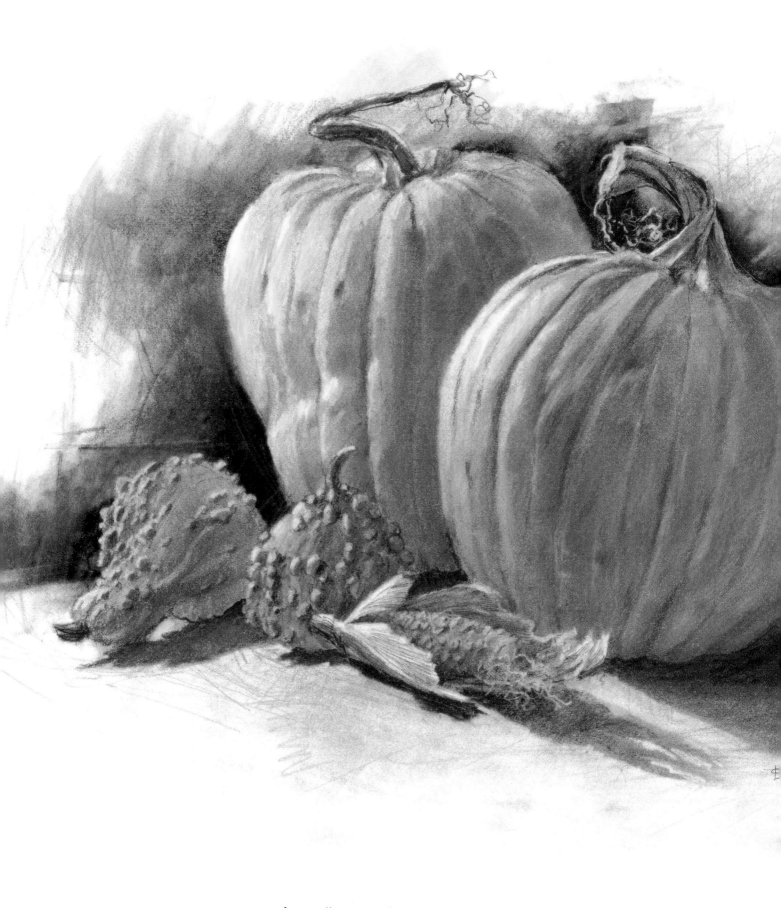

**AUTUMN HARVEST** ▸ Charcoal and colored pencil on bristol paper ▸ 15" x 20" (38cm x 51cm)

# *seeing* VALUE

The term "value" refers to the quality of lights and darks in a work of art. People speak of colors in their daily conversations, but rarely speak of how dark or light something is in relation to its surroundings. It is because of light and shadow that we are able to see anything at all. The degree of value contrast between an object and its background is what makes it visible. A black cat in a coal bin is difficult to see. A black cat on a snow bank is hard to miss.

Value plays two roles in our visual world. First, it makes shapes visible. Second, the gradations of value in a form provide us with the information to understand its volume and planes. When you harness the power of value changes and value contrast, you will be amazed at the range of possibilities. In this chapter, we will explore the wonderful world of value shifts as they simulate the effects of light and learn how to make them work for us in drawing.

# Seeing value contrasts

Value alone does not make something visible; it is the contrast between the object's value and the surrounding value that does. In nature, camouflage is accomplished by reducing value contrasts. A white rabbit is more visible on a pile of coal than a snow bank.

## Contrast Creates Clarity

These branches are a good example of how things are visible not because of what they are, but because of the degree of value contrast.

A dark shape against a light background makes this tree trunk highly visible. Your intellectual brain will try to apply this information to all the limbs.

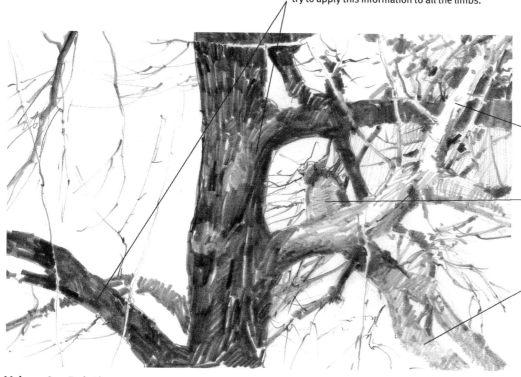

This limb is light, made visible by the contrasting dark limbs behind it. Even the sky is slightly darker.

The owl is one of the last things we discover because the value of his chest is the same as the tree limb below him. His color and the value on his chest are similar to those in the bark.

Even a minor value contrast will make a shape visible, though not eye-catching.

## Values Are Relative

Value is a powerful compositional tool. If you make a shape the same value as its surroundings, it disappears. Value contrast will make the shape visible, while a strong value contrast makes it visually irresistible.

## FROM THE ARTIST'S BRAIN

By controlling value contrast, you can direct the viewer's attention to the exact spot you want. You can also take the attention off other areas by decreasing the amount of contrast.

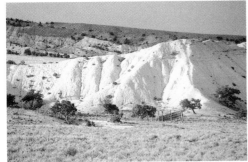

## Light Against Dark

We have no trouble seeing the shape of this hill because it's surrounded by shapes with darker values. Even the lighter value of the foreground is darker than the parts of the hill bathed in light. It is particularly the dark shape of the background hill that makes the light hill so stunning.

This dark shape is responsible for the visual power of the light. Against the light sky, the equally light hill would lose its impact.

How visible is this boundary? There is a change in color, but little value change. Are there other places where edges blur?

The shadow shapes define the form.

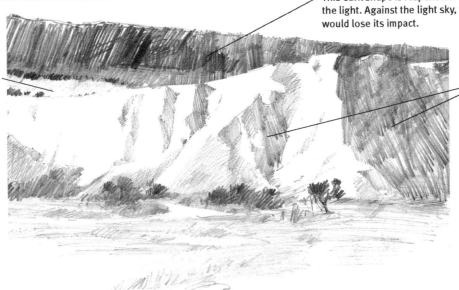

## Dark Against Light

This scene features a dark shape against a lighter background. If the sky were dark, the contrast would be minimal and the effect less dramatic.

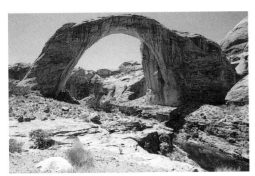

In a few places, the edge of the bridge is lighter than the background value.

The majority of this natural bridge is dark against a background of lighter values.

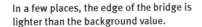

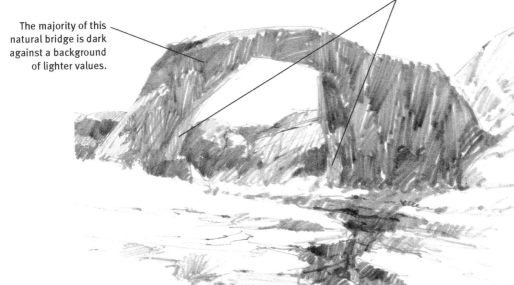

# Using value to define form

Variations of value provide us with all kinds of information. For instance, the illusion of texture can be created by small changes in value on what would otherwise be a surface of uniform value. In the illustration below, the texture beneath the crack on the third rectangle looks like carefully rendered detail. However, all I did was roll a kneaded eraser across the area, and then I added shadows below or above the lightened areas to create the effect of light across a textured surface.

When rendering the effects of light and shadow that define a form, don't rely on some quick, glib bit of information supplied by your intellectual brain. Nothing can take the place of careful observation. Ask questions like: "What is the exact shape of the shadow area, and what does it tell me about the form?"

There are so many variables for the behavior of light that a complete list of rules would be impossible. Draw what you see, not what you think, expect or know.

A shape with no value changes and bounded by a dark line appears flat.

The sudden value change here reads as a sharp change of plane.

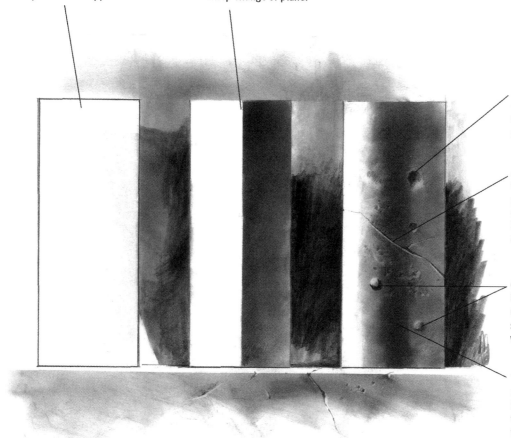

Reverse the values that simulated a bump to create the light falling on a depression in the surface.

A crack is not just a dark line. See how the gray of the surface plane is interrupted by the dark line and a lighter value line where the exposed edge catches the light.

Our daily experience usually involves a light source above us: lights, sky, etc. When we see a light spot with a shadow, we read it as a bump.

The core shadow down the center, the reflected light on the far left, and the gradual shift in value between them causes us to read this form as rounded.

## Finding the Information in Value Shifts

Look at these three rectangles to illustrate how we "read" the value information. All three are the same shape, but because of the differing configurations of lights and darks within them, we perceive each differently.

The most difficult technical problem you face in drawing is getting the various values right. "Right value" means the right relationships: how dark or light the value of one area or shape is compared to another. In order to see these relationships, you must compare them. In order to compare them, you need to simplify them. How do you simplify them? The answer is squinting, an important skill touched upon in the last chapter (page 54).

Look at your subject, then slowly close your eyes until you can still see the large shapes but not the confusing little details. What's left are easily grasped shapes of value. You'll be able to see which is darkest, which is lightest and the gradations between.

If you look at the subject with your eyes wide open, your irises adjust to allow for maximum clarity in the area of your focus. On a dark area—one in shadow, for example—your irises open wider to accommodate for the lack of light, and you will see more variety in value. The more of these details you see, the more you will miss of the larger shape and its value relationship to other shapes. If you shift your focus to a lighter area, your irises contract, allowing you to see the small variations within that area. You end up seeing far too many changes in value—more than you need to describe the forms, more than the drawing needs, and more than you can cope with.

# How to see values

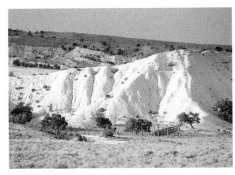

**Reference Photo**
If you squint enough, the print on this page will become blocks of gray and the individual words will disappear. That's what you want. Squint at the large general shapes in this photo. The sky is a light gray shape. The background hill loses its details, and you see a large dark shape. The light hill divides itself into two shapes of value: shapes of light and shapes of gray. The foreground becomes a midtone. Squinting simplifies the information into a manageable form.

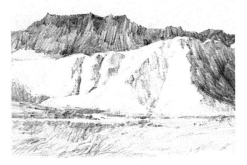

**Squinting to Simplify**
This is what you see when you squint. In this initial stage of the drawing, I have left out the dark accents, which are everywhere in the photo. If I put down the large shapes of value first, I can then decide where I want those dark accents. Like the accent pillows in your living room, they are meant to accent, or to place emphasis. If you throw them all over your room or all over your drawing, the result is chaos.

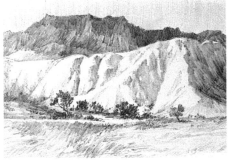

**Adding the Details**
In this final version, the basic value shapes have hardly been altered. The dark accents have been added strategically to create a center of interest. Superfluous value changes in the major shapes have not been added. Squinting helps you avoid the trap of these little details.

# Finding value relationships

Three things affect the value of any surface:

1. The local tone, or the actual value of the surface free from the effects of light and shadow.

2. The brightness of the light source. Even a dark local tone can have a highlight from a strong light source.

3. The direction of the light source. Surfaces at right angles to the light source receive the most. As a plane turns away, it receives less light and becomes darker.

## Capturing These Relationships

There are numerous ways to render the changes of value you see. The method you choose is completely personal, a result of your likes and dislikes and your choice of medium.

Don't worry about developing a personal style. Learn to see value relationships, become familiar with the various mediums, and your personality will imprint itself on your drawings naturally. Later, I'll teach you how to render these relationships using the most common drawing tool, the graphite pencil, so you can focus your attention on seeing the relative value in the subject.

## Everything Is Relative

Values are only evident in relation to other values—a light object will appear lighter next to something dark, and vice versa.

## The Different Areas of Value

A black and white sphere is a good illustration of the six different areas of values that form under a light source.

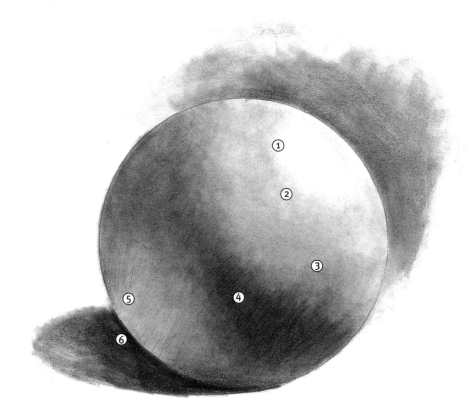

**1** Highlight: The area receiving the most direct light.

**2** Light: The surface area receiving indirect light.

**3** Shadow: Where the form turns gradually away from the light source.

**4** Core shadow: The most concentrated area of dark on the sphere. Since it is parallel to the light source (which is coming from above right), it receives the least amount of light.

**5** Reflected light: Light bounced back from nearby surfaces. Reflected light is still part of the shadowed area and as such is never lighter than the shadow area on the lighted side of the sphere.

**6** Cast shadow: The shadow cast by the object is almost always darker than the core shadow. The length of the cast shadow depends on the position of the light source. It's darkest and its edges are sharpest closest to the object.

It is impossible to create with any medium the full range of value shifts that you can see in nature. Simplifying the range is a necessity. Most artists use the standard value scale, which divides the ranges of value into nine increments: a middle gray, four gradations of darks and four of lights. This may not seem like a lot, but it's actually about as many as most people can easily distinguish.

Creating your own value scale is a useful exercise for learning to adjust a value to the values around it. Divide a 9-inch (23cm) rectangle into 1-inch (3cm) segments. Using a 2H pencil and very little pressure, shade the first segment a very light gray. Switch to a 6B pencil and make the last one as black as you can get it. Now shade each of

the remaining segments in even jumps between these two extremes. You may want to use a blending stump to even out the value in each segment.

Two problems will arise: First, the transition from one segment to the next may vary—you might have a minor jump in one place and a huge jump in another. If you adjust one, you have to adjust all the rest. Note: it is easier to make a value darker than lighter.

Second, the value in one segment may become lighter as it approaches the border of the next. This will cause you to shade the next segment incorrectly because you're basing it on the border value and not the interior. As always, it's helpful to step back and squint.

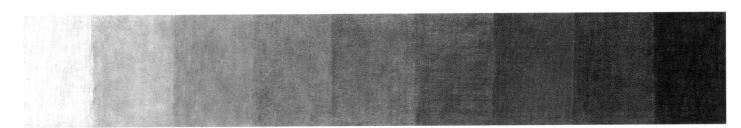

**The Value Scale**

**Practice With Your Scale**
Gather a few simple items that are light in value. Hold up your value scale and find the square that most closely matches the value of an area. Comparison is one of the most important abilities needed in drawing.

**Practice With Your Pencil**
Here is a great subject for drawing value relationships and the effect of light on a curved surface. Squint and use your scale to capture the values correctly.

# RENDERING SHAPES OF VALUE

*All forms, from people to trees, are made of shapes of varying value. Some of these shapes are very distinct and some have blurred edges. Accurate drawing requires seeing and recording the configuration of each value shape, their relative values, and the edges where these shapes meet. This gull is made up of light, gray and dark shapes. Forget about the bird and focus on the value.*

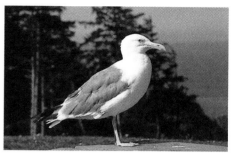

**Reference Photo**
Your intellectual brain sees birds in terms of legs, feathers, eyes and beaks, not shapes of value. Take your focus off these nameable items and put it on shapes.

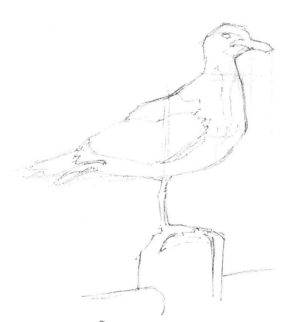

**1 Begin With a Search for Angles**
Begin with the angle of the shapes, the relative size of each shape and the relative position of key points. After that, you're ready to conduct a search for relative values.

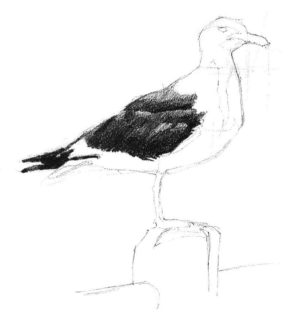

**2 Establish a Range of Values**
There is no right place to start adding value to a drawing, but if you're comparing values (and you should), establish a standard to compare them against. I look for one of the extremes of white or black and begin there. Compare the lighter range of values to the white of your paper. This subject has a black shape. Perfect!

When you squint, you see that there are two tones in the dark shape: black and a dark gray as the rounded plane of its back turns toward the sky. Put this black in with a 6B pencil. Now you have a standard of comparison for the gray tones.

This is the darkest value on the bird. Notice how it gets lighter as it moves up the back.

These two areas are the same value.

### Establish the Middle Grays

This is where squinting is crucial. Your intellectual brain tells you that the bird is black and white. Beginning students typically accept that information and hesitate to violate the white very much. Consequently, the shadow area is rendered far too light. Squint and compare the value on the back of its neck with the dark gray of the light-struck back. A highlight on the black shape is the same value as the shadow on the white shape!

Every dip and turn in the shape of the gray is important: Each turn, each change in the edge tells you where the form turns in space, where it dips or bulges.

The shadow area on these white feathers is the same as the shadow on its neck.

This shadow is the only information about the undulations in the chest and neck. Change it and you change the bird.

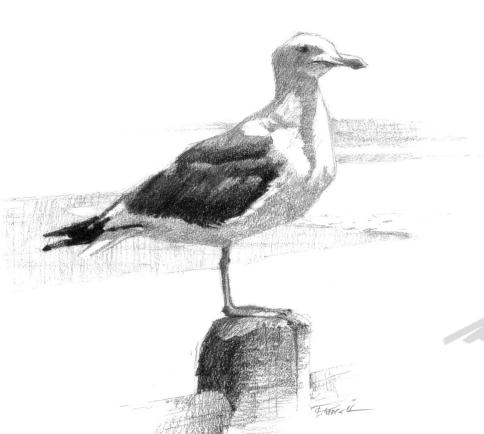

### Finish With a Refinement of Shapes

When we put in the dark of the eye (with its blurred edge just as we see it), the shadow area looks correct. Now add the value of the legs, feet, post, and so on. Seeing shapes of relative value, not detail, is the key.

### FROM THE ARTIST'S BRAIN

You don't squint to see the exact value of an area; you squint to see the relationship of that value to the value of adjacent shapes. Squinting eliminates details and allows you to see the bigger shapes of value.

# Methods of rendering value

The method you choose to create values using a graphite pencil is your choice. Some prefer crosshatching, some prefer to blend, and some (myself included) prefer to create the value with strokes that also define the shape. This latter technique is called broad-stroke.

For the bulk of my drawing, I like the directness of adjusting the pressure of the pencil to achieve the correct value. It's similar to allowing paint strokes to become part of the finished work instead of blending them perfectly.

Getting the value relationships right is far more important than the method you choose. But, so you can see how these methods appear in a finished drawing, I've done the same drawing three times, each employing a different method. In all three, the darkest and lightest areas are the same, as well as the relationship of grays. Only the technique differs.

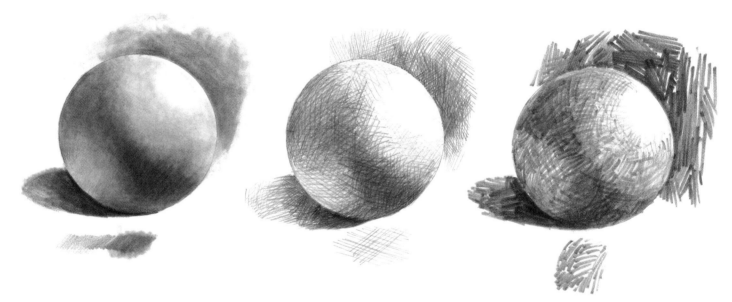

### Blending
Graphite can be blended and rubbed to achieve a nearly photographic effect. In this drawing, I used a 2B pencil for the darker areas and an HB pencil to lay down the lighter values. I then went over the strokes with a blending stump.

### Crosshatching
Crosshatching is a series of straight parallel lines, overlaid by more lines running in opposing directions. These are built up gradually to achieve gradations of tone. Crosshatching should be used for gradations in tone, not to establish the shape of the rounded form.

### Broad-Stroke
This stroke differs from crosshatching in two ways. Instead of using a sharpened point, the end of the graphite is sanded down at an angle to create a chisel point. Also, the strokes follow the plane and vary in length. This is my personal favorite for use in my sketchbook because it's fast and reinforces the planes in the subject.

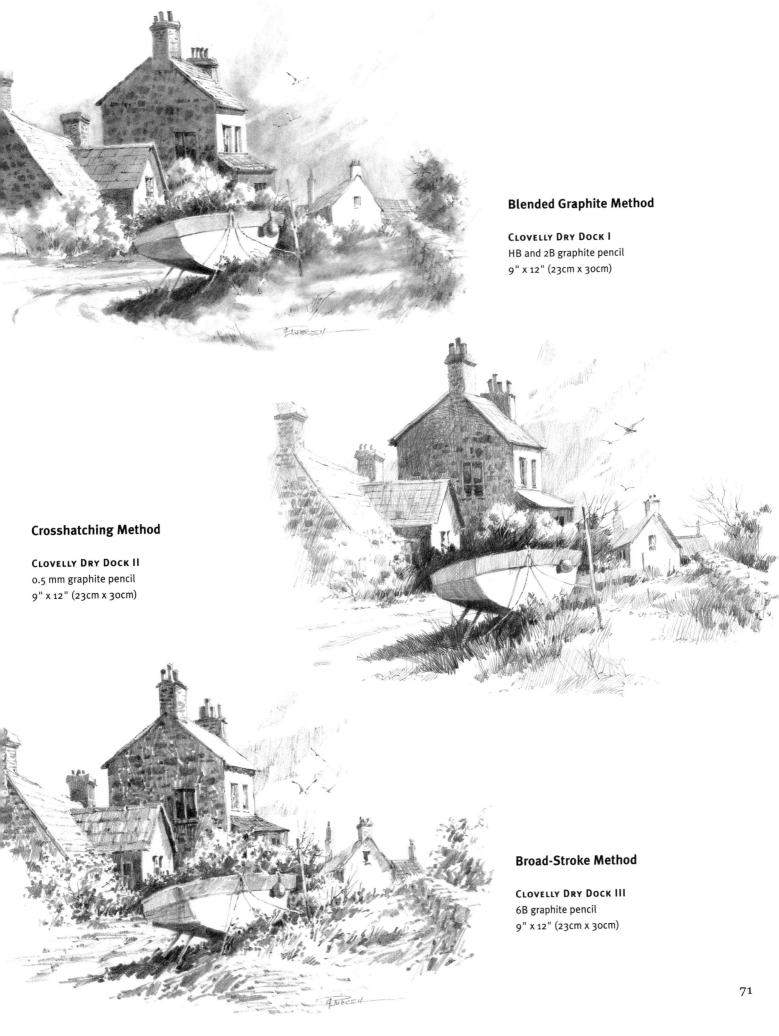

**Blended Graphite Method**

**CLOVELLY DRY DOCK I**
HB and 2B graphite pencil
9" x 12" (23cm x 30cm)

**Crosshatching Method**

**CLOVELLY DRY DOCK II**
0.5 mm graphite pencil
9" x 12" (23cm x 30cm)

**Broad-Stroke Method**

**CLOVELLY DRY DOCK III**
6B graphite pencil
9" x 12" (23cm x 30cm)

# Variations in value
# AND DEFINED EDGES

*After our eyes process the scene in front of us, the image is sent to the intellectual brain for clarification and identification. When it's finished, we believe we saw it in perfect clarity. But we didn't. For our art to look like what we see, we must focus on the visual information.*

*And what did we see? We saw shapes: some with sharp, focused edges; others with vague, barely defined edges; and edges that were completely lost. We saw the value change from one side of a shape to another.*

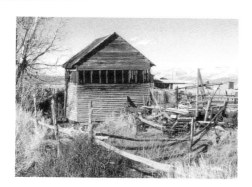

## Reference Photo

This old granary is a good example of the way we typically see. Some of the shapes are fairly well-defined, like the roof and the side of the building, giving the impression that it's all in sharp focus. In fact, where the front of the building meets the ground is *not* in focus—there's a general fuzziness about the shapes in that area.

If you try to define every board and blade of grass, you're headed for disaster. For example, you really can't distinguish each board. Trying to do so would be like counting fleas on a rhino.

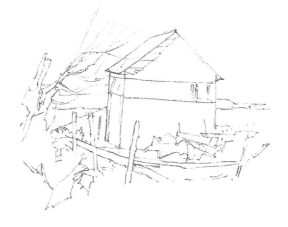

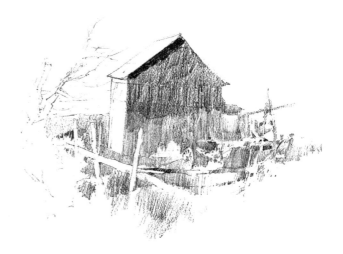

### 1 Start With a Shape

Begin the drawing with a shape you can readily manage, like the roof shape. It's skinny, and two of the edges are parallel. Concentrate on the two angles at each end. Drop lines down for the left side, and measure their length against the length of the roof. Establish the distance to the other side and put in the other pitch of the roof. Now you can relate all other shapes to that.

### 2 Squint to See Shapes of Value

Squint at the photo. Where are the shapes of light? What happens to the value of the shed? Does it remain the same from top to bottom, or does it change? Find where the shape's edge is hard to read because it's so close to the value of the adjacent shape. Duplicate that in your drawing. Resist the urge to clarify it.

DRAWING DEMONSTRATION

Draw vertical boards by drawing the spaces between them.

These negative spaces suggest boards.

These shapes of dark space give all the clues we need to see the posts.

Instead of drawing the wagon wheel, draw the dark shapes between and adjacent to it, and the wheel will appear.

## 3 Draw the Spaces

This step appears to be one of identification, but look closely. If you draw the darker shapes of space, the lighter shapes will become recognizable. Many artists refer to this as "negative painting."

For example, it is the shape of dark space to the right of the wagon wheel and the dark shapes between the spokes that define the wheel. When you put in the dark window shapes, the boards in between are drawn by default. Your intellectual brain does not see these shapes, only objects.

## 4 Make the Final Decisions

If you draw shapes instead of things, you will also know when to stop. You can look objectively at the value shape made by the entire drawing and adjust accordingly.

Look at the drawing and decide how far out to extend the shadow shapes in the weeds at the lower left. Add the shapes of value in the tree. Lean the tree into the subject a little more to help direct the eye around the composition. The dark accents to the left of the building and at its lower-right corner help to build a center of interest. Notice there are no dark accents in the peripheral areas.

**THE GRANARY** ▸ Graphite on bristol vellum ▸ 7" x 10" (18cm x 25cm)

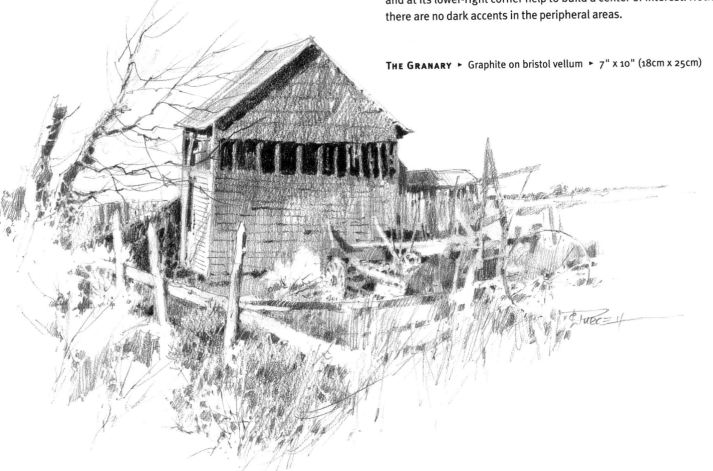

# Seeing shadow shapes
## in a PORTRAIT

*The more complex the subject, the more fun it is to draw. Certainly one of the most challenging and rewarding is the portrait. In order to achieve a realistic likeness to the person being drawn, every relationship—size, angle and value— must be correct. However, it's immensely satisfying to do a portrait that also captures the character of the sitter.*

**Reference Photo**
I met Billy Ayers years ago in Nevada. He's a Choctaw Indian and very personable. I took this photo of Billy in the Valley of Fire north of Las Vegas.

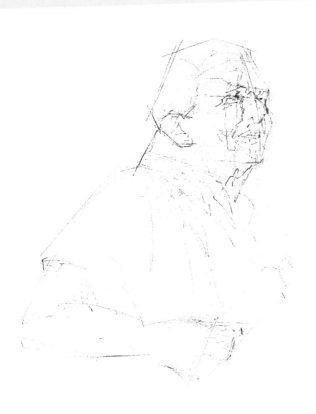

Out of context, the shapes defining the eye are very abstract.

Squint to see how dark one area is in relation to another. The changes are often slight.

Many edges dissolve into the adjacent area. Don't give sharp focus to an edge unless you see a well-defined edge.

**1 Block In the Basic Shapes**

Where do you start? Pick a shape that's easy to see. What makes one shape easier to see than another? Simplicity—a triangle, for example, with well-defined edges. Many shapes in portraits are indistinct or have a number of indistinct edges. Draw those edges lightly so you can create a soft edge later, without having a dark line to contend with. The dark value shapes of the eyes were the most well-defined, so I started there.

**2 Add the Values**

Values are just shapes! The shapes of value define the forms. Things in our visual experience are not defined by a black outline as they are in a coloring book; they are defined by value contrasts. If we draw these shapes exactly as they are and give them the proper value, they will define Billy's features exactly.

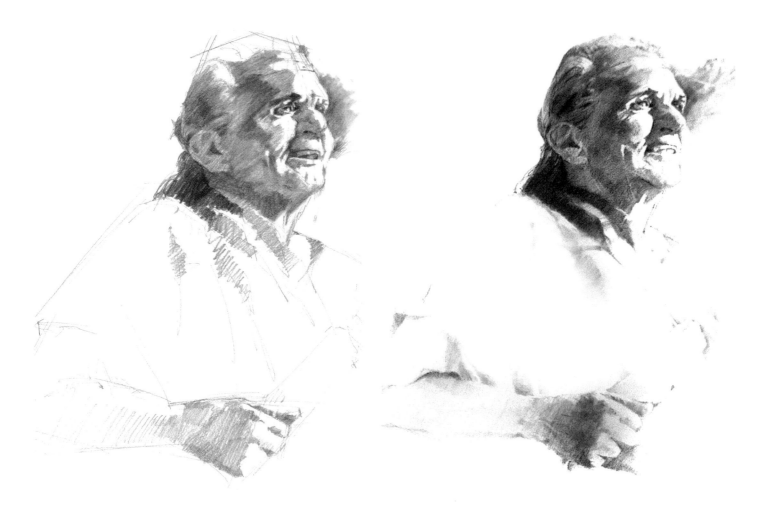

### 3 Establish the Value Range

Remember, every time you look at your subject, squint to see the value relationship. Establish the general value over an entire area, then break up the area into smaller shapes of darker value—like those that make up the ear.

Put in a gray shape, not teeth. Many beginning artists allow the influence of their intellectual brain in the whites of the eyes and teeth. Very seldom do we really see these as "white," because they are usually in shadow.

### 4 Choose the Essentials

Choose only the elements you need to convey the essential information. If you draw shapes instead of things, the decisions are easier to make. In this drawing I chose to blend the strokes, and I used a blending stump to draw the value shapes in the robe and arm.

**BILLY AYERS, GENTLE WARRIOR**
Graphite on bristol vellum
18" x 15" (46cm x 38cm)

# values in landscapes

*Like the figure, a landscape is made of shapes of value. Squint and you will see that a tree's foliage can be broken down into irregular shapes of lighter and darker values. The telling details of leaves and branches occur at the edges of these shapes. And, just like the figure, the complexity of a landscape can be conquered by drawing one shape at a time, each one in relation to the last.*

**Reference Photo**
My wife and I were driving in Devon, England, when we passed this country home.

The strokes follow the curved plane of the ground.

Vary the length and direction of each stroke but maintain a single value for the shape. The light left between strokes helps create an uneven surface.

Figures add interest.

Even though the wall is not white, leave it white at this end to increase the contrast in the center of interest. The other end is light gray.

## 1 Start With the Shapes
Begin with the most obvious shape: the rectangular roof. It's the easiest shape to get right. The distance between the top and bottom is exactly half of the length of the bottom edge. Add the angles at the ends and you're done.

Visualize the scene as a drawing. Try to anticipate problem areas and solve them in your mind before you begin. Place the roof shape where you want it on your paper. Now the other shapes can be drawn in relation to the roof shape, one at a time. Don't draw the trees: Draw shapes of foliage.

## 2 Add Value to the Shapes
Begin in the center of interest and establish the value range. The rock steps break up the area into smaller shapes. Add figures to emphasize the center of interest.

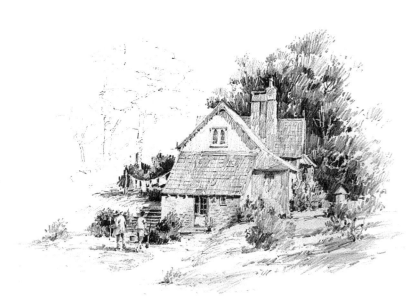

## 3 Continue Shape by Shape

The top window really stands out because part of the windowsill is white, the interior spaces are black, and these two value shapes are surrounded by a light gray. We can change what we see for the sake of the composition: Lessen the contrast a little.

Study the foliage for its character, and then create similar shapes. Stay away from black; save it for the center of interest. Edges are the only thing needed to identify the leaves.

## 4 Put It All Together

This is what I envisioned when I looked at the subject. Of course, I couldn't visualize all the details and every stroke, but I knew the overall composition and the center of interest. Adding the figures strengthens and gives a little life to the center of interest.

Put in the value shapes for the trees on the left. As you add the shapes, keep backing off to see how they affect the overall shape of the drawing. You want a varied edge, loose and undefined. A hard end is like stopping music abruptly. Let it taper off, and reserve the darkest accents for the center of interest.

The darker value here defines the tree trunk. Notice that the upper part has a shadow cast over it from the foliage above.

Put foliage in front of the trunks. Only once have I ever see a tree that had all the branches in front and all the foliage behind. In a drawing, it looks even more unbelievable.

**DEVON COUNTRY COTTAGE**
HB and 6B graphite pencil on bristol plate
8½" x 12" (22cm x 30cm)

Don't make shapes like this quite as dark as they appear in the reference.

Indicate the bricks a bit darker than the surface, but resist the temptation to draw them all. Use one stroke per brick. Keep it simple.

## POINTS TO REMEMBER

- The degree of value contrast between an object and its background is what makes it visible.

- A strong value contrast makes a shape visually irresistible.

- Variations in value define texture and form.

- Squinting will simplify the details of a subject, allowing you to better observe the relative values.

# A short course in broad-stroke

I had to discover the traditions of the masters on my own. In the library, I found drawing books by Ernest Watson and Ted Kautzky. I loved their drawings. They presented the visual world in a clean, fresh manner that appealed to me. Their pencil technique was broad-stroke.

Broad-stroke drawing is very much like oil painting. It is a direct, finish-as-you-go method. I adopted the broad-stroke technique for my own field studies. It gave me a way to quickly set down the broader shapes of value and a means to skip past my intellectual brain's craving for details.

Every year I fill at least one sketchbook with quick drawings in this manner. These drawings become the catalyst for many paintings. I use my camera for gathering color and detail information, but the drawings preserve the feeling of the moment, the inspiration that stopped me and, yes, forced me to draw. My camera cannot capture that emotion (and neither can yours). I sometimes look at a photo and cannot for the life of me figure out why I took it! I never have that problem with a drawing because the drawing distills the essence of the forms and the exciting shapes from the subject. It eliminates the unnecessary trivia that the camera must record.

The following are some excellent uses for broad-stroke. It's a particularly wonderful technique for capturing rough and irregular textures.

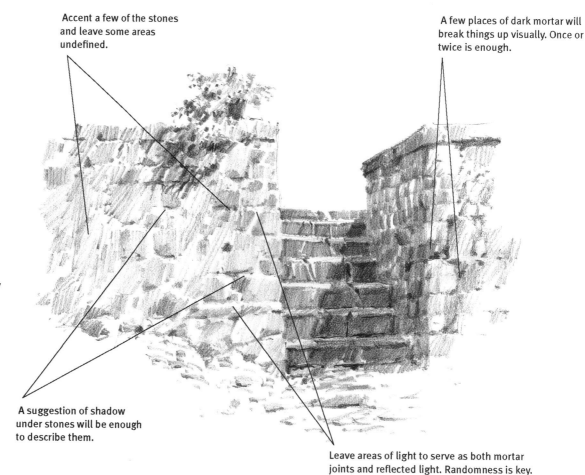

Accent a few of the stones and leave some areas undefined.

A few places of dark mortar will break things up visually. Once or twice is enough.

### Rock Walls

In drawing rock walls, you must think like the mason—alternate the size of the stones to create an interesting pattern. He uses large stones at corners to strengthen the wall and small stones to fill in the spaces. A mason achieves a better bond by not breaking the joints.

A suggestion of shadow under stones will be enough to describe them.

Leave areas of light to serve as both mortar joints and reflected light. Randomness is key.

## Brick Walls

Nothing compares to the knowledge you gain by going out and looking at a wall. And I mean really looking; not that quick glance for identification your intellectual brain is famous for. Look at it as a drawing. Squint and see the patterns of value. Take note of how the value differs between individual bricks or stones. Notice how texture affects value. Notice how light plays across the top surface of the rocks.

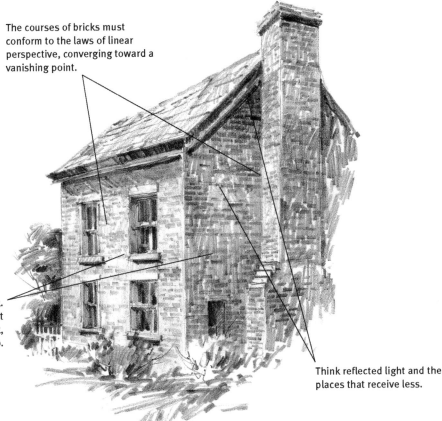

The courses of bricks must conform to the laws of linear perspective, converging toward a vanishing point.

Don't spell out every brick. I probably went too far, but if part of the wall is brick, assume the rest is too.

Think reflected light and the places that receive less.

## Siding and Shingles

First, squint to see the relative values of the walls and roof. Lay in each value using strokes of varying length.

The irregular shadows are caused by separation of the boards. Vary the angle of the pencil to create lines of varied weight.

Don't draw shingles; draw the shadows at the butt of the shingles. These are a series of parallel lines varying in thickness and value. Restraint is a virtue.

What unique marks will help tell the story? The triangular shadows at the end of the boards are an example. These details explain form.

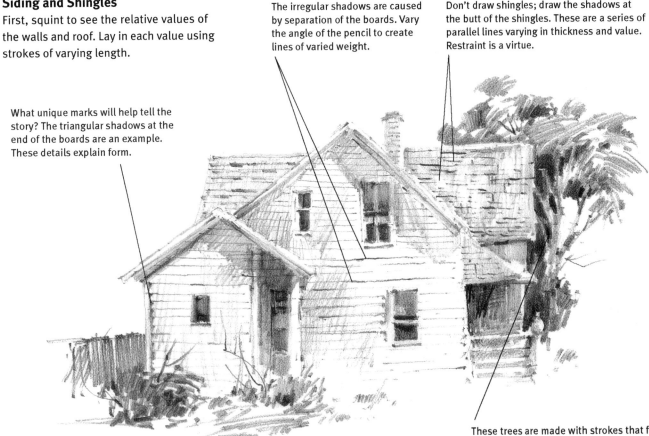

These trees are made with strokes that follow the rounded contour of the foliage. Shadow shapes and a few gray branches give all the necessary information.

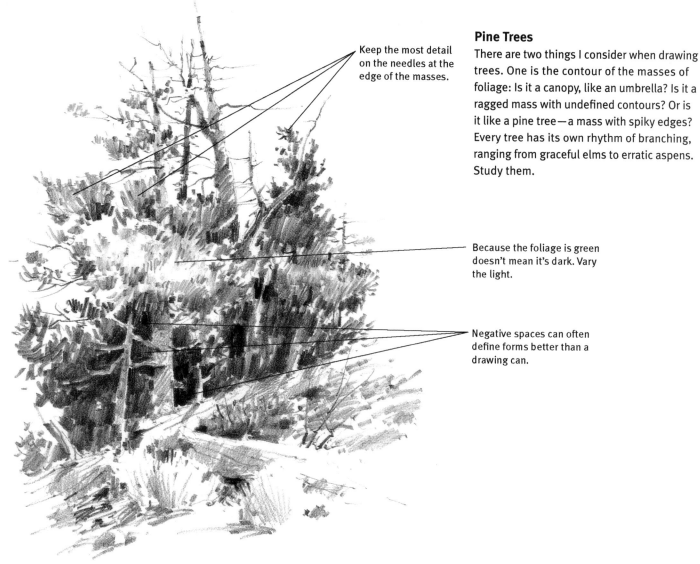

Keep the most detail on the needles at the edge of the masses.

## Pine Trees

There are two things I consider when drawing trees. One is the contour of the masses of foliage: Is it a canopy, like an umbrella? Is it a ragged mass with undefined contours? Or is it like a pine tree—a mass with spiky edges? Every tree has its own rhythm of branching, ranging from graceful elms to erratic aspens. Study them.

Because the foliage is green doesn't mean it's dark. Vary the light.

Negative spaces can often define forms better than a drawing can.

## Rocks

How often have you seen rocks in paintings that look like marshmallows? What are the identifying characteristics of rocks? They're hard. They break into sharp facets with angular edges. Marshmallows aren't like that at all. So when you draw rocks, go for the most characteristic ones you can find, not those worn down like marbles.

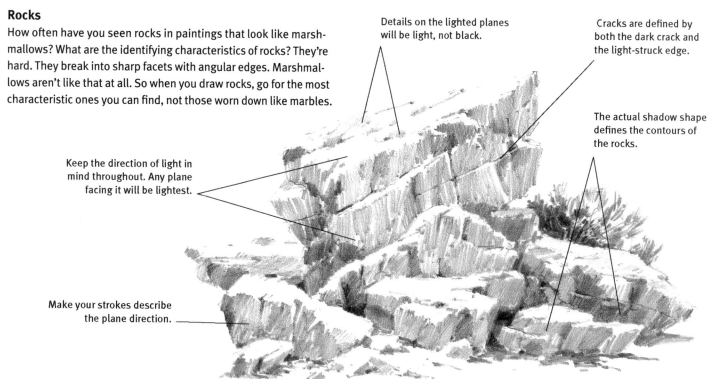

Details on the lighted planes will be light, not black.

Cracks are defined by both the dark crack and the light-struck edge.

The actual shadow shape defines the contours of the rocks.

Keep the direction of light in mind throughout. Any plane facing it will be lightest.

Make your strokes describe the plane direction.

Make broad-stroke marks deliberately and at a steady speed—not too fast or they will look sloppy, not too slow or you'll lose control. Do not make strokes with finger movement. Hold the pencil firmly in your fingers and move your arm instead.

Sharpen a soft pencil, a 2B or 3B. Hold it at an angle to the surface of a rough paper or a sanding block and gently rub it back and forth in one direction until you have created a chisel point. Hold the chisel edge flat against the paper and make a stroke as in "A" (below). The stroke will be wide and of one value. After practicing flat, broad strokes of similar value, try a couple of variations. If you tilt the pencil very slightly toward its point, it will produce a stroke that is darker and accented along that edge and fading out along the other edge, as in "B." Tilt the pencil slightly away from its point to produce the reverse, as in "C." Roll the pencil very slightly either toward you or away from you, and hold it that way during the stroke to produce a darker line with the same pressure, as in "D." Tilt the pencil up so that the tip rests on the paper to produce a thin line similar to one made with a pencil sharpened to a conical point, as in "E."

# Practicing broad-stroke

## Broad-Stroke Paper

Paper with a smooth surface, like bristol (plate finish), is best for broad-stroke. For my sketchbooks, I find ones with the smoothest surface possible. Try the blank book section of bookstores. Many sketchbooks in art stores have paper with varying degrees of tooth, which doesn't work as well.

### Practice

Try the following exercises as shown.

1. Fill a rectangle with strokes, each one touching but not overlapping the previous one, to produce a rectangle of flat, even tone.

2. Fill a rectangle with similar vertical strokes, but this time vary the length of each stroke and leave a small bit of white paper between the ends of the strokes.

3. Do a rectangle as in 2, except this time gradually reduce the pressure on the pencil to create a gradation in tone from left to right.

4. Fill a rectangle with strokes similar to 2, but include a few places where you introduce diagonal lines of varying lengths.

5. Try the same approach as in 4, but grade the values from dark to light.

6. Try the same thing as in 4, but with short curving strokes.

You can see how a few broad-stroke suggestions of detail can create the impression of brickwork, rock walls, lateral siding, vertical boards or shingles.

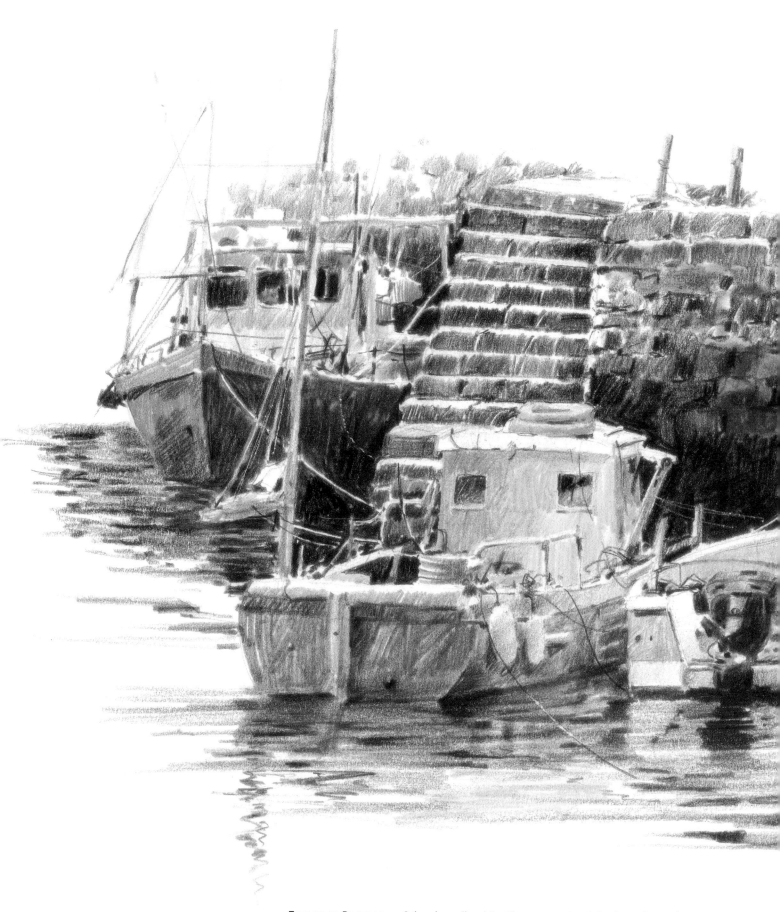

**TIED UP IN BRIXHAM** ▸ Colored pencil and Conté crayon on plate bristol ▸ 9" x 11" (23cm x 28cm)

# *figure and ground* RELATIONSHIPS

The visual world is a complex tapestry of value relationships. Fortunately, it's not beyond the scope of our powers of observation—and good drawings are records of intense observation. Discovering these complexities through drawing is a wonderful experience. When you really look at the world around you in the way that drawing requires, you discover that simple, ordinary objects are not only extraordinary (as Frederick Franck said), but that they exist in a wonderfully complex relationship with the space around them. Don't fear this complexity; embrace it. The drawings that result will be your reward.

The relationships between objects and the space surrounding them are referred to as figure and ground (figure/ground) relationships. Some describe this relationship as positive/negative or foreground/background. In this chapter, we will explore the value relationship between objects and the space around them. When you understand what you see, you can incorporate that understanding into your drawings. It enhances their aesthetic sense and imbues them with convincing reality. You can only get so skillful at putting marks on paper. Marking based on observation is the genie that puts real magic into your drawings.

# Defining "figure" and "ground"

Sometimes the relationship between figure and ground is fairly simple; however, most of our visual experience is with complex figure/ground relationships that require sorting out. These two examples demonstrate what I mean.

Study the group of figures on the bench below, and take note of where a figure is bordered by actual space and where it is bordered by another figure.

Notice also the relationship of the values at these places. You will find that it constantly shifts from a figure that is darker than the value next to it, to one lighter than the adjacent value. And sometimes the values are the same and you can't tell where one ends and the other begins. These lost edges are part of our visual experience; don't feel a need to correct them.

**An Obvious Relationship**
The relationship between figure and ground here is straightforward. The Scotsmen are the figures, and all the space around them is ground. Some parts of the figures are lighter than the ground, some darker, but the figures are easy to define.

**Blurred Lines Between Figure and Ground**
This is the visual complexity we experience every day. The background of one figure is sometimes space, or sometimes another figure. For instance, the space around the man's right arm is not space but is actually the woman next to him. In this case, his arm is figure and her body is ground. The white value behind the woman's hat is another's hair, etc. Very often a positive item can serve as ground for another figure or object. Just think of the value bordering the shape which you are currently drawing as ground, whatever it happens to be.

I don't want to destroy any beloved delusions, but the coloring books we grew up with lied! There are no clear, easy-to-stay-within black lines around anything in the visual world. Everything is defined by value changes, not lines.

Like human relationships, the value relationship between a figure and its surrounding space (ground) can be boring or exciting, static or active. What makes the difference? Interaction. If two people do not interact, there is no relationship. If a figure and its adjacent ground do not interact through value, there is no relationship. The following photos illustrate three levels of figure/ground relationships: static, reversing and alternating.

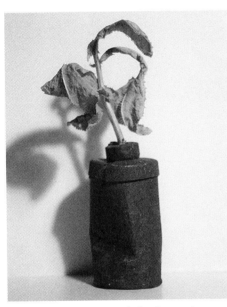

### Static: Dark Figure, Light Ground
This is a static relationship in which all the dark values are in the figure and all the light is in the ground. It may be very clear, but there is no give or take.

### Static: Light Figure, Dark Ground
The opposite also makes for a static relationship. The light figure is separated from the dark background. It would make a horrible marriage.

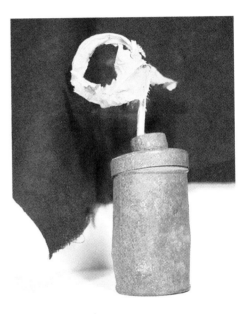

### Value Reversal
Reversing the relationship ties the two together. Begin the figure as dark against light, then switch. This creates an active partnership—common in the visual world.

### Value Alternation
The most common visual relationship we encounter is an alternating relationship. It represents the constant state of flux in the value relationships between figure and ground. This invites the most viewer participation.

85

# Reversing the values

Your intellectual brain, the one that names the images and simplifies information, also separates an object from its surroundings, and if forced, assigns a value to it. "Tree trunk, dark!" "Leaves, light!" It does not, however, acknowledge gradations of value or relative value. These are recognized only by your artist's brain.

### See With Artist's Eyes

Are the limbs on this juniper tree dark or light? See how they change relative to what is behind them? Look around and you will see this everywhere. I first noticed it in a drawing, having never even noticed it in the world around me.

In the upper half, the figure is all lighter than the ground.

This area is the bridge that creates a seamless transition.

This time the figure at the top is darker than the ground.

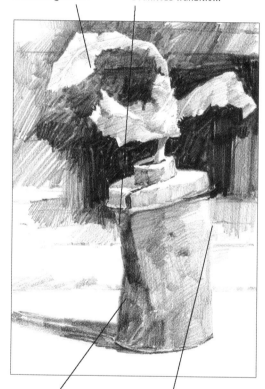

The lower part of the figure is darker than the ground.

The bridge occurs on both the figure and the ground.

Create transition in both the figure and the ground.

The lower part of the figure is now lighter than the ground.

Create transition where the change occurs.

### Areas of Transition

This drawing presents the subject from the last page in a reversal of values. It begins in the upper half with a light figure against a darker ground, then switches just below the can's lid to a dark figure against lighter ground. Notice the transitions where the changes occurs. Like music, a new key is introduced through bridging measures that make for a smooth transition. Similarly in drawing, a sudden change would be awkward.

### Either Way Works

Here, the upper half is darker than the ground and the lower half is lighter. Decide beforehand which arrangement of values you prefer. You will find that thinking of the background as areas of value that complement the figure will help free you from the tyranny of the photograph. Instead, you are the master of what adjoins your subject.

Value reversal is the first level of complexity in figure/ground relationships. As much as your intellectual brain would like you to believe, the reality of your visual experience is not clearly defined. In order to identify the objects around you, your intellectual brain lifts them out of their context and resolves visual problems (where the figure and ground value are the same), leaving you with the impression of clearly defined surroundings.

If you want your drawings to reflect visual reality, you have to sidestep this intellectual trap and look for the value relationships that really define the objects you see. The complexity of these relationships is the stuff of which beautiful drawings are made.

# Alternating values

## Embrace Complexity...

If you look past the obvious (a man in a gray cap, gray pullover, white pants, black boots) to the value relationships along the edges of his shapes, you will see something much more complex.

## FROM THE ARTIST'S BRAIN

Value reversal is not a trick or an artistic gimmick; it is a fact of the visual world. Look and you will find it.

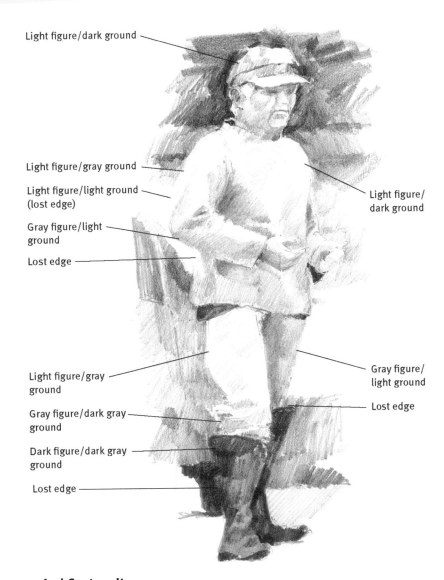

Light figure/dark ground

Light figure/gray ground

Light figure/light ground (lost edge)

Gray figure/light ground

Lost edge

Light figure/ dark ground

Light figure/gray ground

Gray figure/dark gray ground

Dark figure/dark gray ground

Gray figure/ light ground

Lost edge

Lost edge

## ...And Capture It

Squint your eyes and take a trip around the edges of the man where he meets the ground. Limiting the value scale to light, gray, dark gray, and dark, how many changes can you find along the way? There are over twenty. I have indicated twelve. This is the real information you need to be aware of when you draw.

# Keep an eye on the edges

Enjoy the shifts in figure/ground value relationships as you would enjoy the intricate twists in the plot of a well-crafted novel or the changes in a Beethoven sonata. One of the most overlooked and yet most important aspects of any subject you choose to draw is the quality of the edges where the shape meets space. The appearance of these edges is affected by many factors:

1. The nature of the form—what it's made from. (Clouds will have softer edges, rocks harder, etc.)

2. The relative value of an object's edge and the adjacent ground value. If they are in sharp contrast, you will have a distinct edge. If they are the same value, the edge will be lost.

3. The lighting. A soft, diffused light will not produce as sharp an edge as direct bright light.

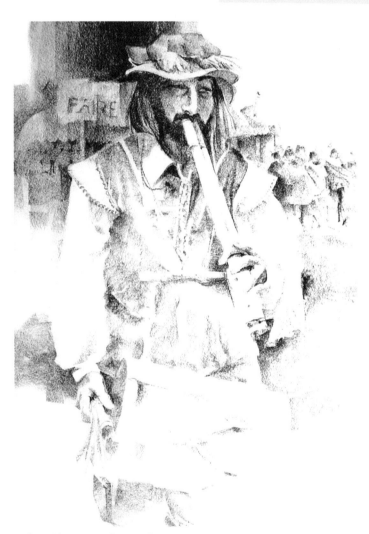

**Value Changes Along Edges**
How many times does the value relationship change along the edge of this figure?

**STREET MUSICIAN**
Conté crayon on bristol paper
14" x 11" (36cm x 28cm)

**Try Different Relationships**
This is an example of the alternating relationship applied to the same subject used on page 86. If you think, "What kinds of value relationships do I want along the edge?" instead of, "This is the can and this is the leaf," you will be free to invent. You will also be able to draw better because disciplined observation gives you the freedom to draw anything.

To draw an edge correctly, you must be able to compare it to other edges. The only way to compare is to squint.

If you find yourself saying, "Oh, that's too complex for me," don't listen to yourself. That is your intellectual brain speaking. Your artist's brain enjoys this as much as your intellectual brain enjoys crossword puzzles or complex novels. Draw what you see. As you get involved with the value relationships along the edges, you will slip into a mental mode much like meditation.

Once you are aware of the different kinds of value changes and types of edges you see along the forms, you are free to create your own. You can create a value relationship between a figure and its ground as subtle or dynamic as you want.

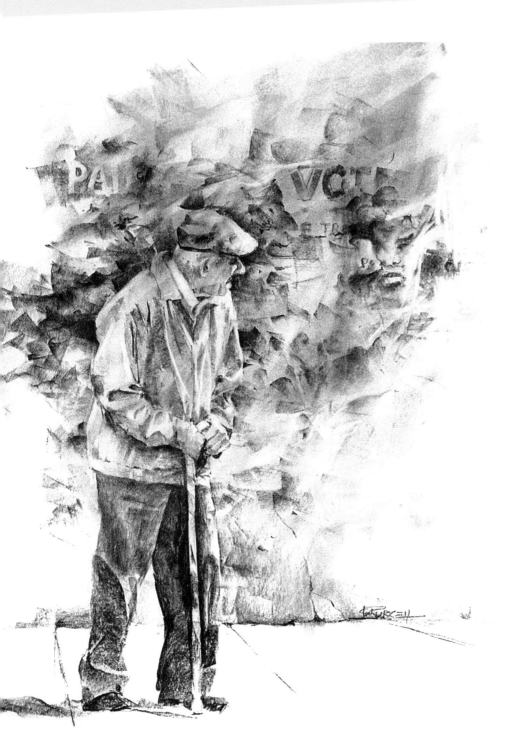

**Create Your Own Relationships**

I photographed this man against a busy street scene. I decided that I liked the complexity along the edges but didn't like all the buildings and people. I began with pieces of value placed next to the lighter edges. They suggested a textured wall. Notice how many times the value relationship between figure and ground changes.

**POSTER WALL BUS STOP** ▸ Sepia Nupastel on sanded bristol board ▸ 20" x 15" (51cm x 38cm)

# alternation drawing

*I refer to drawings that exhibit constantly shifting relationship of values as alternation drawings: the value relationship between the figures and the ground constantly changes. It's necessary to simplify the variations in value to a manageable range. The value scale includes nine increments between black and white. Simplify these into three broad ranges: the lights, the middle grays and the darks.*

**Reference Photo**
You can't pose this kind of subject, and you take what you can get for the value relationships. I did manage to do a quick sketch after I took the photo, but the photo was necessary for a finished drawing. The figure/ground relationships aren't ideal, so new ones had to be invented.

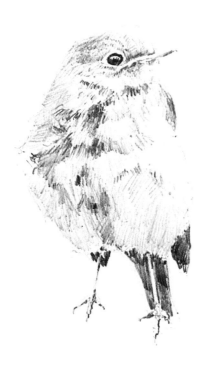

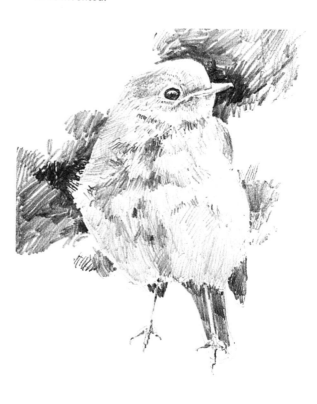

**1 Start With the Subject**
Fill in the existing relative values of the subject. Don't be afraid to squint!

**2 Add Adjacent Values**
Add values in a pattern designed to bring out the subject's head as a light form against dark. Envision a pattern that counters the major thrust of the subject. The little bird is dominantly horizontal, so I made the pattern counter in an oblique thrust.

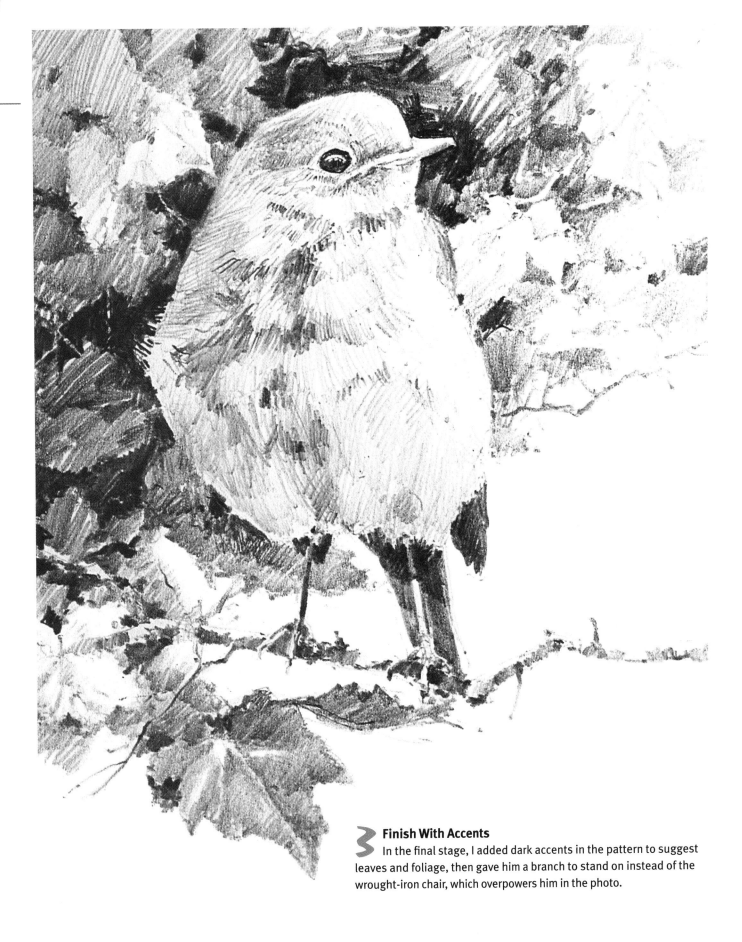

### 3 Finish With Accents
In the final stage, I added dark accents in the pattern to suggest leaves and foliage, then gave him a branch to stand on instead of the wrought-iron chair, which overpowers him in the photo.

LITTLE VISITOR ► 6B graphite pencil on bristol paper ► 9" x 7" (23cm x 18cm)

# Manipulate value relationships

Pick an object in the room, and note how many times the value relationship changes around its perimeter. There may be as many as fifteen or twenty shifts in value relationships around a single object. Include this constant shifting in your drawings and you will mimic the dynamic complexity we see. If your subject is still lacking in complexity, go ahead and alter the actual value relationships to make them more interesting. Remember, don't be a slave to the photograph.

**Reference Photo**
I spied this man in a quaint English fishing village. He was nice enough to allow me to photograph him. In cases like this, you have to settle for a photo because you can't get them to come to the studio and pose.

**The Alternation Drawing**
The figure in the photo is great, but the ground is one single gray: It needs a value pattern countering the vertical thrust of the head. I decided to suggest boats from the harbor to enhance his "salty" appearance. I decided on a lost edge at the top of his hat. The emphasis was on changing the figure/ground relationship as often as possible.

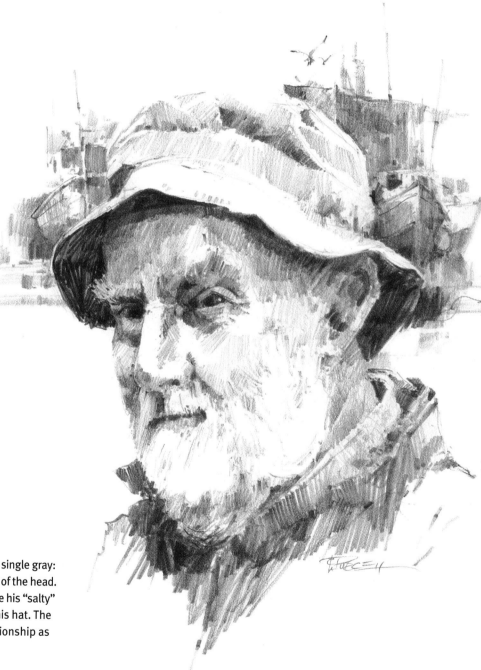

SEA SALT ▸ 6B graphite pencil on bristol ▸ 9" x 8" (23cm x 20cm)

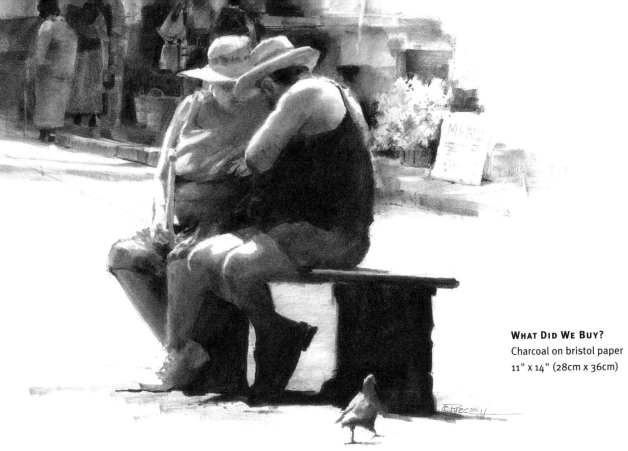

**WHAT DID WE BUY?**
Charcoal on bristol paper
11" x 14" (28cm x 36cm)

## Watch for Lost Edges

This drawing is basically a value reversal drawing of the two shoppers checking their purchases but has a number of lost edges and subtle changes. Even the pigeon in the foreground is a value reversal figure.

## Using Value Contrast

Even if we're aware of concepts like value reversal, when we look at this drawing, we see the flowers first. I even *did* the drawing, and still I see the flowers first and the visual concept second. That's because the stark white-against-dark background resonated with me when I first saw the flowers. The drawing emphasizes that contrast. I am always drawn to the same thing here: strong value contrast.

## POINTS TO REMEMBER

- ▶ Drawing makes you aware of the world's wonderful complexities.

- ▶ There aren't black lines separating objects from their environment.

- ▶ Value changes not only describe the edges of forms, but can also tie those edges to the adjacent space.

- ▶ Don't allow your intellectual brain to oversimplify value relationships. Look for infinite variations and you will find them.

- ▶ You are the boss. Don't become a slave to the subject or to a photo.

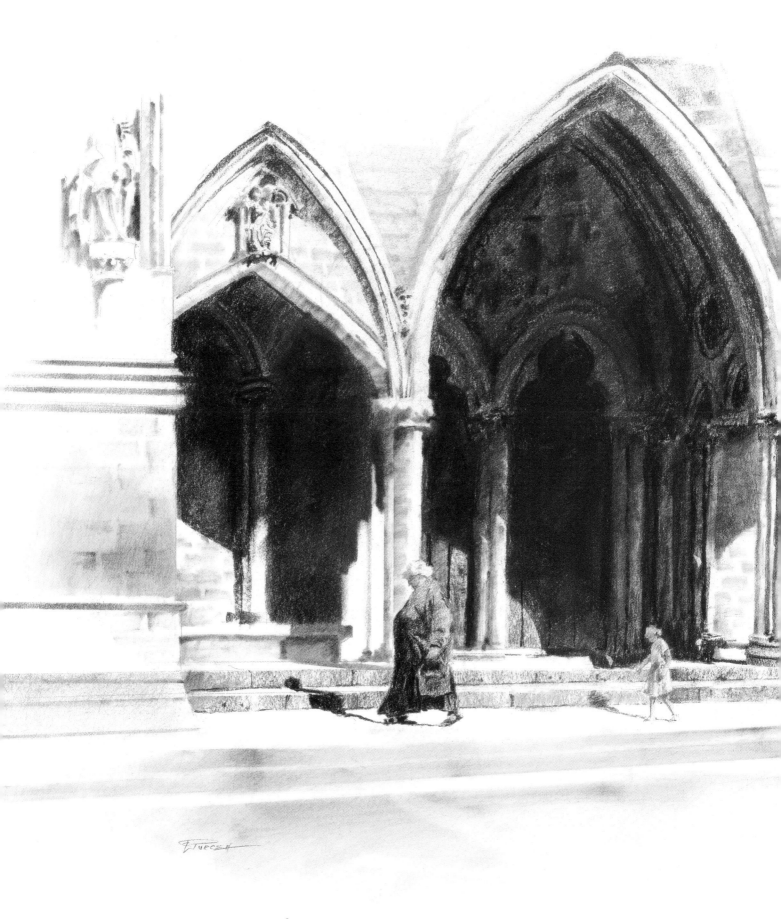

**GOING TO CHURCH** ▸ Conté and colored pencil on vellum bristol ▸ 13" x 18" (33cm x 46cm)

# organizing patterns
## OF value

We have explored some of the most important concepts in drawing: seeing relationships of angle, size and position, seeing the relative value of shapes through squinting, and finding the value relationships of figure to ground. One last area needs to be explored—organizing the areas of value in a format. It was Caravaggio in the early seventeenth century who first discovered the tremendous power of organizing lights and darks in a composition.

The idea of effective visual organization is not new to any of us. Landscaping a front yard is not the same as planting a garden. The garden is organized intellectually, not visually. The front yard is organized visually, using larger and smaller shapes of different texture and color, designed to lead visitors to your front door. Organizing the shapes of value in a drawing is exactly the same (but you don't have to wait for it to grow). As with a yard, you begin with a bounded space. In drawing, that bounded space is called a format. Within this space, as with the yard, you organize shapes. Only instead of leading visitors to the front door, you organize these shapes to lead viewers to the center of interest.

# Why create value patterns?

Call me old-fashioned, but I find organization more appealing than chaos, harmony more pleasing than discord, and design more enjoyable than confusion.

Beautiful music is not created by playing random notes beautifully. Its creation consists of notes put together in beautiful patterns, organized and played masterfully. I believe the same applies to drawing.

## It's All About the Organization

In the first format below, the three values are scattered randomly around the space with no perceptible order. Your eye bounces all over seeking a place to land, but finds none. The arrangement is the same as one created with an explosion. If you look at this for a long time and it begins to feel uncomfortable, go outside and get some fresh air.

The three values in the second format have been grouped together, but in a boring arrangement. Each is segregated from the other, and the black is too far away from the white to create any contrast.

On the far right, in the third format, we find the values are also grouped together; that is, all the grays connect, all the whites connect, and the darks are accents in one area. However, in this arrangement below, the three values interconnect. The lights push up into the grays and the grays push downward into the lights. The darks are grouped for maximum effect to create a center of interest, one area that is more important than all the rest. Squint at the design, and you will be able to see the two mega-shapes of gray and light that form the foundation for the composition.

**The Difference a Pattern Makes**

These three formats each have about the same amount of middle gray, white and black. Which of the three is the most interesting and pleasing to you?

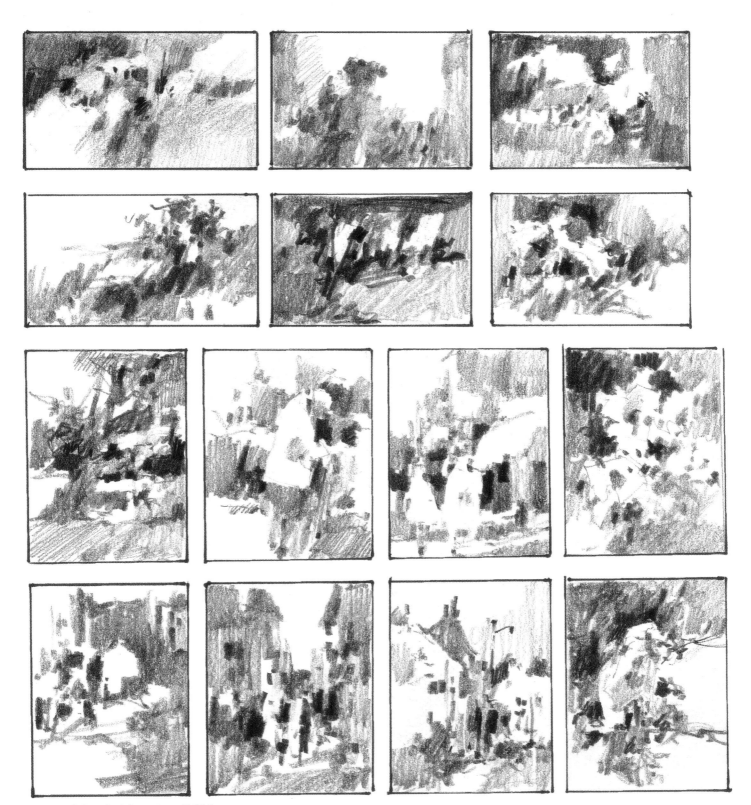

## Some of the Limitless Possibilities

Here are some possible value patterns. Each has a large pattern of mid-value gray and a small area of concentrated lights and darks. There are many variables. The gray pattern can touch one, two, three or all four sides of the box. It can be wide or skinny anywhere in the format. There is no end to the possibilities.

The one standard that applies to all of them is the gray values connect into a single large pattern. Each shape of white either touches another light shape or is close enough to connect visually. A dark shape is either connected to the next dark shape or is close enough to be seen as connecting behind the light shapes. Think of them as families. Don't break them up!

# Composition with value patterns

A single object placed in a format does not make a composition. To compose means to arrange within a space, and you can't arrange one thing by itself.

Try to think more about what the pattern of darks is doing rather than what the object represents. In other words, how are the darks moving through the format? What edges do they touch? How much of an edge do they embrace? Does their direction complement the direction of the subject instead of echoing it? Squint to see the patterns of value.

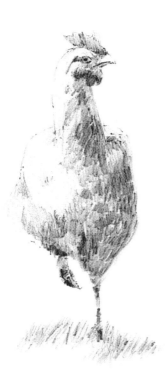

### The Value of a Value Pattern
This little chicken has been placed in a format slightly off-center to the left. However, she's lost in the space and looks isolated and disoriented. A value pattern does several things: It gives the chicken a place to live instead of floating in nothingness, and it breaks up the format space, making it more dynamic.

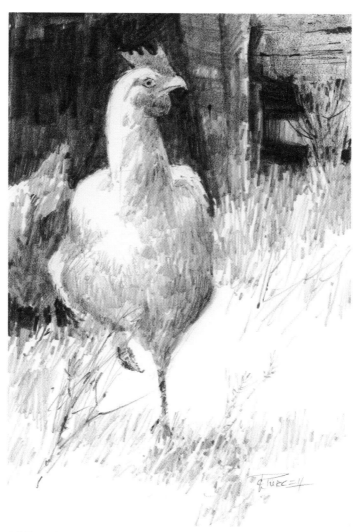

### Adding the Pattern
I began by adding darks next to the light of the neck, thinking of the head as the center of interest. I had no plan in mind except defining the light with dark. I then carried the dark over to the left edge of the format and decided to continue behind the head (but not around it—a black halo). I had envisioned a large dark shape behind the chicken's head gradually becoming gray as it reached the right side of the format. I don't know what happened. No one was there to stop me and the dark shape took on a life of its own and became boards and grass. What I ended up with was a value reversal drawing. I may have gone a little bit overboard, but the drawing is still much more dynamic than the one of the poor chicken lost in space. In this version, the pattern of darker values moves across the top of the format, down the left side, into the bottom of the chicken and down into the grass at her feet.

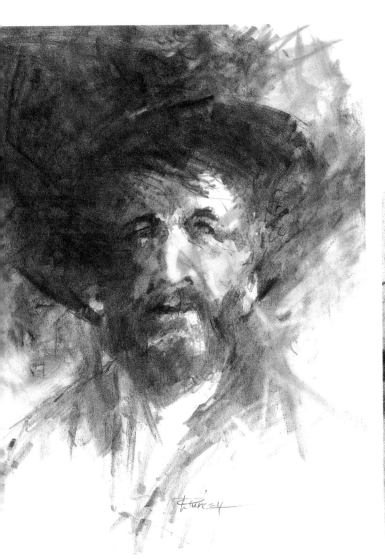

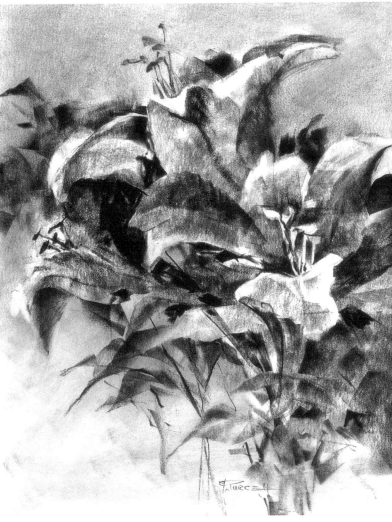

## Patterns Define Features and Create Environments

In this drawing, I placed the head slightly up and centered it between the two sides of the format. I hoped to shift the weight to the right by highlighting the left side of his face (his left side) and subduing the detail in the right side.

Do you see how the value pattern performs several functions here? It defines the features, provides a living environment for the head and fills the format with a dynamic push-pull between the lights and darks. Turning the drawing upside down helps you to see the shapes of value not as things, but as flat two-dimensional shapes arranged in the format.

## See Value, Not Objects

In the previous two drawings, the dark value pattern existed primarily in the background shapes supporting and defining the figure. In this drawing, the dark pattern exists inside the subject as well as in the background. Value patterns exist separately. A dark or light value pattern can be part figure, part ground.

# Value patterns in landscapes

I mostly work with subjects that have some good possibilities, not a perfect, complete pattern: a nice light shape against a dark, a good dark shape against a light, the beginnings of a great pattern of middle darks or a good combination of light and dark shapes amid a great deal of visual clutter. Most of the time, the subject presents more shapes and areas of contrast than I need, so I simplify.

The following are three subject photos and the value pattern drawings done from them. If you turn the book upside down and squint at the subjects and the drawings, you will see the pattern that was taken from each of the photos. I usually begin with the center of interest and work out to the edges. I don't get involved in things that don't contribute to the overall pattern. I often hear the question, "How do you know what to leave out?" My answer is, I leave out everything that doesn't contribute to the major pattern. If I can spot a good possible pattern, then I can visualize the finished drawing.

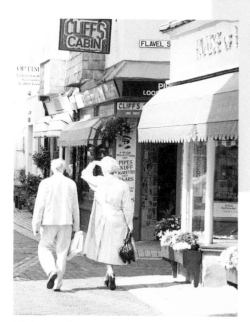

**Light Against Dark**
This is a good example of a pattern of light shapes against a pattern of darker values.

**Only Keep What's Necessary**
This pattern is the essential information from the photo of the shoppers. Your intellectual brain would focus on explaining each item and would miss the overall patterns. By looking at patterns instead of things, I am able to avoid getting caught up in the signs, window dressings, etc. I use the parts of the pattern that help highlight the two light figures. I could create an effective design with even less, but more would be too much.

## FROM THE ARTIST'S BRAIN
You may come across a subject with a ready-made value pattern just ripe to be copied—but don't hold your breath. If you wait for these perfect compositions to materialize, you won't have to worry about doing much artwork.

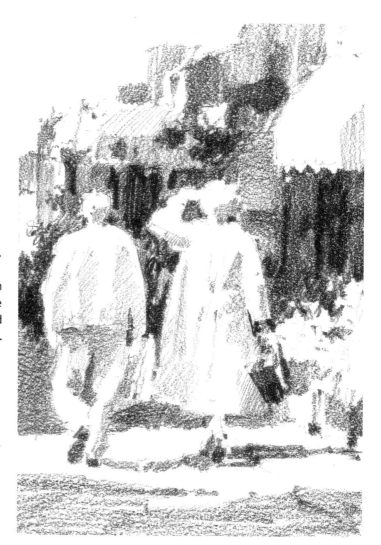

**Reference Photo**

This scene from the Isle of Iona in Scotland is one of those nearly perfect value patterns: a dark pattern silhouetted against the light.

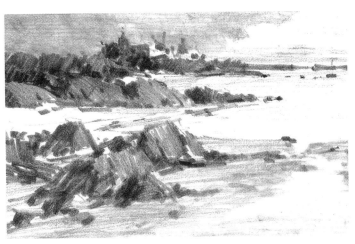

**Tweaking the Value Pattern**

I made a few minor changes to the photo. I grouped all the buildings away from the edge and added gray in the sky to bring out the light pattern. I cut into the dark rock at the left edge to avoid a rectangle shape, and I left out some of the small, isolated dark rocks on the beach because they call too much attention to themselves.

Look for the value pattern, then add detail to enhance the pattern or build a center of interest. Don't get this backward by beginning with the detail and trying to build a value pattern later.

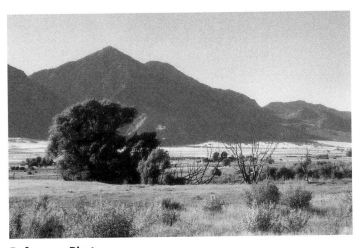

**Reference Photo**

This pastoral scene has beautiful trees with plenty of variation in value. Look for good shapes to build on. You can then change or delete them to strengthen the main one.

The background mountain is too dark. It steals some strength from the dark tree. The mountain shape is also a little too boring, but a bigger problem is the foreground. It consists of a few disconnected pieces of darker value that do nothing for the subject. Make them work, or fire them.

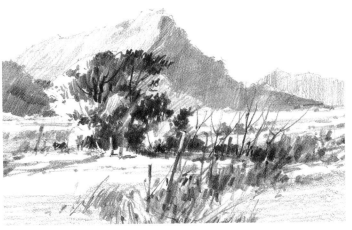

**Making a Path**

The most obvious change in the drawing is the connection of the middle and dark values in the foreground into a pattern which leads obliquely to the center of interest. The trees needed no changes. The highest peak was moved to the right, so it wouldn't be directly above the trees, and the far-left mountain shape was cut off so it wouldn't be as tall as the center one. Now we have a pathway of connected darks leading from the foreground back to the center of interest, and a background that supports the subject.

# Simplifying the subject

More drawings and paintings fail from having too much detail than from having too little. In composing the value pattern, you will often need to simplify the subject by eliminating trivial bits of light or dark; seldom will you have to add more value shapes to your drawing. Grouping shapes of similar value into a larger mega-shape is one of the most effective ways of simplifying a complex subject. Of course, that's after you have ruthlessly eliminated the competition.

**The Basic Value Pattern**
This is an example of a subject with background clutter. First ask yourself, "What is this drawing about?" And then, "Is there a shared value that ties more than one shape together?" Squint at the subject to see the bigger shapes of value.

**Find the Important Stuff**
Start with the big picture. Decide what you want to make for dinner before dragging out spices and ingredients.

This is the value pattern you see with your eyes half closed. This big shape will tell you what else is needed in the drawing.

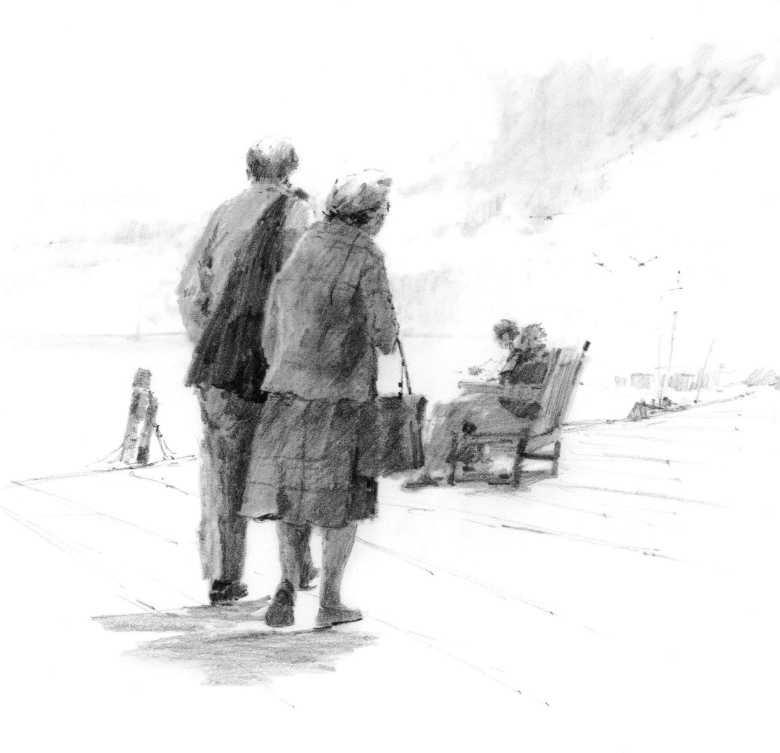

## Develop the Center of Interest

After developing the center of interest, I usually find that I don't need much else to complete the drawing. This drawing is about the couple taking a stroll. Where they are strolling is of secondary importance. I found that suggesting a pier was enough.

The fancy brickwork on the walkway, while important to the city, was not important to the drawing. The city itself is important to those who live there, but not the drawing about these people. The value of the lady's suit is far more important than the fabric's plaid design. Decide the intent of the drawing at the beginning, and keep it firmly planted in your mind to the end. That way enticing details won't lure you off track.

# Drawing a
## COMPLEX SCENE

*Have you ever avoided a complex subject like this because you felt overwhelmed? I have! Don't let complexity keep you from enjoying a drawing activity. The only thing that can get hurt is your ego.*

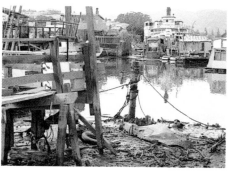

**Reference Photo**
A subject like this can seem daunting at first, but seeing past the details to the bigger value patterns will simplify it into an enjoyable drawing.

### 1 Find the Value Pattern
Squint until you only see the scene as divided into two basic values: all values from middle value and darker, and all the lighter values. The darks can be seen as a large "C" touching both sides of the format.

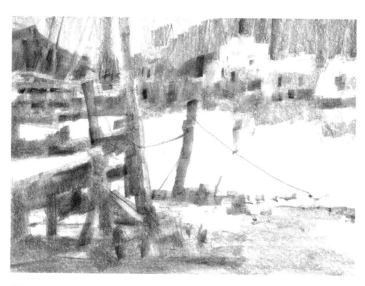

### 2 Add the Value Details
Draw the large pattern of darker values, leaving the light areas as white paper. For this big pattern, use a big tool: a carpenter's pencil or a stick of graphite rather than the small tip of a pencil. Using a larger tool to lay in the pattern also discourages the tendency to pay attention to details that will lure your drawing into the heap of failed works.

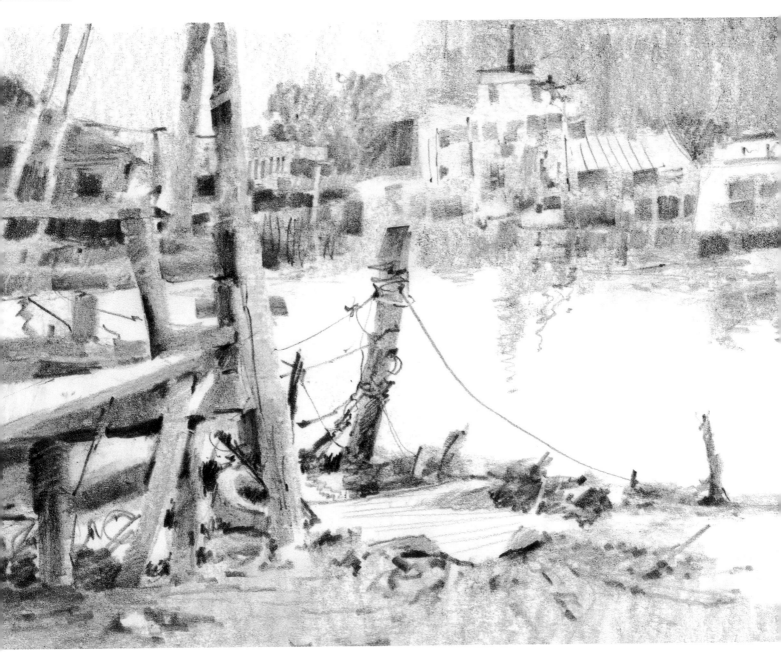

### 3 Develop the Center of Interest

Add darker values in the center of interest and really push the value contrasts; add some details we all love, but keep your eye on the whole.

If I had begun by defining the background, I wouldn't have known how much definition it should receive because I wouldn't have the center of interest to compare. Laying in a value pattern first, then developing a center of interest, may save the drawing.

# Exercises in spotting patterns

Exercises are part of every serious discipline. Here are some exercises to develop an awareness of value patterns and your ability to react to those patterns. Practice on a regular basis, and you'll improve your ability to arrange the values in a drawing.

## Exercise 1: Crop an Upside-Down Photo

Turn some photos upside down and go through them squinting. Find one that has an area in which values of gray, black and white are all present. Tape it to a board upside down.

### Upside-Down Reference Photo

Turn the book upside down so you can see the image. Now, look at the values. Squint! The lower right quadrant has an area where all three values work together: white, gray and black shapes interlock.

### Isolate the Design

Two L-shaped pieces of mat board or any stiff paper can be used to make an adjustable format. Move it around your photo until you find a design with a movement of light shapes against dark. Squint to see the pattern. Select the most interesting arrangement, and tape it in place.

### Draw the Value Pattern

Draw the image from your cropped photo on a piece of drawing paper. Don't make it too large—about the size of a credit card is perfect. Use a 6B pencil to roughly draw the grays and blacks, leaving the white space. Don't duplicate the photo; respond only to the value patterns. The photo is a springboard. This exercise will give you some great ideas for compositions you may not think of otherwise.

## POINTS TO REMEMBER

- You can create movement through your drawing by arranging shapes of similar value into a pattern.

- Many shapes of different values placed haphazardly throughout a drawing create visual chaos.

- Composition is the arrangement of shapes of value in a format.

- Simplify the values in your reference to form more effective patterns.

- Value contrast creates a center of interest.

- Look for underlying value patterns in seemingly complex subjects and respond to those first.

- You will become more "pattern conscious" with practice.

## Exercise 2: Bridging

One of the goals of composition is to direct the viewer's eyes around the format to stop them where you want. You encourage movement with shapes of similar value, and you bring it to a stop with value contrast. Our eyes stop at the boundaries caused by a sudden contrast of value. "Bridging" is the concept of creating eye movement from one side of the format to the other via a "bridge" similar in value shapes. The idea is to create various shapes that touch or nearly touch continuing to the other side of the paper. Vary the shapes to keep it interesting. Don't define the edges of your pattern; leave them a little sketchy. Leave light areas where the two lines cross for a center of interest.

1

2

3

### Bridging: It's as Easy as 1-2-3

Draw a rectangular format and divide it horizontally somewhere above the center with a light line, then again vertically to the right of center. Where they cross is a good spot for the center of interest. Begin developing a pattern of middle darks, as in Rectangle 1. Rectangle 2 shows the completed bridge, and Rectangle 3 shows the addition of the vertical bridge. Create as much variety as possible and think about leaving some lights for the center of interest.

1

2

3

4

5

6

7

### More Bridging Challenges

Provide yourself with challenges to solve in bridging from side to side and top to bottom. Here are some examples of such challenges.

1. Touch the bottom twice and each of the sides, but avoid the top.

2. Touch the top and two sides, but avoid the bottom.

3. Touch all across the top, down the side and partway across the bottom. Move into the central area and create a center of interest.

4. Touch each side at least twice and come almost to the bottom.

5. Begin a bold diagonal at the bottom that moves to the right, then shifts to the left.

6. Isolate a light shape and push a dark shape into it.

7. Lay gray over the entire area, leaving a pattern of light shapes across the format.

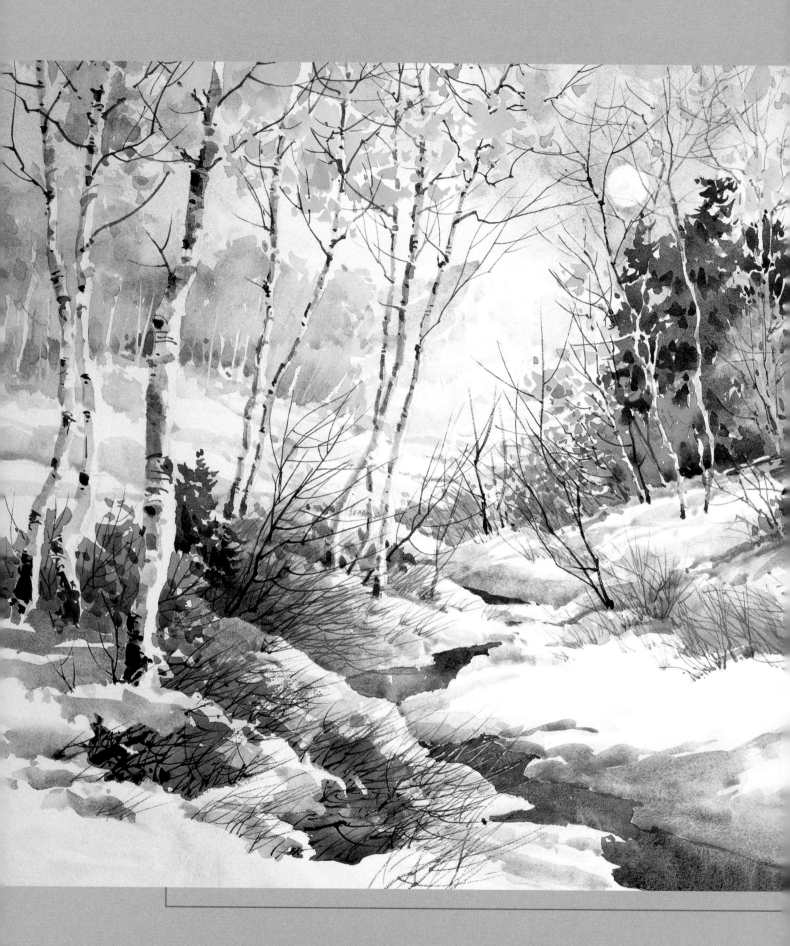

# technique for
# PAINTERS

Before we get into using your artist's brain to produce not just great drawings, but great paintings, we must talk about technique. Technique may be more important in watercolor than in any other medium, because part of watercolor's charm and freshness relies on allowing the paint and water to do what they do so well, with a little guidance from us. This collaborative effort between the artist and the medium is at the heart of good watercolor techniques.

Look at one of your paintings and choose your favorite area: the spot you wish the rest of the painting looked like. Now choose the area you feel is least successful. Chances are you labored the longest in the least successful spot and painted that wonderful area in one quick shot. What follows in this chapter are some basic techniques that are essential for obtaining freshness of color and application every time. These techniques will help you get the most out of your paint and brushes.

**LAST OF AUTUMN** ▸ Watercolor ▸ 28" × 30" (71cm × 76cm)

# Materials and studio suggestions

## Paper

There are numerous brands of watercolor paper. What makes one preferable to another is primarily determined by the individual artist's techniques. My paper of choice is Arches 140-lb. (300gsm) rough, for its texture and durable surface.

If not stretched beforehand, watercolor paper can buckle and warp as the applied paint dries. To prepare the paper for painting, I soak it in water for about ten minutes, then staple it down to one of my painting boards with an office stapler. My boards are made of 12-inch (30cm) or ¾-inch (19mm) foamcore board that have been covered with cotton canvas glued down with carpenter's glue and painted with a few coats of latex house paint. I have found this board provides enough body for the staples so they will not pull out as the paper dries.

**A View of Part of My Studio**
I tilt my drafting table to about 30 degrees. Just beyond my table is my slide projector and beyond that, my projection screen. I work up my drawing from the projected image, then clip the drawing in front of me. I prefer to do the painting from the drawing, turning on the slide occasionally for detail reference. For the bulk of the painting I prefer to stand, as this gives me more freedom and prevents me from focusing my attention on too small an area.

## Paints

Don't save money by using the cheaper, student-grade paints. If it is worth learning, it is worth learning on good materials. There are many brands of excellent quality, but since I love transparent colors, I have fallen in love with the Quinacridone colors first introduced by Daniel Smith. These colors are vibrant, very transparent and flow beautifully in a wash.

Quinacridone Sienna, for example, is much more transparent and richer than traditional Burnt Sienna. Most of my paints are Daniel Smith, but I also use Winsor & Newton and Holbein brands. Try different brands and colors to discover your own favorites.

## Brushes

Generally, flats and large rounds are used to cover large areas with paint, and small rounds are used for smaller areas and details. My requirements for these brushes are: (1) Rounds must come to a fine point and have a full body that's able to hold plenty of water, and (2) Flats must be thick enough at the ferrule to hold plenty of water. I don't want to run out of water three inches into a stroke. The flats must also come to a chisel edge when wet.

It used to be that the only choice was pure red sable—not anymore. Certain synthetic brushes and hair-synthetic blends are just as good for my money and have the advantage of being inexpensive. A few brands of rounds that I particularly like are Dick Blick 2047 series, Utrecht sablette 220 series and the Langnickel Royal Knight 7250 series. When the tip wears out, and they do about as quickly as a sable tip does, you can give them to the grandkids to play with and have no heartburn from it.

## Other Materials

I sketch most with a 4B or 6B graphite pencil. I like the dark values I can get without pressing into the paper and leaving an indent on the next page. I also use these to draw on the watercolor paper. I can leave a line dark enough to be seen after the initial wash covers it, and it is easy to erase after the painting is finished because it is not imbedded in the paper.

The other supplies you need to complete the projects in this book are: a hair dryer, palette knife, spray bottle, paper towels, sketchbook and masking tape.

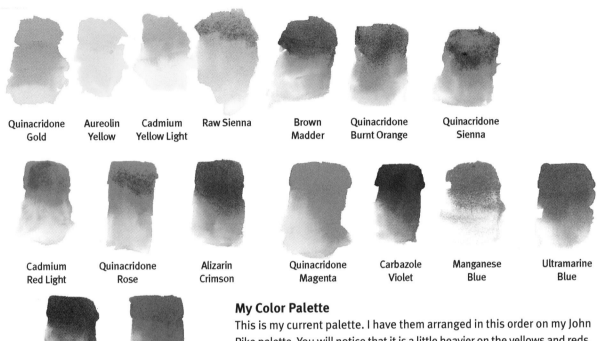

| Quinacridone Gold | Aureolin Yellow | Cadmium Yellow Light | Raw Sienna | Brown Madder | Quinacridone Burnt Orange | Quinacridone Sienna |
| --- | --- | --- | --- | --- | --- | --- |

| Cadmium Red Light | Quinacridone Rose | Alizarin Crimson | Quinacridone Magenta | Carbazole Violet | Manganese Blue | Ultramarine Blue |
| --- | --- | --- | --- | --- | --- | --- |

| Sap Green | Viridian |
| --- | --- |

### My Color Palette

This is my current palette. I have them arranged in this order on my John Pike palette. You will notice that it is a little heavier on the yellows and reds, and lighter on the blues and greens. This is partly because I don't like most of the tube greens, preferring to mix my own, and partly because I respond to warm colors more.

### My Brushes

This photo shows the brushes I use most: two large rounds (nos. 12 and 14), two small rounds (nos. 8 and 6) and a range of flats, from 2-inch (51mm) to half-inch (12mm). Like all artists, I have a lot more, but I have them primarily to make me look like an artist.

# Mastering the graded wash

The graded wash creates a soft transition of color and can be used in many different ways. Mastering this and the other washes eliminates the frustration beginners experience during the painting process. Washes also are the key to the fresh, sparkling quality we admire in good watercolors.

## Getting Started

Before applying any wash, moisten your paints. Saturated paints are essential to good painting. Dry paint results in washed-out, anemic-looking watercolor paintings. Squeeze out plenty of paint onto your palette. (Don't be conservative!) Be sure to keep the paints wet during the entire process of painting. Brushes wear out quicker when scrubbing them on dry paint in an attempt to pick up enough color for a painting.

When painting, match the brush to the shape. For a large shape, use a large brush. If the edge of the shape is intricate or otherwise impossible to paint with a flat brush, use a round brush. My rule of thumb is to use the biggest brush possible for as long as possible. If a shape can be painted with one stroke, it will always look better. Too many strokes ruin the shape.

To practice the washes on the following pages, divide a half sheet of watercolor paper into thirds with 1-inch (25mm) masking tape. In the first third draw a rectangle approximately ten inches (25cm) high and six inches (15cm) wide. In the middle section draw an abstract shape roughly the same size as the first rectangle. In the last section draw another rectangle like the first, but within the rectangle draw a few shapes or block letters.

Mix a middle-value color wash on your palette. In this example I used Quinacridone Sienna and water. Mix enough to cover the entire area of the first rectangle. This is essential. If you have to stop to mix more color, you will never get the same mixture and the previous stroke may begin to dry.

### Begin the Wash

Tilt the painting support at a 15-degree angle, and prop something under it to keep it steady. Too much slant will cause the pigment to settle at the bottom of the bead of paint, resulting in stripes. If the board lies too flat, the water will not pull the pigment down the sheet. Fully load a round brush and pull a stroke of color across the top of the first rectangle. Hold the brush at a slight angle to the surface of the paper—not perpendicular. You must have enough water in the brush to form a bead at the bottom of the stroke as shown.

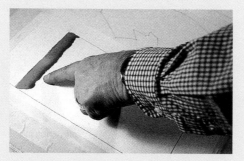

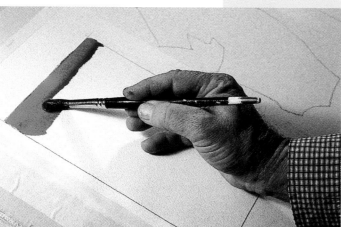

### Pull Down the Bead

Quickly reload the brush with the wash. Touch into the bead and pull down another stroke across the rectangle, right below the first stroke. Resist any urge to go back into the first stroke. You cannot make it better no matter what you do, you will only make it worse. Just pick up the bead and carry it down. If a fleck of white paper shows up, leave it alone. No matter what problem seems to be there, do not paint back into the stroke.

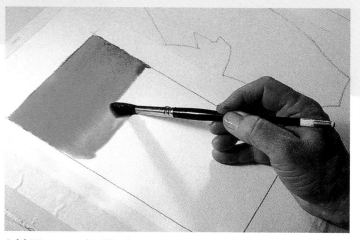

### Add Water to the Wash

Dip the brush into clean water. Do not rinse it out, just add water to the color left in the brush. Pull another stroke into the bead of the last stroke and continue pulling the bead across. Continue down the page, adding more clean water to the brush after each stroke to gradually lighten the value. The last stroke should be clear water only.

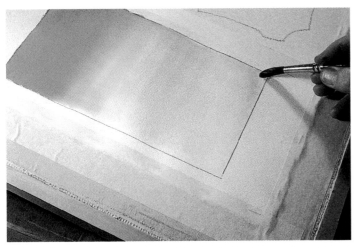

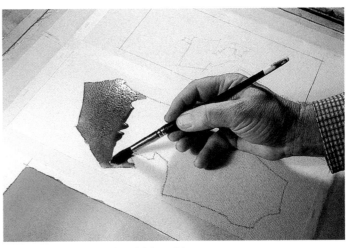

### Pick Up the Final Bead

Lift the final bead of water at the bottom with a thirsty brush. Create a thirsty brush by rinsing it in clean water and squeezing it lightly with a paper towel. Then touch the thirsty brush into the bead of water. This will prevent backruns, where unnoticed little puddles of water at the edge of the paper may creep back into the drying wash. Keep the board tilted at the 15-degree angle until the wash is dry. Use a hair dryer to dry it faster. I find it useful to dry washes with a hair dryer. This speeds the drying and prevents backruns from occurring.

### Paint a Graded Wash Within a Shape

Try the same procedure with the abstract shape you drew in the middle of your paper. Confine the strokes to the area contained within the shape. You can use this technique for smaller areas within a painting, such as mountains, water or wherever you need a gentle transition of color. Remember, just pick up the bead at the bottom of the previous stroke without painting back into that stroke.

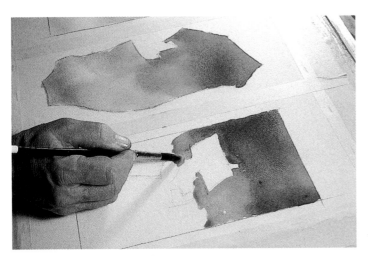

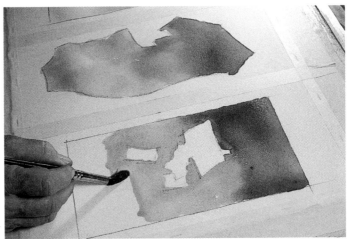

### Paint a Wash Around a Shape

In the third section of the paper, pull a graded wash down the rectangle, but leave the shapes you sketched within the rectangle unpainted. Keep several beads progressing simultaneously until they join below the shapes. Keep practicing painting around these shapes until you feel comfortable doing them. This skill will come in handy in almost every painting you do—for painting around buildings, figures and so on.

### Progress to the Bottom

Join the beads again and continue painting to the bottom of the rectangle. Remove the final bead with a thirsty brush.

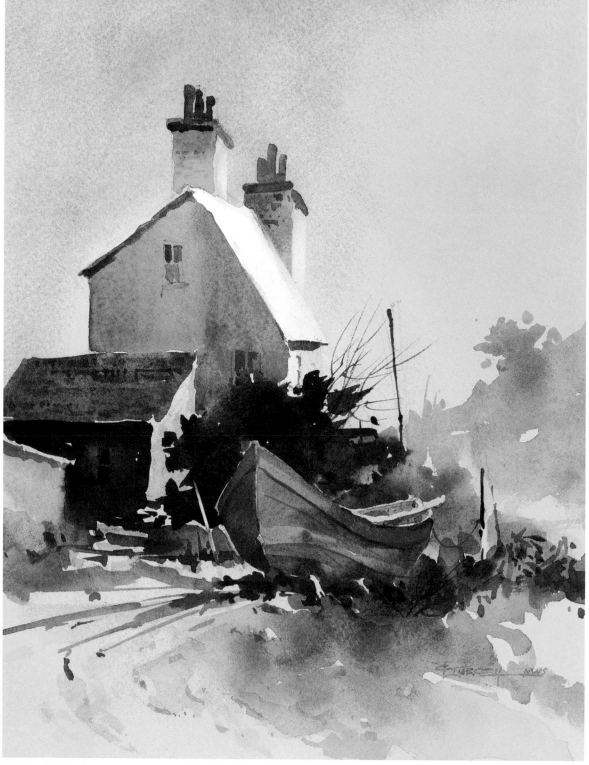

### Finished Painting

This study of a house in Devonshire, England, utilized a graded wash of Quinacridone Gold in the sky, leaving the white rooftop and right edges of the chimneys. A graded wash of Manganese Blue was also pulled from left to right in the sky. Two graded washes, one of Manganese Blue and one of Quinacridone Rose and Quinacridone Sienna, were also used for the side of the building and the boat. Small graded washes of Quinacridone Sienna and Manganese Blue define the chimneys. The foreground is a mingled wash of Manganese Blue, Quinacridone Rose and Sap Green. These washes add vitality to the scene.

**Morning in Clovelly** ▸ Watercolor ▸ 14" × 10" (36cm × 25cm)

No other medium is as adaptable to producing a gradual transition in color as is watercolor. It would take hours of tedious and careful brushing in oils to produce the gradual transition you will create as you do the following exercises. This is sometimes called a glaze, but it is simply a graded wash on top of a dried previous wash.

Graded washes also can be painted wet-into-wet. Wet the paper with clean water, either with a brush or a spray bottle. Pull in the first graded wash as described below, then immediately invert the board and lay down the second wash; however, the first wash must be completely wet. If it has started to dry, it will create a disaster.

There are only two times you can successfully work into a previously laid color: when it is still very wet, or when it is completely dry. When it is damp, leave it alone. Most muddy colors result from working into this stage.

# Layering graded washes

**Build Layers of Graded Washes**
Paint a graded wash on a quarter sheet of paper using Quinacridone Rose. After this has dried, turn the paper upside down and paint another graded wash using Ultramarine Blue. Complete the wash all the way to the bottom; do not stop partway. You should end up with nearly clean water at the bottom. After this has dried, pull another graded wash of Quinacridone Sienna from one side to the other.

1 Ultramarine Blue
2 Quinacridone Rose
3 Quinacridone Sienna

**Try Another Variation Using the Same Colors**
This time we will change the directions of the washes. Begin with the Quinacridone Rose in a graded wash from bottom to top. Next, pull a wash of Ultramarine Blue from right to left, and then one of Quinacridone Sienna from left to right. Notice that the Ultramarine Blue doesn't stain the Quinacridone Rose in the lower right, but allows it to visually mix with the blue.

1 Quinacridone Rose
2 Ultramarine Blue
3 Quinacridone Sienna

## A Word About Pigments

Pigments range from quite opaque (Yellow Ochre, Naples Yellow, Burnt Sienna and Cerulean Blue) to very transparent (Alizarin Crimson, Quinacridone Rose, Phthalo Blue and Viridian). A few colors are termed staining colors because they sink into the paper and stain it rather than create a thin layer on top of the paper. Among these staining colors are Alizarin Crimson, Phthalo Blue, Phthalo Green, Prussian Blue and Carbazole Violet. Because they stain the colors underneath them as well as the paper, it is usually wise to use them in the initial washes and use the more opaque colors on top. Used in thin washes, these more opaque colors create a thin veil of color that allows the color underneath to peek through.

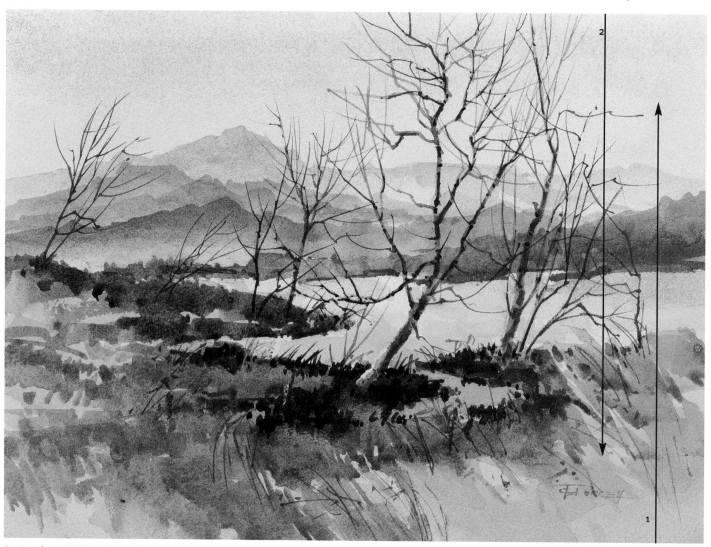

2. Graded wash from top to bottom of Manganese Blue

1. Graded wash from bottom to top of Quinacridone Sienna

## An Underpainting Sets the Tone

The underlying wash (or underpainting) of Quinacridone Sienna provides a warm glow to all the subsequently applied colors. This could not be attained in any other way. Note how it warms all the land area. The graded washes in the mountain ranges give a hazy appearance to the distance and provide atmospheric perspective.

**EVENING CALM** ▸ Watercolor ▸ 10" × 14" (25cm × 36cm)

Replace those overworked areas with rich washes of mingled color and add richness and vitality to your paintings. Mingled washes are based on a visual reality that is overlooked because our intellectual brain gets involved.

In an effort to simplify the wealth of visual information it receives minute-by-minute throughout the day, the intellectual brain wants to simplify color. It sees the gradation of color in the sky from deep cobalt blue above us to warm green at the horizon and says, "blue sky." It labels a field as "green grass" even though it may have eight different greens, plus sienna and purple colors mingled throughout. It is rather Tarzan-like in its short reduction of facts: "tree green," or "house white." If we follow this lead, we fall into what I call the one-item-one-color syndrome.

When we really look, we will see a myriad of colors present in almost everything. Mingled washes are a way of bringing out that aspect by overstating it just a bit. Pablo Picasso said that the artist tells a lie to get at the truth. This kind of lie is okay to tell. It helps people see the beauty in the world around them.

## Getting Started

On a quarter sheet of paper draw a vertical rectangle, and in the remaining space, two abstract shapes: one, a good shape for tree foliage, and the other a shape for ground. Then mix several puddles of warm and cool colors, all about mid-value.

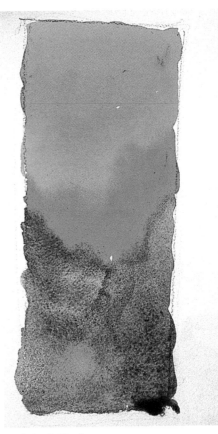

**Finished Wash**
Practice this with all the colors on your palette. You will find that some colors travel more slowly into the succeeding color, while others virtually explode into other colors.

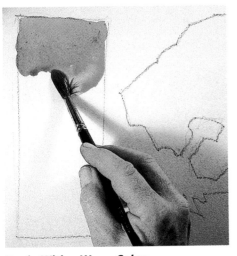

**Begin With a Warm Color**
Angle the painting support to about 15 degrees. Begin painting with one of the warm colors at the top of the rectangle. Give this stripe a varied edge. Use enough water in the mix to produce a bead of color along the bottom of the painted area. If you don't have a bead, you will only get hard edges between colors.

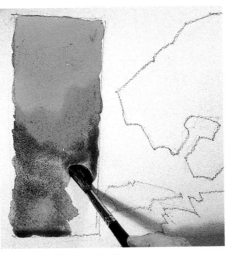

**Mingle Different Colors**
Rinse the brush and load it with another color. With the brush at an angle to the paper, and with the tip pointing up into the bead, pick up the bead and carry it downward. Every time you recharge the brush, do so with a different color: first use the warm colors, then the cool greens and blues.

When you reach the bottom, remove the water from your brush with a paper towel. Pick up the final bead by touching the thirsty brush into the bead of water; otherwise, it will run back up into the last color.

## Paint a Mingled Wash Within a Shape

Now let's try this wash in different shapes. This time as we paint each area, we also will focus on varying the edge of the shape so that it has both varied color and varied edges. This will be very important when you apply this technique to trees and other shapes in your paintings.

Continue on to the next shape. As you apply the first color along the top, angle the brush horizontally to the surface and drag it along quickly to produce a ragged edge. Point the tip of the brush into the shape so the edge is created with the heel of the brush. If the brush is pressed down nearly to the ferrule, the heel of the brush will produce a more ragged edge than the tip. Then add more color and increase the area of color. Remember to use enough water to produce a bead.

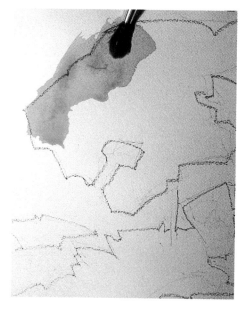

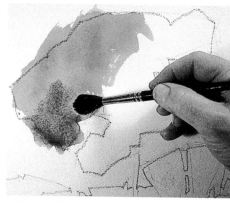

### Mingle a New Color

With a fully loaded brush of a different cool color, pull the bead down into the shape.

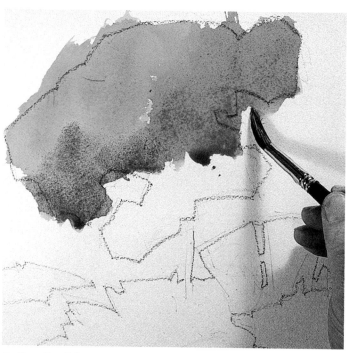

### Soften the Edges

Before the wash has a chance to dry, use a damp brush to soften edges here and there, creating eye-pleasing variation. Don't take too long or the bead will dry. If the bead dries, you will get a hard edge that will be much more difficult to soften without scrubbing it into submission. Grab the bead with a new color and continue.

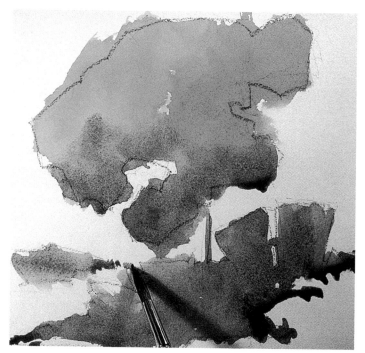

### Finished Shape

You now have an interesting shape painted with exciting colors and a variety of edges.

Do the same with the shape below it, this time using more greens and yellows. I prefer mixed greens to tube greens as they look more natural. Some of my favorite mixtures are Manganese Blue and Quinacridone Gold, Ultramarine Blue and Quinacridone Sienna, and Manganese Blue and Quinacridone Sienna.

To create a tree with foreground grasses and a fence, add a few calligraphic details on top of the last mingled wash.

Mingled washes

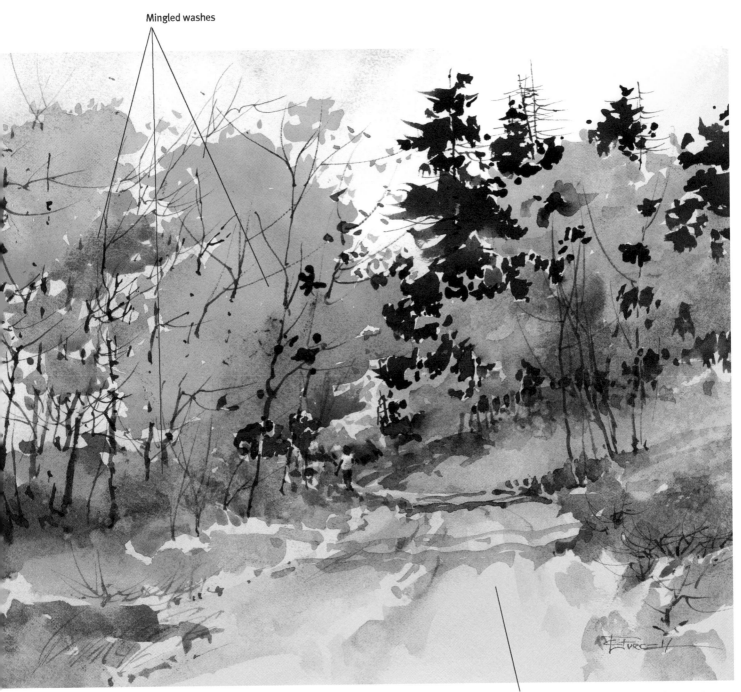

Pale graded wash of Quinacridone Sienna and a touch of Carbazole Violet

## Breaking Free From the One-Item-One-Color Syndrome

Here you can see how mingled washes enhance the trees, ground and foreground areas. Using mingled washes will free you from the one-item-one-color syndrome. The warm foreground wash of Quinacridone Sienna helps create a sense of distance, since warm colors appear to advance and cool colors appear to recede. It also gives this scene a warm autumn glow.

**AUTUMN PASSAGE** ▸ Watercolor ▸ 11" × 14" (28cm × 36cm)

# Getting the most out of your brushes

The two basic watercolor brushes, the pointed round and the flat, are designed especially for watercolor. Too often they are treated as mere paint applicators. They should be thought of as specialized tools designed to produce the best possible effects. When used correctly, they will serve you wonderfully.

A good watercolor round brush holds a lot of water and is versatile in that you can paint with the body of the bristles or use the tip for fine lines. A flat brush has more versatility than one would think, but it can also cover large areas of paper quickly, with fewer strokes. Practice these strokes to see what your brushes can do.

### Loading a Brush

Using a no. 6 or no. 8 round, mix a puddle of rich, dark color on your palette. The consistency should be fluid but with plenty of pigment. Then load the brush. As you pull it away from the edge of the puddle, twist the brush handle between your thumb and forefinger as you lift up. This aligns the hairs to give you the best tip.

### The Controlled Line

Hold the brush as shown, perpendicular to the surface of the paper. Only a vertical position gives you control at the tip. Do not hold the brush at an angle like you do a pen when writing. Let the heel of your hand rest on the paper. This position gives you vertical stability and control of the pressure at the tip.

Lock the wrist and fingers in this position. Use your arm to move the brush, not your fingers or wrist. Paint a series of straight lines, both horizontal and vertical. Practice until you can consistently pull lines of the same width. Watch your hand as you do this. Don't allow your fingers or wrist to move.

Now try some combinations of diagonal and curved lines, similar to what you will find in trees. A slanting position to the brush will not allow you to control the width of the curved lines, so maintain a perpendicular position for the brush at all times.

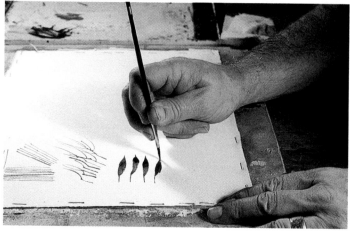

### Paint Lines of Varied Width

By practicing proper brush position, you control whether the stroke will be thin or thick. Hold the brush the same way as before, but as you begin the line press the brush straight down into the paper while continuing the stroke. As you pull the stroke, twist the brush handle between thumb and forefinger as you pull the brush up to the starting position. Maintain the vertical position throughout. Practice these strokes to gain control and mastery of the brush.

Consider taking a brush calligraphy class; this is a great way to learn brush control.

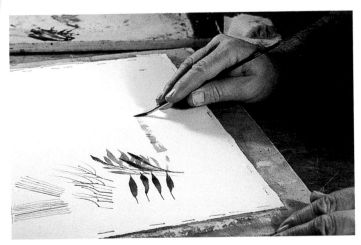

## The Side-Drag Stroke

Load a no. 10 or no. 12 round with juicy color (plenty of pigment and water). This time we will lay the brush down and drag it sideways instead of using the tip. Point the tip away from you and hold the brush almost horizontal to the surface. Drag the brush sideways. Vary the line lengths. Drag, then lift and skip a little space. This lifting will leave some lights.

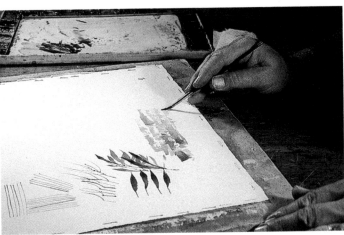

## A Broken Wash

Drag another stroke along the bottom of the previous line. Each time you recharge the brush with color, vary the color. This produces a kind of broken wash, which is great for grasses and foreground texture. Stagger the lights so they don't line up vertically.

## See the Possibilities

Adding a few lines here and there with the tip of your round will complete this textural foreground.

## The Stab

Load a brush with color and, holding it vertically to the paper, press the brush down to the ferrule and then lift off. Try twisting it as you lift off. This will produce a different mark every time, and can be turned into chickens or used in foliage or for any number of other possibilities your imagination can create.

## Spattering

Load a brush with color. Hold the brush over the paper and tap it with your other hand. This distributes droplets of paint over the paper.

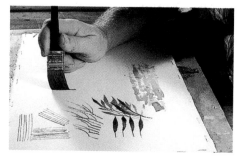

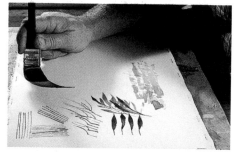

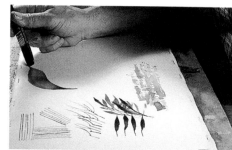

### Paint a Thin Line

Load a 1-inch (25mm) flat with color and hold it vertically above the paper. With the long edge pointing away from you, begin painting a thin stroke away from you. A good flat brush can produce a fairly thin line.

### Continue With a Wide Stroke

As you push the line up, lean the brush over and push down on the bristles without changing the brush position in your hand. This produces the widest stroke possible.

### Finish the Stroke

Finish the stroke by twisting the brush slightly and lifting up, with the far edge of the chisel leaving the surface last.

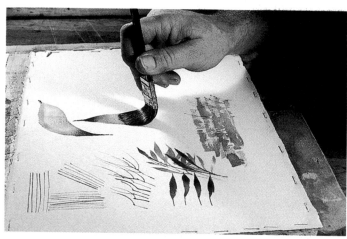

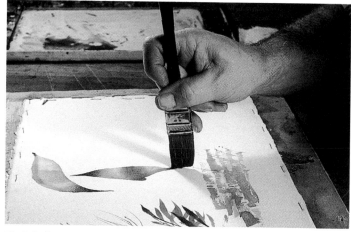

### Try a Variation of the Previous Stroke

Begin with the brush in the same position, but this time pull the stroke toward you. As you do, begin twisting the brush while pushing it down into the paper.

### Finish the Stroke

Lift the brush as you twist it. Finish the stroke with just the corner tip of the brush. This stroke is useful in a number of applications, especially for building the planes in rock formations.

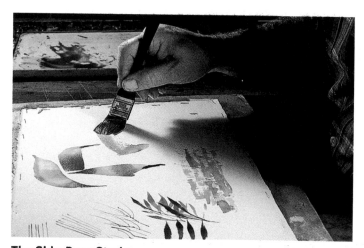

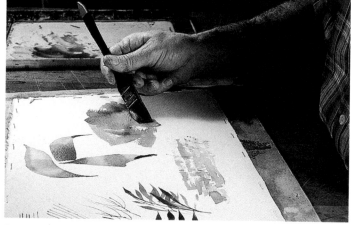

### The Side-Drag Stroke

When you drag a flat brush sideways, you will find that the hairs splay out and produce some accidental edges—wonderful for foliage. Press the brush down all the way to the ferrule and quickly drag it sideways, pressing the corner of the brush into the paper, not the flat edge.

### Ragged Edge

Notice that the most ragged edge of the stroke is made by the part of the brush at the ferrule end, not the tip end.

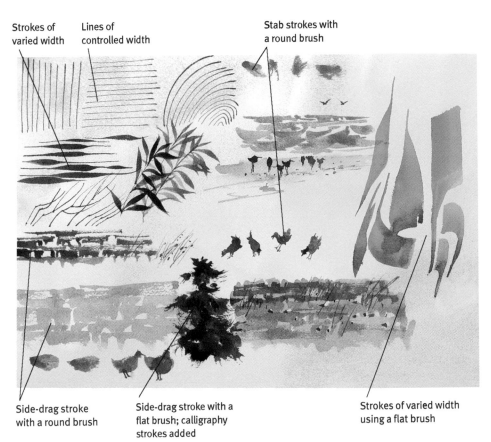

Strokes of varied width

Lines of controlled width

Stab strokes with a round brush

Side-drag stroke with a round brush

Side-drag stroke with a flat brush; calligraphy strokes added

Strokes of varied width using a flat brush

## Make a Practice Sheet

Making practice sheets like this one will help you see the possibilities with each brush. Build your paintings with a combination of basic washes and carefully placed strokes. Use these strokes to suggest or reveal "things" as you bring a stroke around a shape. Don't approach the process as an exercise in painting things or you will end up simply coloring between the lines.

## A Painting Built on Washes and Brushwork

Here is an example of a painting done completely with basic washes and applied strokes. Can you identify the different strokes?

**SANDSTONE BUTTE**
Watercolor
10½" × 14"
(27cm × 36cm)

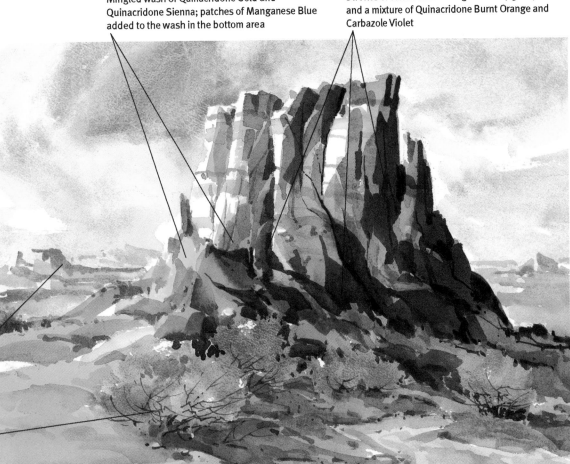

Mingled wash of Quinacridone Gold and Quinacridone Sienna; patches of Manganese Blue added to the wash in the bottom area

Strokes of varied width using a 1-inch (25mm) flat and a mixture of Quinacridone Burnt Orange and Carbazole Violet

Side-drag strokes with a no. 12 round

Calligraphic lines with a no. 8 round

123

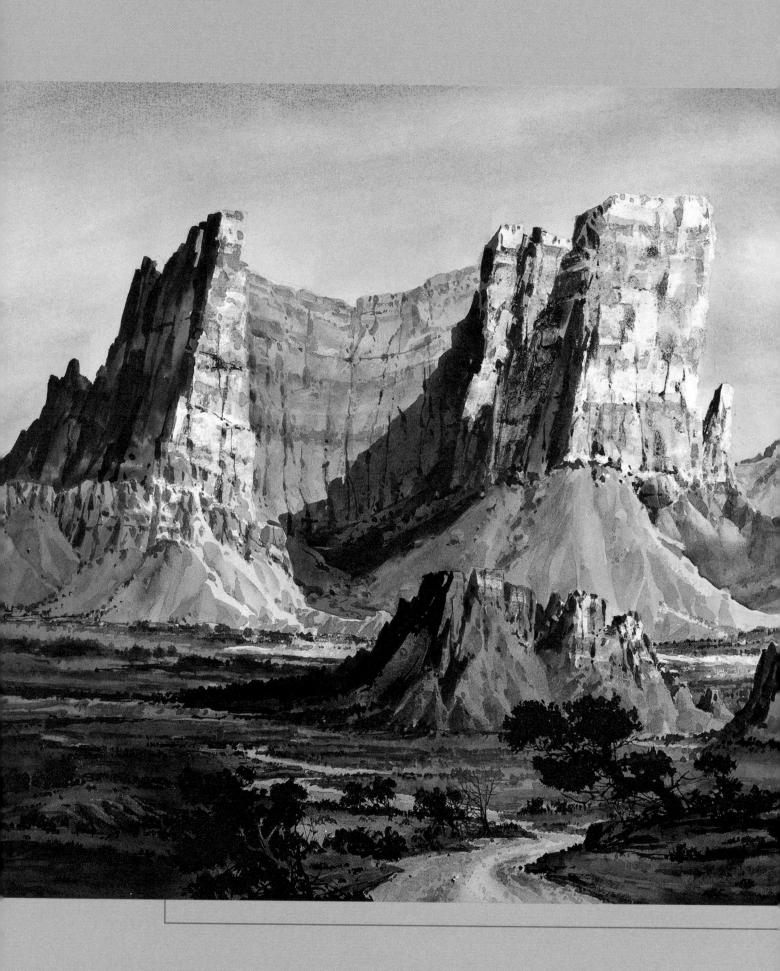

# seeing
# SHAPES

*The same information-processing problems that the analytical or intellectual part of the brain creates for those who draw plague those who paint. Fortunately, the solution remains the same: To be a good artist, you need to rely on your visual brain, or artist's brain. Training your artist's brain is really a matter of bringing what it normally does on an unconscious level into conscious use. To paint a tree you need to consciously access the visual information first recorded by your visual brain. You need to see the actual shape of the tree, the value and color nuances of that shape, and its relationship to the shapes around it. You don't need the simplified symbol your intellectual brain stored when you were five years old. You don't need to know there are thousands of leaves on it, or that foliage is green and the trunk is brown. These generalities replace actual observation. This information actually prevents you from seeing.*

**DESERT CATHEDRAL** ▶ Watercolor ▶ 24" × 33" (61cm × 84cm)

# Use silhouettes to find interesting shapes

Everything you paint is a shape. You cannot paint a tree; you can only paint a shape of color and value that conveys the visual information of a tree. You are working on a two-dimensional sheet of paper. A tree or any other object is a three-dimensional form in space. As soon as you represent that form on a flat surface, you have done so with a shape; therefore, it is critical for you as an artist to be able to see subjects as shapes.

To help you see the shape of any item, ask yourself, "If the object I am looking at were cut out of black paper, what would its silhouette look like?" Seeing a form as a silhouetted shape allows you to discover if that shape is either visually interesting or boring. Visually interesting shapes entertain the eye. Visually boring shapes are static, uniform simplifications or generalizations of facts.

Most people can tell an interesting shape from a boring one. But, when we pick up a pencil or paintbrush, a curious thing happens. If the shape we're looking at is boring, we paint it that way. We tend to want to paint the shape just as it is, without changing it to make it more interesting in our composition.

Looking at an object from several different points of view will help you find which view presents the most visually interesting shape, or silhouette.

### Interesting Rock Forms

At the base of this beautiful waterfall is a collection of rocks. As forms the rocks are interesting, but that doesn't mean their overall shape is interesting. I liked the rocks as a visual element and their location, but notice what happens when you silhouette the shape.

### Uninteresting Rock Silhouette

This is what the shape would look like if you cut it out of black paper. I like the placement of these rocks, but their shape is unexciting — just slightly more interesting than that of a marshmallow. However, the silhouette could look very different and more interesting if the rocks are viewed from another angle.

Sometimes you may see an interesting shape in nature but turn it into a boring one on paper. Even though you realize the attributes of the interesting shape, this does not deter the intellectual brain from affecting your ability to re-create the interesting shape. Let me illustrate why this happens.

# How your brain can make an interesting shape boring

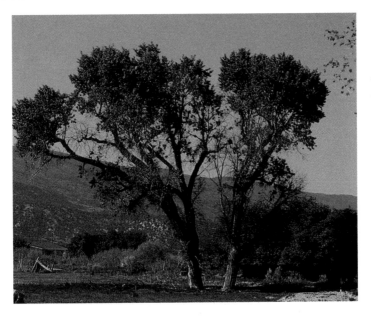

**What You See**

This tree is an interesting shape. There is some complexity and variety to it.

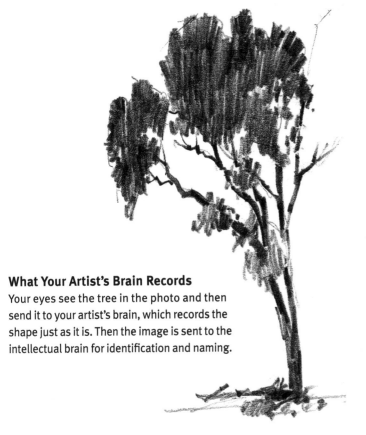

**What Your Artist's Brain Records**

Your eyes see the tree in the photo and then send it to your artist's brain, which records the shape just as it is. Then the image is sent to the intellectual brain for identification and naming.

**What Your Intellectual Brain Produces**

Here the image links with previously stored information, including other symbols for trees, and becomes simplified. All the visual complexity that makes the shape interesting is eliminated. A symbol is created to stand for the tree. It is not meant to look like the tree, only represent it. This symbol is then sent to your hand for recording. If you draw a symbol for a tree, it doesn't mean you can't draw. It means the intellectual brain intervened and dictated the drawing.

# Modify boring shapes

When painting any item ask yourself, "Is the shape interesting?" This is different from asking if the item is interesting. It may be interesting because it belonged to your grandfather; however, this does not make its shape interesting. My grandfather's pocket watch is a very interesting artifact, but not an interesting shape. Our challenge as artists is not only to see an item's shape, but to analyze the shape for its visual interest and its ability to contribute to our painting. Some shapes are perfect and don't need modification.

Often shapes need just a little adjusting to make them more interesting. Other shapes need a full makeover.

## Good Shapes

Shapes are like people—some are interesting and interact with others, some are boring recluses who avoid relationships. Good artists create shapes that interact with the surrounding space and allow the space to move into the shapes.

## Uninteresting Shapes

Imagine you want to include a rock and a bush in your painting. First look at the shapes. If the shapes are boring, as these are, you need to modify them.

No variety in edges (all are relatively uniform, unbroken and hard)

Neither the rock nor the bush interacts with the background, creating a static feeling.

Nearly perfect semicircles that are too symmetrical and predictable

No variety in width of shape

## Interesting Shapes

These shapes are more interesting than the first example. Neither the rock nor the bush is predictable. These shapes have various widths; they are narrow in some places and wide in others. Both shapes interact with their background, which creates a dynamic sense of space on the picture plane.

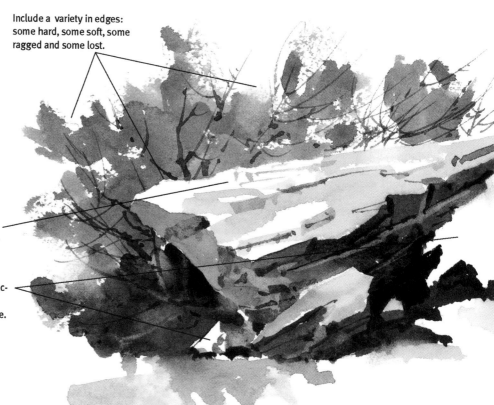

Include a variety in edges: some hard, some soft, some ragged and some lost.

This shape is wide at one end and very narrow at the other.

Create plenty of interaction between shapes and surrounding space.

128

### Boring Building Shape

This little building has quite a boring shape. Notice that it is self-contained—there's no place for the surrounding space to get in and interact with the shape. There are no parts of the shape that jut out into the space (the white of the paper). All of the edges are the same. Its height and width are approximately equal. It has no visual surprises.

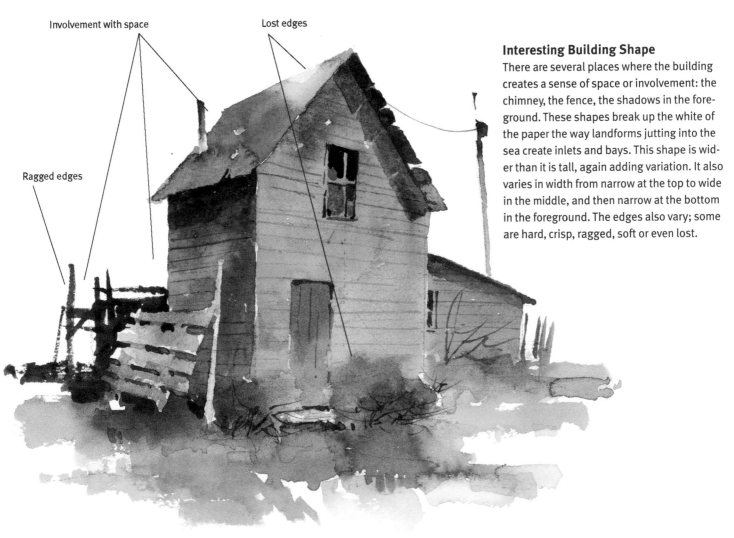

Involvement with space

Lost edges

Ragged edges

### Interesting Building Shape

There are several places where the building creates a sense of space or involvement: the chimney, the fence, the shadows in the foreground. These shapes break up the white of the paper the way landforms jutting into the sea create inlets and bays. This shape is wider than it is tall, again adding variation. It also varies in width from narrow at the top to wide in the middle, and then narrow at the bottom in the foreground. The edges also vary; some are hard, crisp, ragged, soft or even lost.

# Place shapes into visual categories

When you name items you put them into intellectual categories. We all do this, but few people outside the field of art take note of an item's shape. Progress beyond the intellectual category and train yourself to place shapes into visual categories, such as:

- ▸ shapes of light value
- ▸ shapes of dark value
- ▸ shapes of color
- ▸ shapes of space

You can't paint good shapes if you are not aware of them. Train yourself to see interesting shapes and you will respond more to them when painting. Building a painting involves organizing shapes into a unified visual statement wherein each shape, like a piece in a puzzle, contributes to the whole. Good shapes are all around us; however, be aware that they tend to keep bad company. Everywhere you find an interesting shape, you will usually find a boring one, too.

Here are two paintings that were based on strong shapes.

### Streetside Shapes in Daytime

Several interesting shapes caught my eye on this little street in Ashburton, England. The most important was the light shape with the archway at the end of the street. In my painting, I increased the size of the archway for greater interest. The dark shape of shadow cast by the buildings onto the street also caught my eye, as did the shapes of the people. I loved the shape of the space with signs and chimneys pushing into it. Little complementary shapes of blue and orange also add interest to the scene.

**ASHBURTON SIDE STREET**
Watercolor
27" × 19" (69cm × 48cm)

### Seaside Shapes at Sunset

The intriguing shape of the light-struck sea as it interlocked with the dark shape of land at sunset was a visual treat for my wife and me when we arrived at this remote village on the north coast of Scotland.

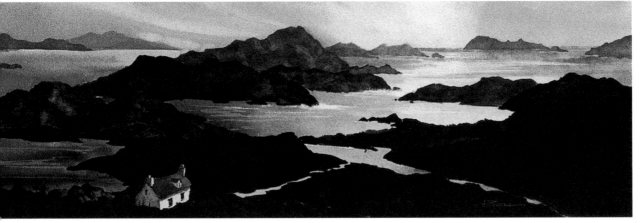

BADCALL BAY ▸ Watercolor ▸ 11" × 28" (28cm × 71cm) ▸ Private collection

When I draw on location, I begin with whichever interesting shape first catches my eye. Then I add what is necessary and change any shapes to improve the composition. A camera cannot do that. You can't rely on it because it doesn't discern interesting shapes from boring ones.

In the following photos I have pointed out some of the interesting shapes and boring ones. Practice doing this yourself so you can edit with ease every time you select a subject to paint.

# Overcome camera dependence

### Determine Interesting and Boring Shapes
The most interesting shape here is a dark shape made up of the shadowed side of the barn, the tree trunks, the foliage in shadow and the shadow on the ground with fence posts. But the overall shape of the tree is boring because it is too round and looks like a large, uniform oval. The grassy area at the bottom is a boring light rectangle.

In a painting, I would create places where the space around the tree would push into it, making the shape of the tree more irregular. I would push the dark shadow on the grass down into the foreground light, creating better shapes out of the rectangle.

### A Boring Shape Within an Interesting Seascape
Among the beautiful coastal shapes in this photo, a tree/shrub shape has perched itself on top of the rocks and looks just like a big hedgehog—a cute animal, but not the most interesting shape in the world. In a painting, create a better shape by pushing some of the dark out into the space and allowing the light space to cut into the dark. Adding another tree might also help.

### Discover Hidden Interesting Shapes
Some shapes are fascinating just as they are; however, you have to be aware of them. Most people would simply pass up this beautiful shape and never notice it.

# Practice altering shapes

If we see everything around us as shapes, and see ourselves as arrangers of shapes, then we will be free of the tyranny of the photo. We will feel at liberty to change any shape to suit our needs, move any shape to enhance our compositions, and add any color to a shape when we feel it is necessary.

Find a good shape and use your artist's brain to adjust it in several ways. Explore the characteristics of the shape and try out several possibilities. This is the joy of art. The excitement is not in the final product, but in the journey you take to get there.

### Reference Photo
The rocks in this photo create a very interesting shape; however, some areas need changing. The background isn't doing anything for the rock forms. The dark shape is too big and too far away from the point of the rocks. The shape needs to be made more interesting and brought over where it can add to the excitement of the rocks. The straight diagonal line at the bottom of the rocks needs to be broken up and given some irregularity.

### Experiment With Thumbnail Sketches
Start with a linear exploration, or basic line drawing of the shape. Place it in a format to see how it divides up the space. Then try several variations, quick thumbnail studies that show what the shape will look like if you vary some of its characteristics. In these sketches I have tried several types of the tree form, changed the configuration of the rocks and moved the trees. Nothing in the photo is sacred; you won't go to jail for changing anything.

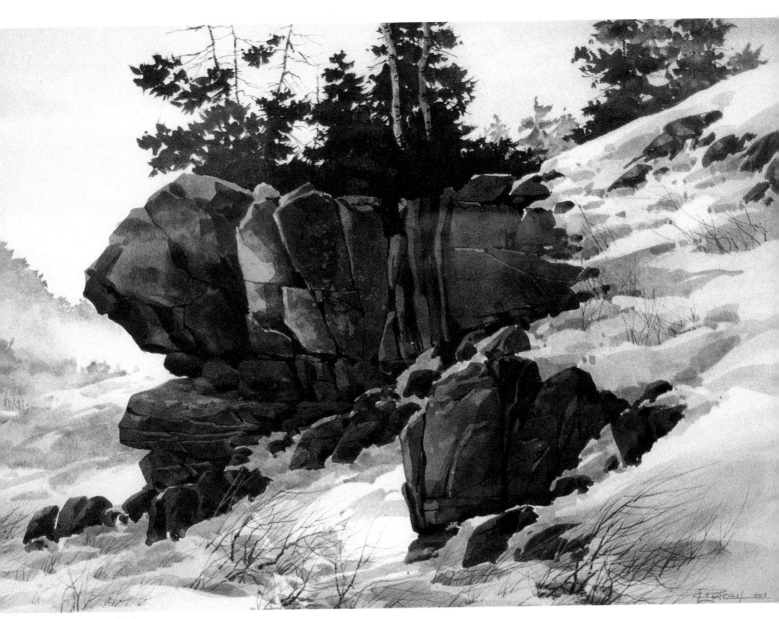

## The Finished Painting

The painting is not the same as the photo. Does this make it less real? No! It is a different reality than the photo. Think of the photo only as a springboard for ideas. The art occurs after you leave the springboard. In this new reality, the major lines from the left lead to the rock forms, and the dark trees provide an area of strong contrast where the rocks end.

**NORTHERN EXPOSURE**
Watercolor
22" × 28" (56cm × 71cm)
Private collection

### A Lesson From a Master

The great Michelangelo is reported to have said after completing a statue of the Duke of Urbino for the Medici tombs, "What, it looks not like the Duke? Who will know a thousand years from now?" After nearly five hundred years we could safely add to that, "And who will care, either." If changing the shape will enhance the artwork, it's OK to change it!

# Resist the intellectual brain's cloning tool

Anyone familiar with the computer software program Adobe Photoshop knows what the cloning tool is. It allows you to copy any section of a photo and repeat it somewhere else. For example, if you had a short section of fence in a photo, you could clone it to make one long fence. However, every post would be identical in length, width, height, color and value.

Your intellectual brain has a similar feature—it can register a sequence and repeat it. Remember, it is always looking for an opportunity to involve itself in the painting process. You give it the opportunity whenever you paint a sequence that can be repeated—fence posts, rocks, tree branches, bushes, grass blades, windowpanes and so on. Once you paint the first one or two, the intellectual brain jumps in and says, "I got it, let me do that!" And it does.

The next time the intellectual brain tries to interject its oversimplified versions into the painting process, deter it by basing your shapes on observation and assuming nothing. For instance, if you were looking at a house and a tree, ask yourself what you actually see. What happens along the bottom edge of the building shape when it meets the lighter or darker shape of ground? At what angle do the tree limbs leave their parent branch, and what kind of rhythm do they have? What variations in value and color do you see on the side of the building?

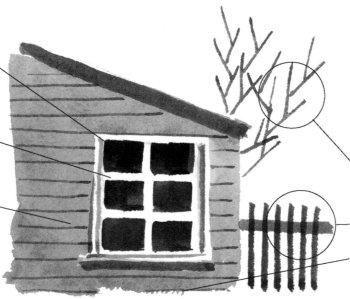

The windowpanes are identical—dark and flat.

The window casements are white, so you leave the white of the paper.

The wall is only one color.

## How Your Intellectual Brain Wants to Paint

The intellectual brain taints your visual thinking. It wants to oversimplify and take the easy way out when painting the images it interprets. The elements in this image are painted not from observation but from previous knowledge.

All the tree branches are comprised of just two lines: one emerging from the center of the other at a 45-degree angle.

All fence posts are equal height and equidistant.

The building rests parallel to the ground, so the bottom of the building should be a straight line where it meets the ground.

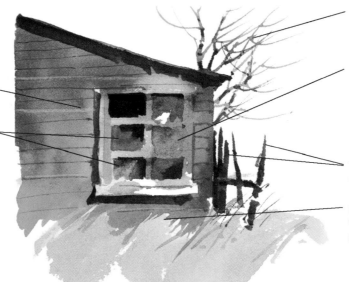

Make the wall varied in color.

Make every pane different to avoid boredom.

Vary the position and angles of the branches, to create rhythm.

Carry the color of the wall over the casements, leaving just a few spots of white. This ties the window to the wall, making them better relate to one another.

Vary the height and spacing of the fence posts.

Imply the bottom of the building with a varied top edge of grasses overlapping it.

## How Your Artist's Brain Wants to Paint

Careful observation and the ability to make visual revisions are the keys to overcoming the intellectual brain—the enemy within.

Master watercolorist Edgar Whitney is reported to have said that we should become collectors of shapes and inventors of symbols. I have discussed the kind of visual symbols, based on observation, that I believe he was talking about. Now a few words about collecting shapes.

Some people collect stamps, while others collect toys, or baseball cards. I collect shapes. When my wife, Nan, and I are on trips, she has to remind me to take "memorabilia" shots. I am always looking for good shapes that will work well in paintings. It requires a conscious shift in thinking for me to take the photos that go into a photo album.

Begin your collection of shapes now. Collect them with your sketchbook and pencil, or your brush. The more you train yourself to look for interesting shapes, the more natural it becomes. You will find yourself seeing the world a little differently. Whereas before you looked for things of interest, now it won't matter what the thing is, only the shape it has. Here are a few examples of interesting shapes from my collection.

I collected these figure shapes with my paintbrush on a bustling street. Collecting moving figure shapes precludes the collecting of details. Respond to general shapes of dark and light color with deliberate brushstrokes, allowing the shapes to bleed into each other.

These wonderful overlapping shapes were collected in Clovelly, Devon, England, with pencil.

I really like the dark and light shapes formed by the light headstones and the dark tree. I balanced these with the light figure shape in the archway and a suggestion of the stained glass window shapes on the left.

# Focus on shapes to make a
## STRONGER PAINTING

WATERCOLOR DEMONSTRATION

## materials

**PAPER**

Arches 140-lb.
(300gsm) rough

**BRUSHES**

Nos. 6, 8 and 12 round

1-inch (25mm) and
2-inch (51mm) flat

**WATERCOLORS**

Cobalt Violet

Manganese Blue

Permanent Rose

Quinacridone
Burnt Orange

Quinacridone Gold

Quinacridone Sienna

**OTHER**

6B pencil

Sketchbook

Hair dryer

Paper towels

*Here is a simple subject made of large shapes. Remember, you can either approach it from an intellectual standpoint—allowing yourself to name the grass, road and so on—or you can use your artist's brain to focus your attention on the shapes, the colors within those shapes and how their edges convey essential information.*

**Reference Photo**

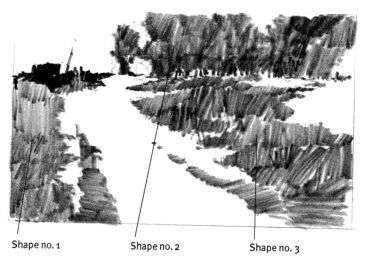

Shape no. 1    Shape no. 2    Shape no. 3

**Value Sketch**

Reduce the scene in the photo to three basic shapes. Each is interesting and needs little changing. The first shape is formed by the grasses on the left, ending with the buildings. The second shape is formed by the trees at the top of the composition, and the third shape is formed by the grasses on the right side. Draw these shapes carefully rather than drawing objects. This allows you to capture the heart of the scene— what gives it visual impact. Place the horizon line higher in the composition to avoid dividing the picture in half. This will mean shortening the height of Shape 2.

Focus attention on the edge of the shapes, not the interior.

The edge of this shape identifies the fence, building and so on.

Let the edge of the dark value define grass.

Ragged edges define the foliage.

The darker value will tie this to Shape 1.

Leave pieces of light for spaces between trees.

Extend the shape to the edge of your paper.

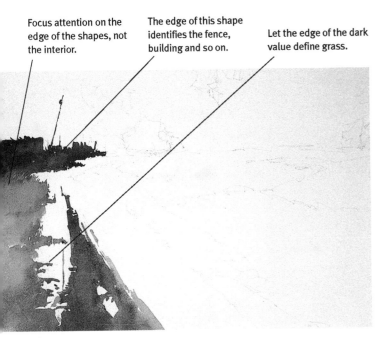

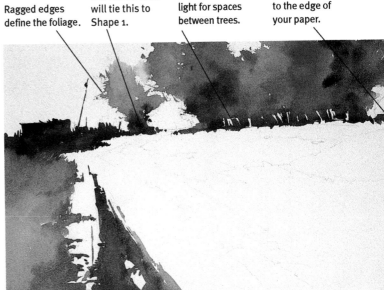

## 1 Paint the First Shape

Load a no. 12 round with a juicy mixture of Quinacridone Burnt Orange and Cobalt Violet. With the painting support tilted about 30 degrees, paint the top part of Shape 1. There should be a bead of color at the bottom of the painted area; if not, you need to use more water.

Rinse the brush and load it with Quinacridone Sienna. Begin painting along the edge of the bead, allowing the first color to run down into the new color. Continue the wash down your paper, recharging the brush with a new mixture of Quinacridone Gold and Manganese Blue.

At the bottom, carry the wash over to the dark shape of the rut in the road. Without a break in the wash, carry it on up this shape until you reach its point. You now have one single shape with varying colors. The top is geometric, revealing the silhouette of a building and fence. At the bottom edge of the darkest part, paint a few strokes of a dark shade to reveal grass.

## 2 Establish the Second Shape

Load a 1-inch (25mm) flat with Quinacridone Sienna. Hold it horizontally and drag the color with the edge of the brush to produce a ragged edge for the tree shape on the left. While that is still wet, load a no. 12 round with Quinacridone Burnt Orange and Cobalt Violet and touch this mixture into the base of the shape you just created.

With a 1-inch (25mm) flat loaded with Quinacridone Sienna, begin the larger portion of the tree shape, moving from left to right. Tilting the board to make the left side about 30 degrees higher will allow the paint to puddle in the direction you will be traveling. As you carry the bead along this shape, charge it with some Permanent Rose and Quinacridone Burnt Orange. Then add Cobalt Violet followed by Manganese Blue. Leave some light patches between tree trunks.

Once you reach the right side of the tree shape, drag the brush along its edge again to produce a ragged edge. This gives the impression of foliage without too much detail. Extend the bottom of the shape until it touches the right side of the paper. Now we have created a single interesting shape that reads as a number of trees, with places where the surrounding space moves into it. The shape also changes color from very warm on the left to cool on the right.

Quinacridone Gold adds excitement to the color near the focal point.

Merge the shapes here.

Red and violet cool the shape as it gets farther from the focal area.

The edge of the shape, not a thousand grass blades, describes the grass.

## 3 Move On to the Third Shape

This shape is not as clearly defined in the reference photo, leaving itself open to interpretation. I have chosen to draw it with smaller intrusions of white along its left side. The choice is yours, but it must be interesting.

Load a 1-inch (25mm) flat with a mixture of Quinacridone Sienna and Cobalt Violet and begin the shape at the right edge of the paper just below the tree shape. Touch just the tip edge of the brush to your paper and drag it sideways with a somewhat jerky motion to produce a stroke of varied width. About halfway along the base of Shape 2, merge the wash with the tree shapes so they connect. As you approach the left side of the shape, charge the brush with Quinacridone Gold in addition to the other mix. Carry the bead of color down to the bottom, changing the colors as you go by introducing Permanent Rose and Cobalt Violet.

Keep the interior of the shape simple. Never go back into a previous stroke; this will muddy it. Break up the edge of the shape in places with strokes indicating grass. If the edges of the shape are carefully treated, you won't need much more detail. Notice how well you can read the subject at this point even though there are no supporting details. The painting is strong because of its shapes.

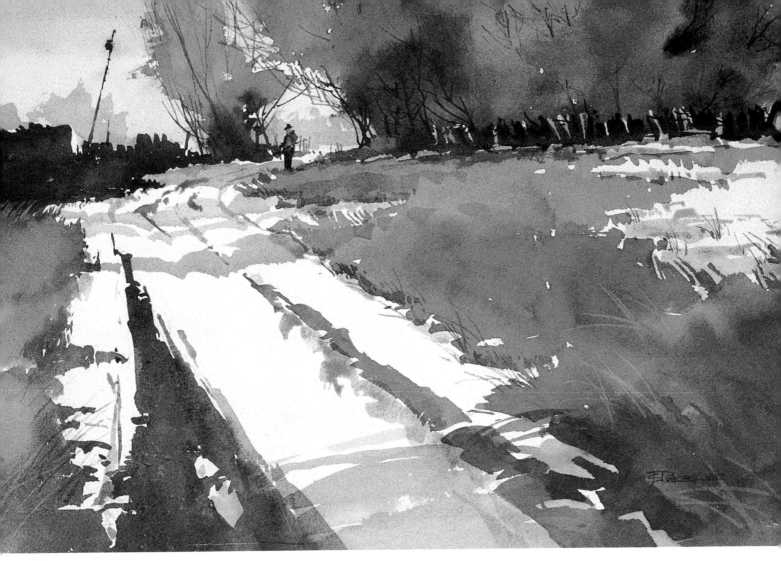

## 4 Add the Finishing Details

Think of the details as decorations on shapes—little touches that help explain the shape. Add a few calligraphic lines with a no. 6 round to describe tree branches. Add a few more in the opening where the road leads, and place a tree trunk on this side. On the right side, add a tree trunk and limbs. Along the edge of the grass shapes, add a few strokes to indicate grass.

With a no. 12 round, paint the shadows across the road using Cobalt Violet and Manganese Blue with a touch of Permanent Rose. Make sure the shadows undulate over the surface of the road, defining the road's contours. With a pointed no. 12 round, paint some shadows at the edge of the snow with Manganese Blue and Permanent Rose.

Add the background sky last. With a 2-inch (51mm) flat and a light mixture of Cobalt Violet and Quinacridone Burnt Orange, quickly paint the background directly above the trees. Dry it immediately with a hair dryer to minimize any bleeding of color. With a pointed no. 8 round and clear water, paint a few grass blades in the interior of the shapes and then lift them out with a paper towel. These details enhance the shapes but don't alter the structure of the painting.

**ALONG THE FARM ROAD** ▸ Watercolor ▸ 19" × 27" (48cm × 69cm)

POINTS TO REMEMBER ☞

- ▸ Everything you paint is a shape.
- ▸ An item may be interesting in content, but have a boring shape.
- ▸ Instead of seeing items, notice shapes—specifically shapes of light, dark, color and space.

- ▸ You can change any shape to make it more interesting; your camera cannot.
- ▸ For interesting shapes, avoid perfect, predictable symmetry and vary the quality of the edges.
- ▸ Lavish attention on creating the edge of shapes, not surface details.

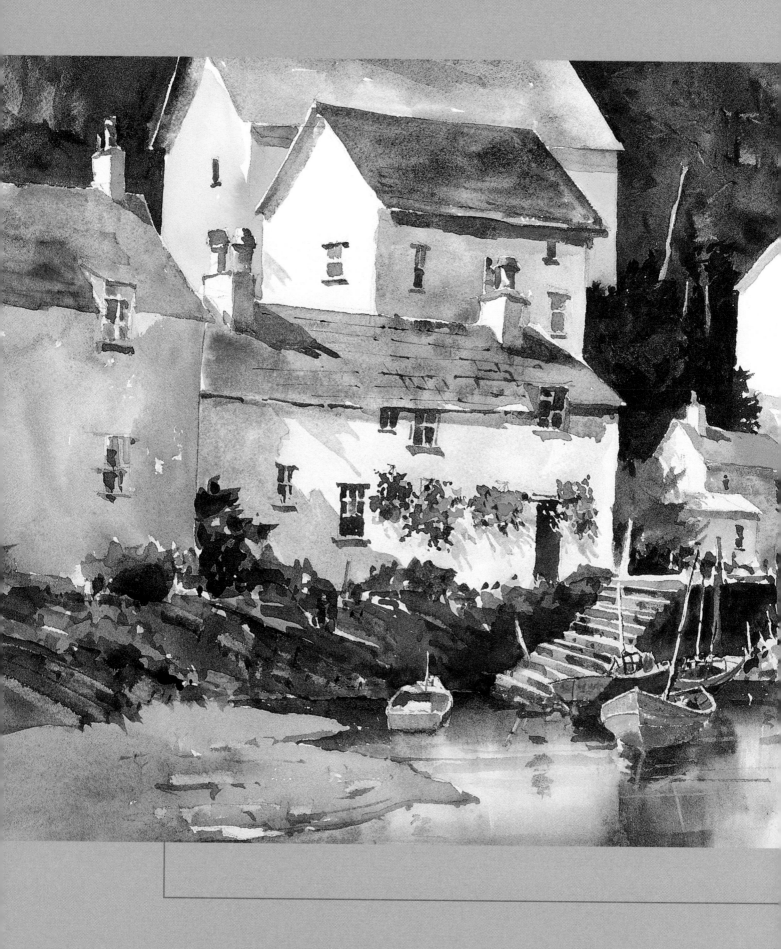

# seeing the
# SHAPE OF SPACE

Your ability to compose or design paintings is inseparably connected to your ability to see shapes. As you discovered in the drawing section, the shapes of the space around the objects you see are equally as important as the shapes of the objects themselves. These shapes are a vital part of your painting. I prefer calling them "shapes of space" rather than negative shapes, because the former is a more positive reference—nothing about them is negative! They are one of the most positive design aspects with which you can work.

Instead of "negative" painting, think of it as defining objects by painting the space around them. Your intellectual brain wants you to believe that everything needed to define any object is within or on the object. This is false. Often the most revealing detail is at the edge of a form where the surrounding space defines it.

**LOW TIDE IN POLPERRO** ▸ Watercolor ▸ 14" × 19" (36cm × 48cm)

# Designing shapes of space

If we think of the space around an item as a space shape, it doesn't matter what it is specifically. Therefore, I consciously try to design the shape of the space around any object. Sometimes it is part of a larger object, or it may just be sky. The important aspect is to see it as a shape. Whether it receives a lot of color, texture and detail, or whether it is a simple wash, it is still one of the shapes in the painting.

Following are good reasons to make the shapes of space part of your thinking:

▸ They share an edge with a positive shape. If the edge of the space shape is interesting, then the edge of the positive item also will be interesting.

▸ These spaces are easier to see as shapes than are nameable items, because we have no preconceived ideas about how they should look. This makes them easier to change. If we change the space shape, we automatically change the item shape.

▸ Dealing with the space shape helps us avoid awkward tangents and boring shapes. A tangent occurs when a line touches another line but does not intersect it. For example, if the line from a distant hill coincides with the roof line of a building, it creates an awkward tangent because, at that point, the roof and the hill occupy the same space and one does not appear to overlap the other.

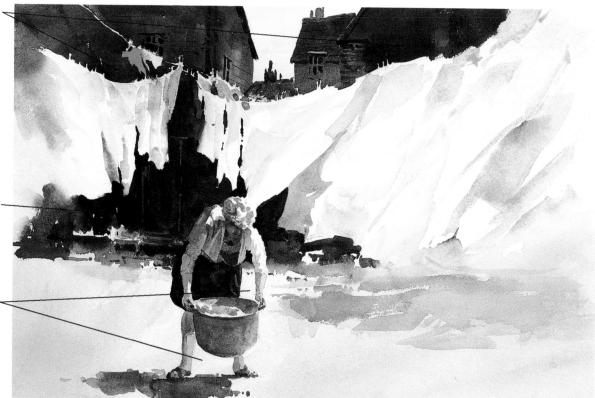

The dark of the buildings functions as a negative shape or space shape defining the clothesline.

This important shape of space defines the sheets on the line as well as the figure.

Drawing these space shapes is easier than drawing the figure. When you have drawn these spaces, you have correctly drawn the position of the arm in relation to the body, the legs and the laundry tub.

### Viewing Positive and Negative Shapes
If the sky is a negative (or space) shape and the buildings are positive shapes, then what do we call the shape of dark around the clothesline? The positive shape just became a negative shape. The sky is a light space shape, and the buildings become a shape of dark space around the clothesline.

**WASH DAY** ▸ Watercolor ▸ 14" × 19" (36cm × 48cm)

- The shape of space often defines the character of the positive items. For example, if you correctly draw the shape of space between a figure's arm and torso, you've automatically drawn the edge of the arm in relationship to the torso.

- Drawing the shape of the space around an item is often easier than drawing the item itself. It helps us avoid mistakes in drawing that are the result of the intellectual brain, which substitutes stored knowledge for visual facts. This is especially true when drawing the human figure or other subjects where perspective presents us with a foreshortened view.

## Positive Shapes Can Act as Shapes of Space

I painted this in the quaint North Devon coastal fishing village of Clovelly in England. While walking down the stone steps, I looked back and saw the light falling on them. The white shape of the building at the top captivated me. The two ladies who came home while I was painting were the icing on the cake.

The white shape of the building actually functions as a space around the dark figure. The doorway becomes a dark shape of space behind the other figure. This is an example where the positive shape of a building becomes a negative shape when a figure is painted over it. Consider the space around any object as a shape for you to design—it is as important as the shape of the object. Do you see how the light shape interacts with the darker shape?

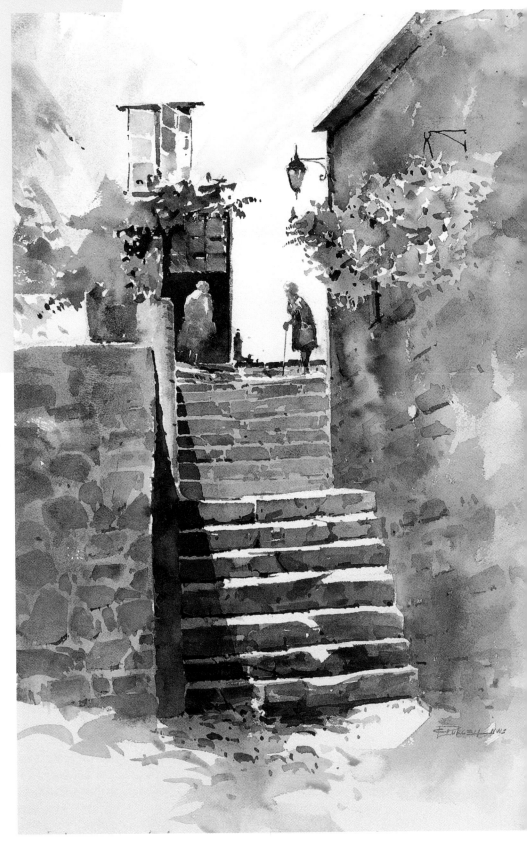

**COMING HOME IN CLOVELLY**
Watercolor
21" × 14" (53cm × 36cm)

# Make the shape of space enhance your subject

Remember how the small space is between the finger of God and the finger of Adam in Michelangelo's painting of the creation of Adam in the Sistine Chapel? That tiny space creates an enormous tension that seems to spiritually unite God and Adam. Shapes of space possess that intensity of electric energy. Negative space can either unite two items with dynamic tension between them, or it can push them apart with the same force.

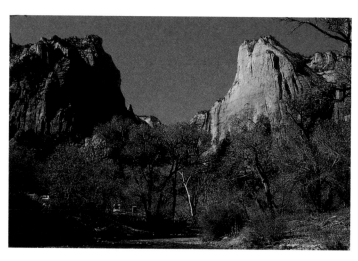

### Negative Space Repels Structures

This is one of my favorite spots to paint in beautiful Zion Canyon in southern Utah. Notice how the space between the two towering rock formations seems to push them away from each other. This is because the space shape between them is as large as the positive rock forms. The energy in the space is a force driving the two forms apart.

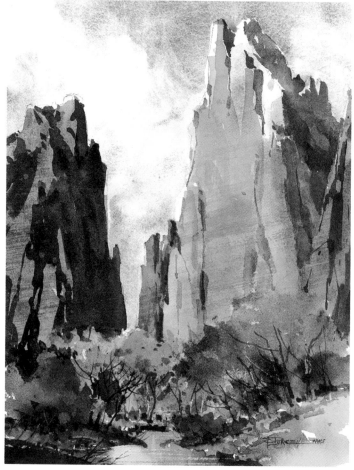

### Shrinking Negative Space Helps Subjects Work Together

I made several small changes to this subject, but the major enhancement was simply making the space shape between the rocks smaller than the peaks. Now the two are working together. The space between them becomes a dynamic one that seems to pull the two together, rather than an empty space forcing them apart. Space then is not "nothing"; it is energy and force. This is a life principle. Often the little things in a relationship that seem to have no substance can end up becoming so large that they drive two people apart. Make the space work for you by creating energy of attraction between subjects.

**ZION CANYON** ▸ Watercolor ▸ 13" × 10" (33cm × 25cm)

The background and foreground meet in an awkward tangent.

The hill creates a second shape of space between the subject and the sky.

The space shape of the sky is too far away from the subject to enhance it.

Too much surrounding space engulfs the subject.

## Reference Photo

This old mine has a very interesting shape; however, there are a few problems. There are two shapes of space behind the subject: the sky and the hill. The trees along the top of the hill create a line between them that does nothing for the subject—in fact, it takes attention away from the subject. Also, by just kissing the top of the A-frame, the hill creates an awkward tangent. The other space-shape problem here is the abundance of space around the sides and bottom of the subject. The subject ends up floating in this space instead of being defined by it. Beginning painters often encounter this problem. By not considering the shape of the surrounding space, you are forced to surgically amputate the excess parts of the painting after it's completed.

## Problems Solved

Here I have consciously considered the shape of the space around the subject. Eliminating the hill created one background space shape that now shares an edge with the subject. I also made a few adjustments to the space shape by adding a few poles to create more places where the subject's shape interacts with the space. I moved the right edge of the painting closer to the subject shape to create an interesting ending to the space shape. I added some vent pipes on the buildings to break up the line between space and subject shape. I also decreased the space at the bottom. Now the shape of the subject activates the space by touching the sides and bottom of the painting.

**HORN SILVER**
Watercolor
14" × 28" (36cm × 71cm)

Vent pipes are added to break up the line between the object (roof) and the space (sky).

Here are additional places where the object interacts with the space.

The amount of space on the right and on the bottom is decreased, allowing the subject to be dominant instead of the space.

# Combine photos to create ideal shapes

An artist's duty does not involve painting scenes just as they are. Painters aren't recorders. It is more important for you to express what you feel about your world. A camera can record exactly what is there, but only you can record your perceptions and feelings about a subject.

My best advice is to be passionate about painting and get in touch with that passion. Look at a subject and see the possibilities for a painting. If you look for the perfect composition, you will do a lot of searching and a little painting. Once you realize that you are free to rearrange and edit the material, you will smash the shackles of copying and revel in your freedom of expression.

The possibility of a painting often stems from a combination of elements in two or three photos I have taken. This new reality looks the way I wish the scene had looked. Here's how it works.

### Rough Sketch
Roughly sketch the scene to see how combining the two photos would look. This is just a quick thumbnail to "try on" the composition; if it doesn't work, do another. Even in this rough draft we can see the dynamic potential of the scene without that bothersome continuous line. The combined references make a good composition with interesting shapes, so let's take it one step further.

### Reference Photos
Here is a photo of a wonderful rock formation, and another that focuses on a juniper tree in the same desert scene. This scene has some very good points and one very big problem. Notice that in the first photo, the line that divides the space shape of the sky from the shape of the rocks is almost perfectly straight. The line is broken only once by the tree form.

Now imagine the sky shape coming around the main rock form. What would that do to the rocks? Let's see.

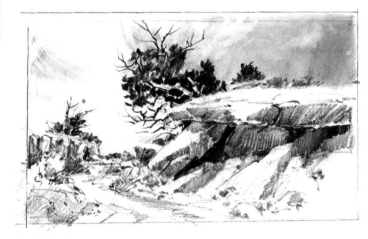

### Final Sketch
Let's plan the composition some more. Borrow a better tree from the second photo because it has a more irregular configuration and interacts with the surrounding space. Now do another more complete drawing. Everything should help draw your eye to the point where the rock meets the tree, the focal point of the painting. With this plan, the painting has a much better chance of success.

This shape of space is now dynamic because it pushes down into the composition.

The shape of the tree has been changed to avoid a perfectly round shape.

Mingled washes of cool Manganese Blue with Permanent Rose and Quinacridone Sienna add variety of color.

This rock pushes up into the space, creating more interaction between the subject and space.

The light and dark patterns in the wash pick us up and lead us back to the focal point.

These bushes provide a repeat of the blue-greens found in the sky and the main tree.

The dark shape of space defines the lighter rocks.

## Finished Painting

I have always felt drawn to these trees that seem to defy all odds and grow where nothing else could. To me they are symbols of the tenacity and power of life. The changes made to the composition support this theme.

**TRIUMPH OF LIFE** ► Watercolor ► 10" × 13" (25cm × 33cm)

# Define light subject shapes with
## DARKER SHAPES OF SPACE

## materials

**PAPER**

Arches 140-lb.
(300gsm) rough

**BRUSHES**

Nos. 6 and 12 round

1-inch (25mm) flat

**WATERCOLORS**

Manganese Blue

Quinacridone
Burnt Orange

Quinacridone Gold

Quinacridone Sienna

Sap Green

Ultramarine Blue

**OTHER**

6B pencil

Sketchbook

Paper towels

*In this demonstration focusing on leaves, you must fight the urge to give into your intellectual brain, which will want to repeat the same leaf shape over and over again. Instead, we will use the dark shapes of space around the leaves to really define them.*

These dark shapes give information about the leaves' edges.

Each of these little dark spaces defines the edges of three different forms: two leaves and a stem by one, and three leaves by the other.

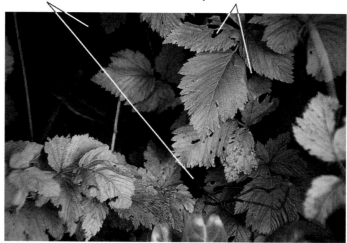

**Reference Photo**

**WATERCOLOR DEMONSTRATION**

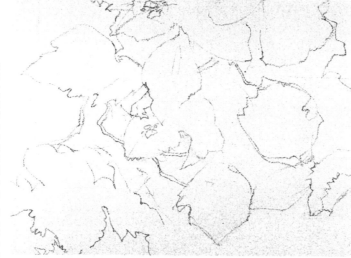

### 1 Draw Some of the Leaf Shapes and Space Shapes

Don't attempt an exact replica of these leaves or you will be bored silly. Instead, draw some of the leaves and spaces on the paper so you'll know where you are headed. Then study the characteristics of the light and dark shapes. In this case, the light shapes consist of leaves and patches of light falling on them. The dark shapes are the background space and the darker leaves.

## 2 Establish Overall Color and Shape With First Wash

Lay down a unifying wash to establish the mood and general color. Our painting will be sunnier than the reference photo. Begin in the upper left with Sap Green and Manganese Blue using a 1-inch (25mm) flat. Leave areas of sparkling light as you progress. Add Quin-acridone Sienna and Quinacridone Gold to the mix as you near the center.

## 3 Define Larger Shapes and Patterns

Don't try to control this stage by painting individual leaves. Fear of losing an edge or losing control will make you choke up and do a colored drawing. Instead, carve around light shapes with the darker values. Using a no. 12 round, apply the same colors from the previous step, but with a little less water and a little more pigment.

Leave light patches, not whole leaves. Define the edge of a leaf with a cast shadow. Define edges, but never an entire leaf. That is not how we see them. Define parts and leave places for one leaf to merge with another. Add just a little Quinacridone Burnt Orange to the area just below and to the left of the center of the painting, which will be our focal point.

### 4 Bring the Scene Into Focus

This could be the final stage, depending on how detailed you want the painting. The idea is not to count leaves, but to create the impression of layers of leaves and convey the feeling of growth. If you tell the viewer everything, you dominate the conversation and the possibility of communication is lost.

Still using the no. 12 round, darken the background space and define a few leaves in the process. A very dark green can be made with Sap Green, Quinacridone Burnt Orange and a bit of Ultramarine Blue. Go into the focal point area to define a few edges and leave a few bits of vine. Some of these are nothing but quick brushstrokes based on the kinds of dark shapes that exist in the reference photo. Keep the contrast to a minimum in the outlying areas; don't draw your viewer's eye to the edges of your composition because it may leave the painting.

A simple area shape such as this makes sense out of this somewhat abstract mass of leaves. These shapes of space magically make the leaves pop out.

## 5 Add Final Details

This final stage brings enough areas into focus to convince the viewers that they are seeing more than they think. The shapes are the key—if they are right, less detail is needed. Even when looking at the real subject, we see fewer entire leaves than we think. With the right context and a few details, the viewer will fill in the rest.

With a mixture of Ultramarine Blue, Quinacridone Burnt Orange and very little water, begin to further define some of the leaves and stems in the focal area. You will end up eliminating some of the leaves already created. Don't approach this with the feeling that anything you previously did is sacred. At this point, watch the painting, not the photo. The photo will only confuse you because it is not the same.

Create some soft edges here and there. Place single strokes and watch details appear. Add a few suggestions of veins in some of the leaves by painting them with clean water and a no. 6 round, then wiping with a paper towel. Paint some others with a slightly darker version of the leaf color. Your intellectual brain wants you to make these much darker than they should be; don't do it. My rule for surface detail is to make the details just a little darker than the surface they are on.

Notice that many of the shapes left for leaves are not typical leaf shapes. But look at the reference photo again and see how many shapes are not exactly leaf shapes. Base your painting on observation, not intellectual symbols.

**LEAF STUDY** ▸ Watercolor ▸ 14" × 21" (36cm × 53cm)

# Adjust subject and space shapes
## FOR A STRONGER COMPOSITION

### materials

**PAPER**
Arches 140-lb.
(300gsm) rough

**BRUSHES**
Nos. 6 and 12 round
1-inch (25mm) flat

**WATERCOLORS**
Cadmium Red Light
Carbazole Violet
Manganese Blue
Quinacridone
Burnt Orange
Quinacridone Gold
Quinacridone Rose
Quinacridone Sienna
Sap Green
Ultramarine Blue

**OTHER**
6B pencil
Sketchbook
Paper towels
Palette knife
Spray bottle

WATERCOLOR DEMONSTRATION

*When I recall this scene, I remember the sound of the stream gurgling along at the foot of these towering pines, the scent of fresh pine in the air and the warm sun on my face. This is what I wanted to convey in my painting. To capture the excitement of the moment, we'll have to make some changes to the scene my camera recorded.*

This space shape is basically a large triangle with a varied bottom edge. It will be a key to vitalizing the composition.

This edge between the object shape (trees) and space shape (sky) weakens this composition the most because it lacks enough interaction with the sky shape to make it more exciting.

The background mountain shape has a top edge which nearly continues the edge of the large tree mass. It needs a different angle.

This tree is well placed because it stops the downward movement of the diagonal line between the sky and the large mass of trees before it reaches the edge. However, it is a boring triangle shape that needs adjustment.

The middle-ground shape is interesting and provides a nice light area at the base of the dark.

The wonderful shape of the stream brings you back slowly through a series of turns to point where the large tree mass shape ends. This is a focal point.

This large, simple foreground shape works well. If we keep it somewhat darker, it will help establish the ground plane.

**Reference Photo**
Let's analyze the shapes of this scene. We'll want to keep the number of shapes down to fewer than ten; too many shapes will confuse the viewer, and probably you, too, as you're painting. You won't remember which one was the focus of the painting.

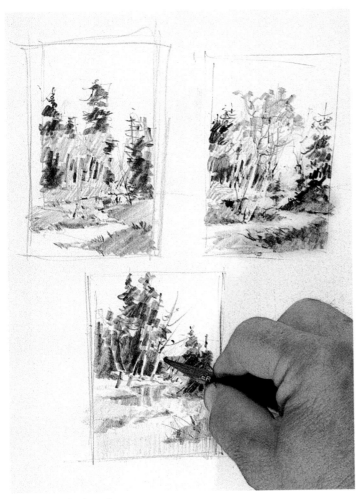

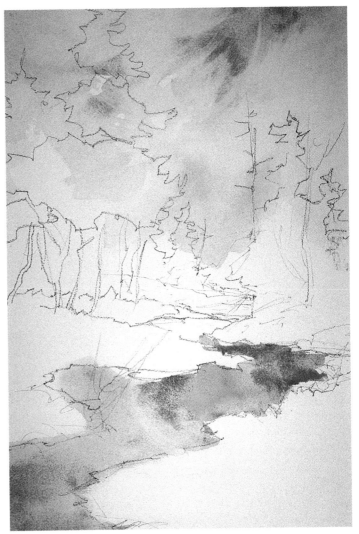

## Thumbnail Sketch

Try several thumbnails to determine the best arrangement of the masses, and develop some different solutions to the problem of the boring edge between the tree and sky shapes. Notice how I am holding the pencil flat rather than in the normal writing position. This helps me lay in broad shapes of value and keeps me from getting bogged down in picky details. A tight grip on the pencil causes your brain to shift to a consideration of tighter, smaller items.

I liked the top left drawing best; it was the most interesting, having a good breakup of space and a range of values.

## 1 Make a Drawing and Lay In the Foundation Colors

Transfer your plan to the stretched watercolor paper. Sketch a contour line drawing with a 6B pencil to identify the main shapes. Notice that I have drawn the pine trees as groups of shapes.

Begin painting, working from light to dark. Since the tree forms will be dark, paint the sky first. With your flat brush, quickly lay in a loose pattern for the sky with Manganese Blue and Quinacridone Sienna. Use Quinacridone Sienna with a lot of water to warm up the cloud areas, which should reflect the warmth of the earth. While this is still wet, use a clean, damp brush—one that has been rinsed out and then squeezed between paper towels—to lift out some light edges for the clouds. You want a mixture of soft and hard edges.

With the same colors, paint the stream, which should reflect the scenery. Bringing these colors down into the foreground will also help unite the painting.

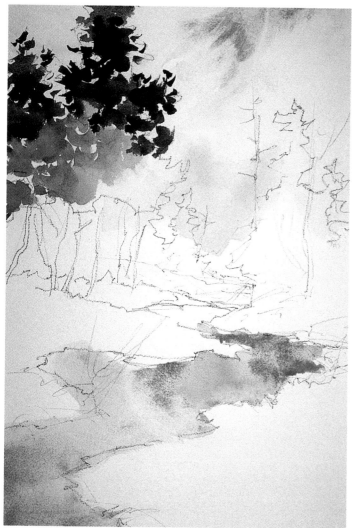

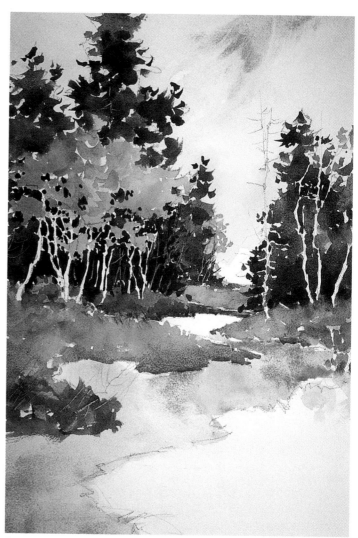

## Begin the First Mass

Create the group of trees on the left using a no. 12 round and a mixture of Sap Green and Manganese Blue. Add a little Quinacridone Sienna here and there to warm it up. Paint around the white tree trunks. While it is still wet, drop in the autumn colors with Cadmium Red Light, Quinacridone Gold and Quinacridone Sienna. Notice the suggestion of detail is at the edge of the foliage shapes, not within the interior.

## Continue the Background Tree Shapes and Begin the Middle Ground

Continue painting the major mass down the left side with your no. 12 round, changing color as you go. The middle ground is a mixture of Quinacridone Gold, Quinacridone Rose and then Manganese Blue. Use plenty of water and pigment so you can move the bead of color around. Mingled washes provide wonderful color transitions. Before the wash dries, push some of the paint around with the edge of a palette knife to add a little texture.

Begin the tree mass on the right, adding some variety with a little Quinacridone Gold and Carbazole Violet and leaving bits of white paper showing to add sparkle. While the dark color at the base of the mass is still wet, paint the lighter green ground with some Sap Green and Manganese Blue. The soft edge will provide a better transition between the horizontal ground and the vertical trees. Remember, change color every time you re-charge your brush. Once again, the palette knife can add a little forest texture to the wash.

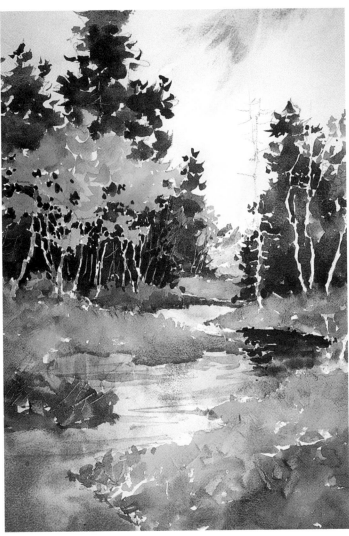

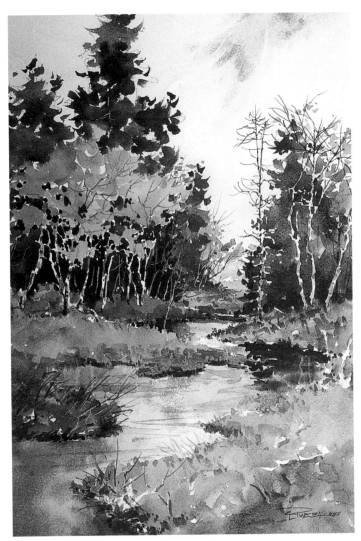

## 4 Head for the Foreground

Bring the wash on down into the foreground beginning with some Quinacridone Sienna, then adding Manganese Blue and Quinacridone Gold. Along the left where it meets the water, switch back to Quinacridone Sienna. Keep the lower right less vibrant. You can dull the Sap Green and Manganese Blue mixture with a touch of Quinacridone Sienna. We don't want attention in the corner.

Now add a suggestion of distant mountains in the gap between the two major tree masses with a mixture of Manganese Blue and Quinacridone Rose. Wet the stream with clean water and a 1-inch (25mm) flat, and, with a no. 12 round, drop in the reflections from the dark trees and the autumn foliage. Add a little Manganese Blue in the middle as it reflects the sky, and darken the foreground water with Ultramarine Blue. Add a few horizontal strokes. Remember that the reflections are vertical, but the water is horizontal; you need both.

## 5 Add Final Details

Details are meant to explain shapes. You don't need too many. Add a little dark at the edge of the ground on the left where it meets the water. With a no. 6 round and a mixture of Manganese Blue and Quinacridone Rose, add some shadows across the white trunks. If you wish to scrape out lines and texture with a palette knife but the wash is already dry, simply re-wet it with a spray bottle and scrape in the texture. Use your no. 6 round and a mixture of Carbazole Violet and Quinacridone Burnt Orange to add the calligraphy for the dead pine and other branches.

**SPLASH OF AUTUMN** ► Watercolor ► 13" × 21" (33cm × 53cm)

## POINTS TO REMEMBER ☞

- The space around an object is also a shape, usually referred to as a "negative shape."

- The shape of space often defines objects.

- The shape of the space around objects is often easier to design than the objects themselves. An interesting shape of space guarantees an interesting shape for the positive objects.

- The space around an object is often another object.

- If you can't see the shape of the space around your subject, you probably have too much space.

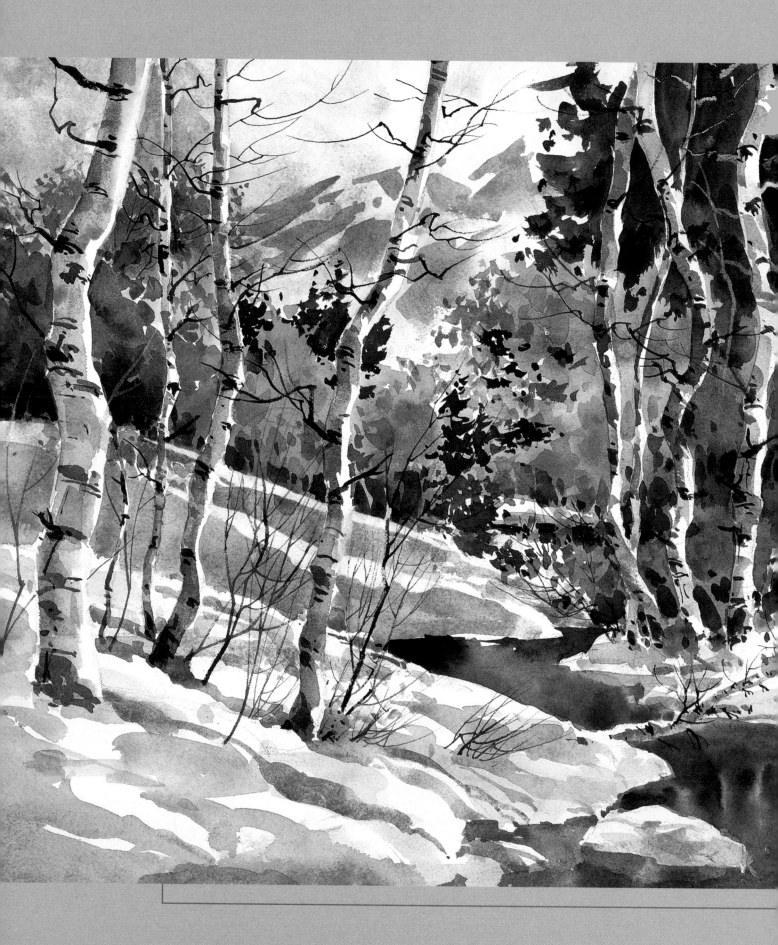

# *seeing* SHAPES OF VALUE

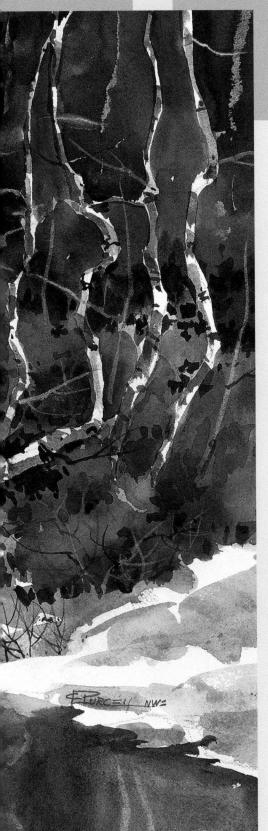

In training yourself to see the four categories of shapes listed on page 130, the most powerful tool you can cultivate is the ability to simplify your subject into shapes of value. Doing this turns hundreds of items into a few simple shapes for painting. Just as squinting helps you with drawing, it will help you in painting. This may cause wrinkles at the corner of your eyes, but it eliminates detail and allows you to see big shapes of dark value more easily.

You read shapes by seeing differences in value—a critical art skill. At first your intellectual desire to separate all the items might interfere, but you will overcome this by persistently using your artist's brain. You are deprogramming your brain from what you learned as a child. Remember the coloring books you enjoyed when you were young? Each item was clearly outlined in black and you were encouraged not to go over the line. Now you have to unlearn all of that training to see shapes of value.

**EARLY WINTER** ▶ Watercolor ▶ 32" × 40" (81cm × 102cm) ▶ Private collection

# See dark shapes

Every time we approach a subject we are faced with the same dilemma: The intellectual brain wants us to see it as a collection of nameable items, while the artist's brain wants to see it as a group of shapes.

Squint your eyes while looking at these photos to move past the details and see the larger dark shapes. It may be helpful to view the page upside down. This further separates you from the pictorial context and allows you to focus on the shapes.

Several trees compose these dark shapes.

We see the shadows as one dark shape.

The dark value unites both buildings into one shape.

The figures, wagon wheels and shadow all form one shape. A single value can pull multiple different items into one strong shape. Separating each item as you paint will destroy this large shape.

Once you can see the dark shapes, you can use your artist's brain to determine what a shape needs to make it more interesting in your composition. These changes usually involve:

▸ Adding places where the shape interacts with its surrounding space shape.

▸ Varying the width to avoid same-width dullness.

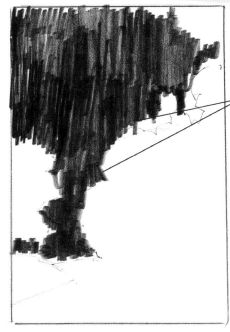

This edge has a boring, predictable curve. There is very little excitement along the edge to integrate it with the surrounding space.

## Draw the Shape and Identify Any Problems

Now draw the dark shape. When you do, you should notice one very big problem with it.

## Stare to Avoid Details

Stare at the dark shape in this photo until the detail disappears and you see it only as a shape.

Push a light tree shape up into the dark shape to change its configuration.

Vary width of negative space by narrowing it considerably here, then spreading it out at the base.

## Modify the Boring Dark Shape

Varying the width of the predictable curve and creating interaction with the surrounding space shape enhances the composition.

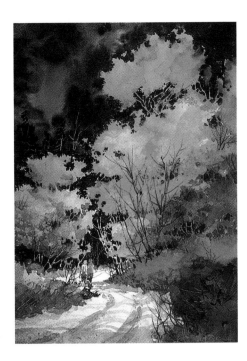

## Finished Painting

Most people who see this painting comment on the color, but it is really the dark shape carving out the light shape that gives it visual impact. Without changing the shape, you would only have a colorful boring shape.

**AUTUMN WALK** ▸ Watercolor ▸ 21" × 14" (53cm × 36cm)

# See multiple shapes as one shape of similar value

Simplify numerous items by uniting them into one shape of similar value.

## Reference Photo

If the intellectual brain were in charge of painting this group of people, you would outline each figure and color them in, clearly distinguishing each person. But that is not the way you see. Look at this group. Your artist's brain actually sees only a few shapes of light and dark.

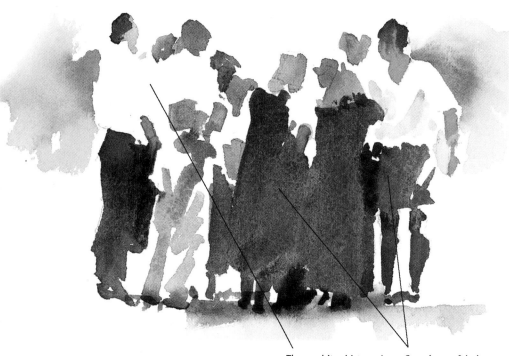

These white shirts and the lights of the pants blend together into one white shape.

One shape of dark encompasses at least three dresses, a pair of shorts and legs.

## A Watercolor Sketch of Lights and Darks

This is not just a clever way to paint the group; it's a painting of the actual pattern of lights and darks that entered our brain as we saw the scene. Our eyes fill in the detail we don't see. If you get these larger value shapes right, the viewer will fill in the detail.

## Practice Many Watercolor Sketches

Paint some single figures and groups of figures. Eliminate the boundaries between items and concentrate on keeping the similar values flowing together into one shape.

## Reference Photo

If we started naming all the things in this photo—signs, people, buildings, and so on—we would soon get discouraged by the complexity. Instead, squint to see the larger shapes of value. These shapes are easier to draw and paint, and they are more visually accurate than the intellectual brain's version of the items would be.

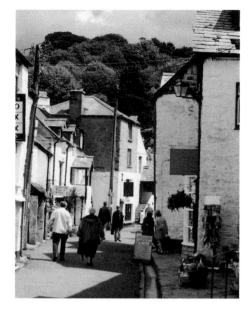

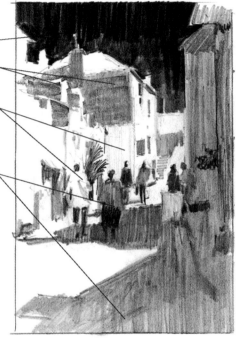

Dark shape of space

Middle-dark shape of connected shadows

Large shape of connected lights

Large shape of merged middle-darks

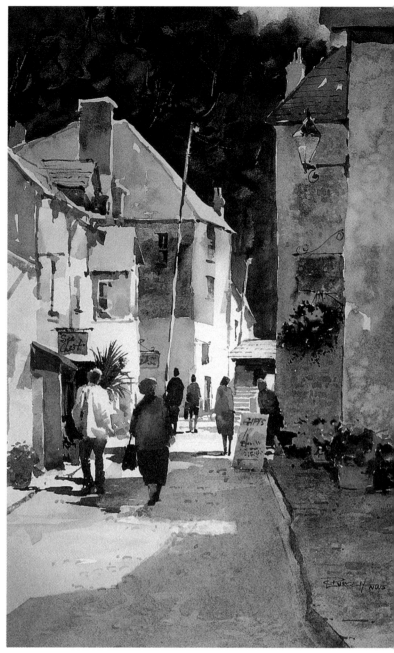

## Find Big Shapes of Similar Value

If we look for the large shapes of value, we discover there are only a few. The area on the right along with the figures and the shadow on the ground become part of one huge shape of middle-dark value. The dark figures merge with the larger shape when we squint.

## Finished Painting

Exercising the practice of seeing large, simple value shapes helped me to switch into shape mode for this painting. Notice the considerable range of color within the value shape. However, when you squint you will find the value of the shape does not change. This preserves the integrity of the shape. It is the value that builds a shape, not the color.

**SHOPPING IN POLPERRO** ▸ Watercolor ▸ 21" × 14" (53cm × 36cm)

# Use shapes of light to create visual paths and bridges

Artist Gerald Brommer correctly observed that, "The eye moves most easily along pathways of similar value." If you have to jump from one place to another, you will naturally stop first and plan your jump. Your eye will do the same. If no bridge is provided, it will stop, then jump. Keep the viewer's eye moving until it gets to the center of interest.

Shapes of light have the same ability as dark shapes to connect areas of your composition and provide a visual path for the viewer. Provide a bridge from one shape of light to the next to create whole shapes of light value. And remember this: A good light shape without a dark shape to go with it is no more effective than a flashlight at noon in the Sahara.

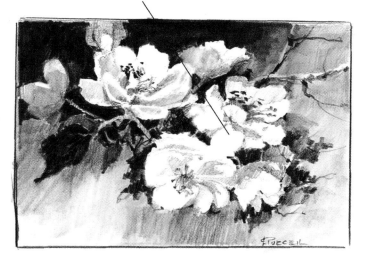

A well-placed blossom connects the upper and lower flowers, creating one large interesting shape out of all the blossoms. This light shape can now play opposite the large dark shape moving down from the top.

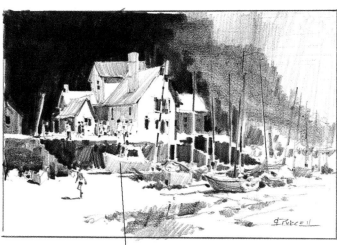

This white boat provides a bridge from the white sand shape to the white building. We now have one big shape that provides a pathway for the viewer.

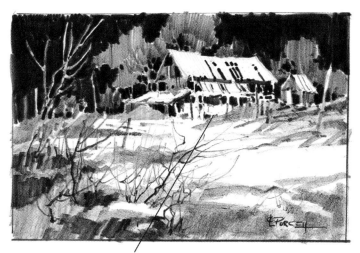

This vague white shape provides a bridge from the white foreground shape to the white of the barn roof. It doesn't have to be a specific thing, just light in value.

In the reference photo for this scene, the entire barn appeared in shadow. The light on the barn added in this sketch provides a good center of interest.

## Reference Photo

In this case, there is too much of the light value and it is divided into two separate shapes. The light shapes should be interesting and lead the viewer's eye to the center of interest.

This point of the light shape heads off to its own destination. It needs redesigning to lead to the center of interest.

This part of the light shape leads into the center of interest, which aids the composition.

This light shape is boring and cut off from the others. It leads into the corner instead of to the center of interest.

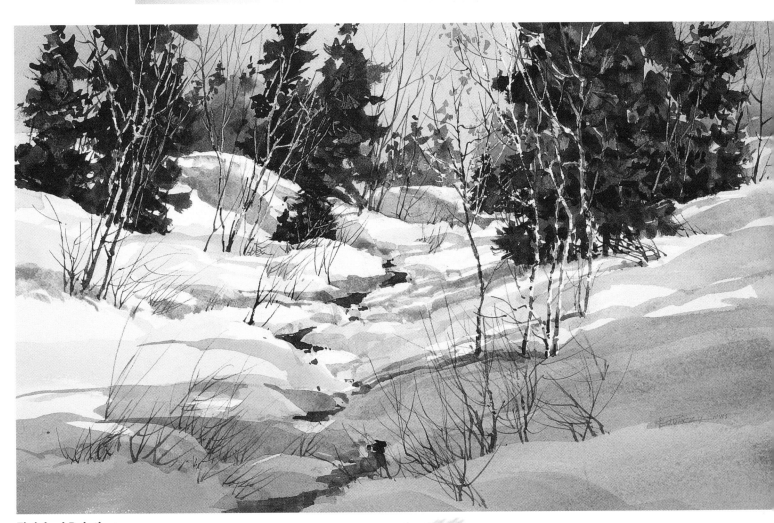

## Finished Painting

The large tree shape was broken up among the light shapes to enhance their interest and lead the viewer's eye into the center of interest. I expanded some darker values to the ends of the format to diversify the foreground light shapes. The stream also breaks up the foreground and provides a bridge to the center of interest.

**SHADOW PATTERNS** ▸ Watercolor ▸ 14" × 21" (36cm × 53cm)

### Seek Good Values, Not Great Subjects

If you look for interesting light or dark shapes instead of looking for interesting subjects, you will be on your way to creating stronger paintings.

# Develop a better
## LIGHT SHAPE

### materials

**PAPER**
Arches 140-lb.
(300gsm) rough

**BRUSHES**
Nos. 8 and 12 round
1-inch (25mm) flat

**WATERCOLORS**
Carbazole Violet
Manganese Blue
Quinacridone
Burnt Orange
Quinacridone Gold
Quinacridone Rose
Quinacridone Sienna
Sap Green
Ultramarine Blue

**OTHER**
6B pencil
Sketchbook
Palette knife
Paper towels
No. 60 grit sandpaper

*You will rarely find the perfect composition. In every subject good dark shapes are found alongside boring light shapes, great linear motifs are mixed in with lines leading out of the picture, or you will find great shapes but with the value contrast in the wrong place. It is your job to paint it ideally. Vincent van Gogh was right when he said that artists should not paint what they see, but what they feel.*

*Follow along as I make a number of changes for a better composition in this demonstration, specifically a better light shape.*

**WATERCOLOR DEMONSTRATION**

**Reference Photo**
Evaluate the strengths and weaknesses of the shapes and other motifs in this subject.

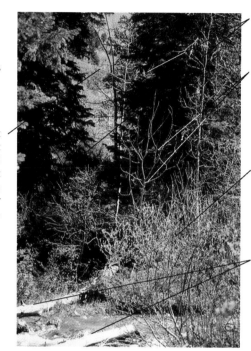

This is a great pair of dark shapes connected by a narrow bridge.

Good light linear motifs break up the dark shape.

A boring shape of lighter foliage

A well-placed light shape, but too small. It needs to be connected to the light shapes at the bottom. This shape is the key to a better composition.

Isolated light shapes—too separated from the other light shape

Carry the light shape to the bottom of the dark shapes. Narrow the light shape by having the darks nearly touch. This adds variety to the shape.

Position the foreground light (the stream) so it enters at a diagonal and then turns towards the "bridge," but not too swiftly.

**Solve Problems With a Value Sketch**
The greatest problem here is that there is no bridge between the light values. I redesigned the foreground to provide one.

These linear motifs, both dark and light, are lovely—keep them.

Make this shape more interesting.

Bridge the light shape of the sky and the light shape of foreground water.

Create a dark shape of grasses to define the light shape of the water.

## 1 Establish the Middle Values

Transfer your plan to watercolor paper, and complete this entire first step with a 1-inch (25mm) flat. Create a fluid wash of middle-value colors, letting them mingle on the paper. Start at the upper left, changing from Sap Green and Manganese Blue to Quinacridone Sienna. Change colors but not values each time you reload your brush. Paint around the lines that will become limbs on fallen logs at the bottom of this mass. Add some middle-value forest colors in the center area using Manganese Blue and Quinacridone Rose.

Begin the upper right with Carbazole Violet and gradually add Quinacridone Sienna. Bring in some Quinacridone Gold and Sap Green in the middle area. Leave plenty of sparkling whites—some will become part of the light trees. While the wash is still wet, drop in Quinacridone Sienna at the base of this mass to help establish the center of interest. Let the colors mix on the paper. End the mass with whites for log branches.

Repeat some of the same colors for the water reflections below the fallen logs. Rinse the brush and gradate out the color to white paper. Create the grasses in the lower right by loosely brushing on Sap Green and Quinacridone Sienna.

## 2 Build the Dominant Dark Mass

Begin in the upper left with a mix of Sap Green and Quinacridone Burnt Orange using a no. 12 round. The only detail necessary is at the edges of the shape. Flip the end of your brush to suggest pine needles. While this dark area is still wet, use a palette knife to scratch a few limbs and to push the paint around a bit. This will provide some lighter textures within the darks.

Continue the dark wash downward, adding some Ultramarine Blue to the green. Numerous greens exist in nature, so don't fall into the one-item-one-color mental trap. Some more scratching with the knife will enliven the wash. Rinse out the brush and soften some edges.

Begin the upper right with the Sap Green and Quinacridone Burnt Orange mixture. Leave some light branches here and there. Soften some edges for variety. Build the narrow bridge between the two dark masses. Bring some of the darks under the bushes where the sun doesn't shine. Add a dark shape to the foreground grasses, then spread it around a bit with a palette knife.

### 3 Build the Structure for the Water

A few washes will turn the remaining white shape into water. Start with the reflections by wetting the area and floating in a lighter version of the colors used for the foliage above with a no. 12 round. For the birch trunk reflections, paint a couple of vertical strokes onto the wet area with your flat brush and Quinacridone Sienna.

As you head toward the foreground, leave some white at the edge where the water cascades into the falls, because as the water goes over the edge it reflects the light from the sky, not the trees. Suggest moving water with a few splashy strokes using a no. 12 round and a mix of Ultramarine Blue and Quinacridone Sienna. Drag the brush sideways to create ragged-edged strokes. Add sparkle to the ragged strokes by spattering a small amount of the paint; just tap the brush across your finger.

166

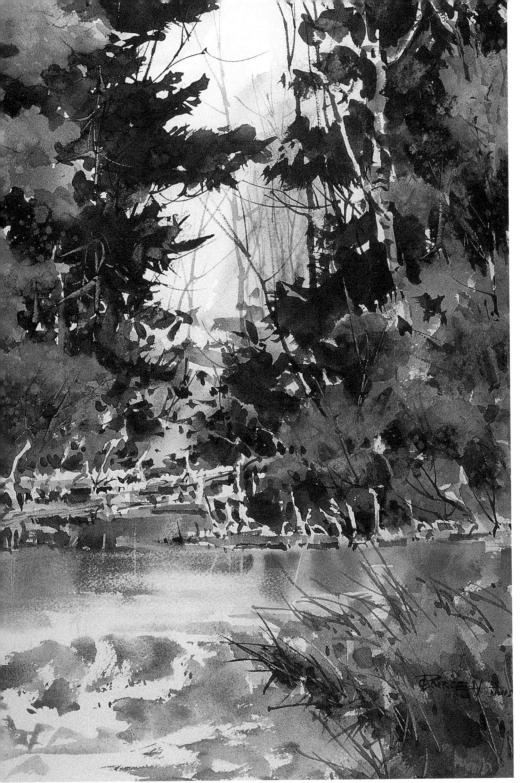

## 4 Define Some of the Objects With Detail

Completing the painting involves bringing a few things into focus. With a pointed no. 8 round and a light mixture of Carbazole Violet and Quinacridone Burnt Orange, add some calligraphic strokes to the distant trees. Darken the mix with Quinacridone Burnt Orange and add limbs for the closer trees. All of these calligraphic lines add rhythm and life to the central part of the painting while establishing depth.

Add shadow to the fallen logs, switching between Manganese Blue and Quinacridone Sienna. A piece of no. 60 grit sandpaper can add a little sparkle to the surface of the water. Wipe it horizontally across the middle part of the water where the light from the sky would be reflected. Add a few bits of dark and some cast shadows along the riverbank, but not too many. A few calligraphic strokes suggesting bushes and grass complete the painting.

**WOODLAND STREAM**
Watercolor
21" × 14" (53cm × 36cm)

## POINTS TO REMEMBER ☞

- We read shapes by value. The most powerful tool you can cultivate as an artist is the ability to simplify your subject into shapes of value.

- If you get the large shapes right, the viewer will fill in much of the details.

- For more impact, connect the light shapes into one large value shape, and do the same with the dark shapes.

- A good shape is built with value, not color.

- A good light shape needs a good dark shape by its side.

- Do a value study before painting to plan the value shapes.

- Details can only embellish the shapes that are already there. Hang your details on a strong value shape.

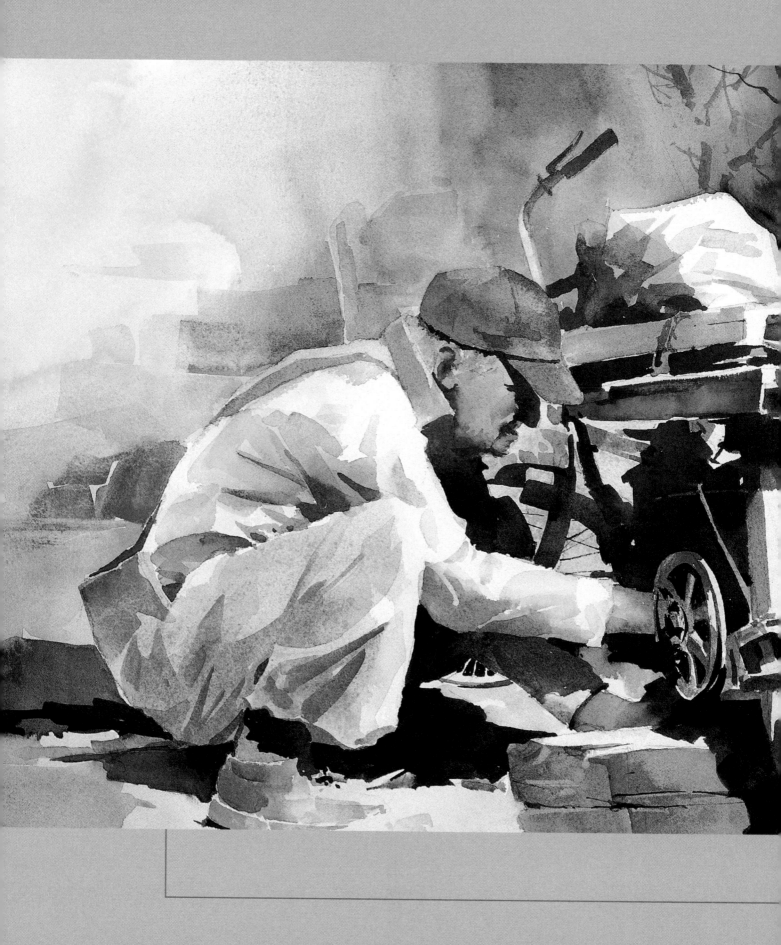

# building a painting
## on value patterns

It is common to be overwhelmed by the many shapes of value that you encounter when looking at a scene. Your intellectual brain wants to separate every single shape and tackle them one at a time. As a result, your painting may have a fragmented or "checkerboard" appearance. However, by using your artist's brain, you can avoid this trap by linking shapes of similar values into a large pattern that touches several edges of your format. This strengthens the composition of the painting. It only took me a decade to learn how powerful this concept is. Master it, and you will be surprised at how well your paintings hang together.

**REED THE TINKERER** ► Watercolor ► 14" × 21" (36cm × 53cm)

# Value patterns bring order out of chaos

Value patterns can do so much for your paintings, including:

- Connecting otherwise disparate pieces of similar value into one unified whole

- Activating the format

- Leading the viewer's eye through the composition

- Providing a structure on which to hang your detail

Nothing builds cohesive structure in a painting better than connected patterns of similar values. By bringing all the little pieces of dark value together into one large, connected pattern of dark values, and making that pattern touch several edges of the paper, you will unify and strengthen your composition. For some reason, this concept seems to be the most difficult to learn. Our intellectual brain interferes with the process, demanding that we identify all the things that make up the pattern. And once the intellectual brain takes over, our paintings are finished.

**Values Working Against Each Other**
Notice how your eye seems to bounce in this composition. Each of these pieces of dark value is demanding your attention. There is no teamwork or pattern; the movement is completely random.

**Values Working Together**
Here the same dark shapes, plus a few additions, are unified into one complete pattern. Squint your eyes to see how they are all connected. The viewer's eye is led to the center where the most contrast occurs. This is a good example of harnessing the power of value patterns.

Just as with drawing, it is important to know how to evaluate the value patterns you see and feel the freedom to make changes for a painting. Look at your subject with a critical eye to determine which shapes are working within the composition and which ones are not. Remember, do not identify the items by name. Use your artist's brain to see them as value shapes, then eliminate the shapes that don't work and enhance the ones that do.

As you create value plans like the ones shown on this page, think ahead to other possibilities or variations of the pattern. The most creative question you can ask yourself is, "What would happen if I...?" Squint your eyes to see patterns that exist and to see possibilities in your drawings that don't yet exist.

# Practice evaluating value patterns

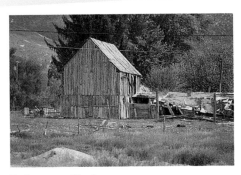

**Reference Photo**
This rural scene has some good points and, like most scenes, it also has some aspects that could cause chaos in a painting.

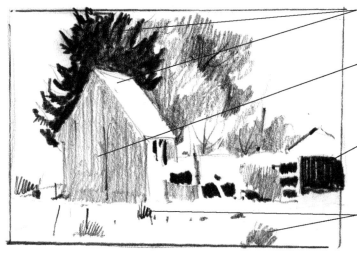

This light shape looks good next to the dark shape.

The shape of the focal point needs some enhancement.

This dark shape is too far from the focal point. It competes for attention.

This foreground shape is too boring and has isolated dark pieces in it.

**A Sketch, Not Necessarily a Plan**
This drawing of the subject has light, dark and middle values distributed exactly as they appear in the photo.

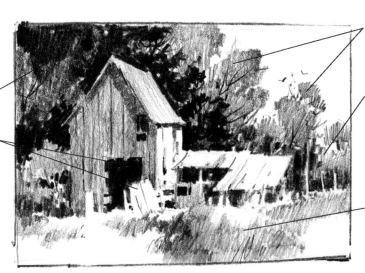

Extend the dark shape to touch the left edge.

This dark shape enhances the focal point. A light shape in front of the dark shape increases visual interest.

Design a middle-value shape to add interest to this shape of space.

Remove the original dark shape on the far right and shorten the shed shapes connected to the main subject. This keeps all the lights near the focal point.

Create a middle-dark value shape for the foreground, which leads the viewer's eye from the bottom to the focal point.

**A Value Pattern = A Painting Plan**
This is the same subject, with some modifications. It certainly looks better dressed up in a value pattern that extends to all edges of the picture. Squint your eyes to better see the patterns of dark and light.

# Simplify nature's complexity with value patterns

Using your artist's brain to think in terms of value patterns allows you to simplify the dizzying array of things you find in nature. An isolated shape of dark draws attention to itself. If you don't want it to be a center of interest, merge it with a larger pattern of darks. If you can't tie it into a pattern, then get rid of it.

### Reference Photo

Every time you evaluate shapes and patterns in a subject, you will find shapes that fit nicely into a coherent whole and those that don't. This scene has a powerful sweeping shape of dark that pulls the viewer's eye across the top part of the format to the light shape of the waterfall. Build around this. The scene also has a series of unconnected darks in the foreground rocks.

### Connect Value With an Initial Sketch

Notice how the pattern moves across the top third of the paper, then turns back across the very top. Now we need to connect it to some values in the foreground. After doing this sketch, I asked myself, "What would happen if I moved the white over to the right, so the viewer's eye travels farther before moving downward?" The answer can be found by doing another rough, five-minute value pattern sketch.

### Make Adjustments in a Second Sketch

Switching the location of the white value shifts the emphasis out of the center. Now activate the foreground by adding values to the basic shape. There are probably hundreds of different patterns that would work. Think connected darks, not "this rock and then that rock and then..."

Compare this final plan to the photo. Notice how much simpler the foreground is. Now there isn't any competition with the center of interest.

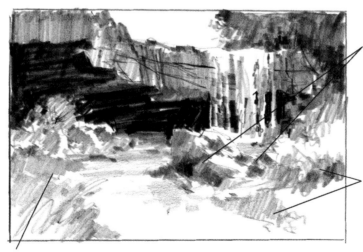

Connect these darks to the darks in the middle-ground rocks. You may have to change the shape of the rocks to make them more interesting. Have them point back up to the main dark shape.

Bring the pattern down to touch the bottom of the paper somewhere other than midway across.

Connect these values into a pattern of varied width leading down to the bottom of the paper. This leaves a pattern of lights moving up from the bottom and over to the main subject.

The color and a few lines will suggest grass. Nothing else is needed here. Keep it simple, especially in the areas farthest from your main area of focus.

Leave some lights for sparkle.

Add color to the darkest darks to prevent them from looking flat.

Scratch out these lights with a knife after the dark is dry.

For variety, change colors but not values as you move along.

Change the color but not the value as you move from dark rock forms to dark foliage. The overall value pattern is more important. Allow the two to flow together wet-into-wet.

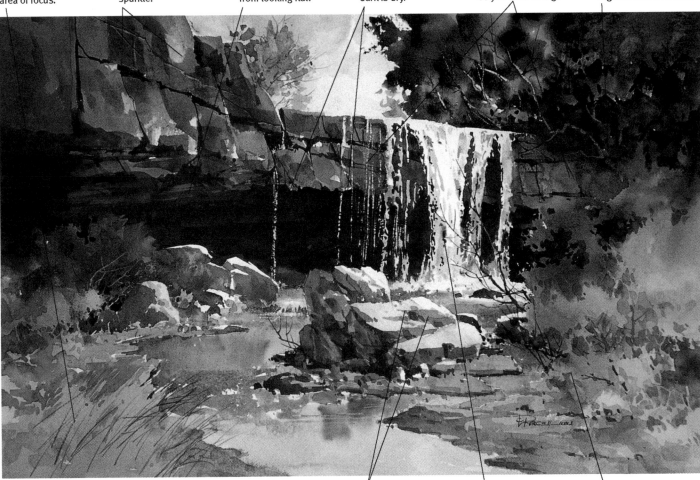

Define the planes in the rocks by value.

The water shapes are left by faithfully observing the kind of edge the dark space shapes have. Paint a light bluish wash over most of the whites after the darks have dried.

Suggest form with pattern. Don't try to define everything.

## Translating the Sketch Into a Painting

In this case, I may have gone a little too far with the finishing details. But the value plan in which the values were organized into a cohesive pattern saved me from slavishly copying the photo. Most of the time I complete a drawing on location and take a reference photo. Later when I compare the two, I always like the drawing more. I use the photo only for detail reference once I have created the basic painting.

**SERENITY FALLS** ▸ Watercolor ▸ 21" × 24" (53cm × 61cm)

# Build a value pattern
## in a painting

### materials

**PAPER**
Arches 140-lb.
(300gsm) rough

**BRUSHES**
Nos. 6, 8 and 12 round
1-inch (25mm) flat

**WATERCOLORS**
Aureolin Yellow
Carbazole Violet
Manganese Blue
Quinacridone
Burnt Orange
Quinacridone Gold
Quinacridone Rose
Quinacridone Sienna
Sap Green

**OTHER**
6B pencil
Sketchbook
Palette knife
Paper towels

*Keep in mind that the value pattern is the structure that holds a painting together and the details merely entertain. Viewers notice the entertainment, but seldom recognize the pattern holding it all together. That's OK. No one notices your skeleton either, and it holds you together, provides support for all your details and gives you mobility.*

*In this demonstration, we'll take a rather complicated outdoor scene and simplify it with a value pattern. Once this pattern is in place, we'll add just enough detail to enhance the scene without boring the viewer by spelling everything out.*

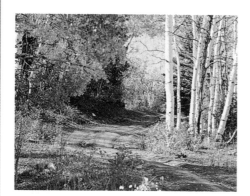

### Reference Photo
At first glance this scene may seem perfect for painting, and if you painted it just as it is, it would be passable but not strong. To make the scene stronger, we need to address two problems: (1) The darks are not quite joined into a complete pattern, which gives the composition a slightly disjointed appearance, and (2) The aspen trees on the right beg the intellectual brain to name and count them. It's afraid that you will lose them, so it wants you to get out the masking fluid and preserve each one. This literal approach separates these lights from the rest of the painting, which will make them difficult to deal with later to create a final, unified composition.

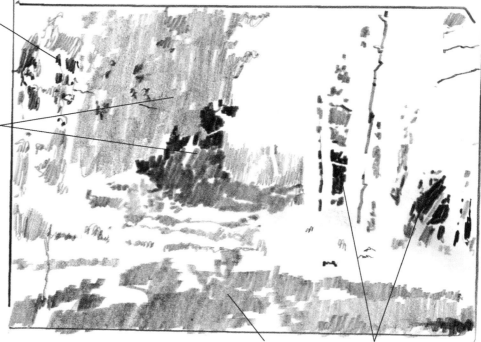

This little dark is isolated from its fellow darks.

These middle-dark and dark shapes form one nice, large shape of dark.

The middle-dark shadow unites the foreground, however, it doesn't connect with the other darks.

These dark shapes are isolated.

### Analyze the Values in the Photo
When you really look at the values and not the colors, the problem is evident. This composition suffers from value separation disorder.

## Solve Composition Problems

This version of the composition solves the problem and connects the darks. Now they form a complete pattern touching all four sides of the paper.

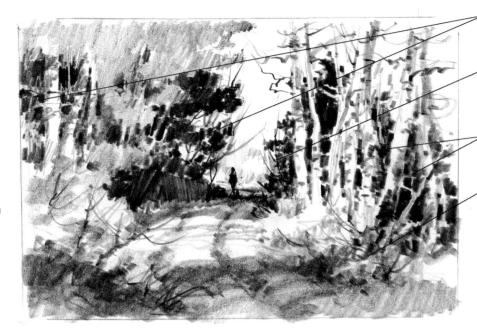

Provide a bridge between these two dark masses.

Bring this dark out from behind the trees to connect the left darks to the right darks.

Continue the darks through the trees to the right side of the paper.

Bridge the foreground darks.

## 1 Limit the Whites and Create a Mood

Using a 1-inch (25mm) flat, lay in an initial wash with Quinacridone Gold and Aureolin Yellow. This wash limits the whites, creating a warm mood. Don't try to leave every tree intact; this is not what we see. We see pieces of white on various trees. This provides sparkle and visual excitement.

Continue with a no. 12 round. Apply a light wash of Manganese Blue and Quinacridone Rose in the upper right to provide some background for the trees. Change to Quinacridone Sienna and add some foliage patterns near the base of the trees. At this point you are only painting patterns. However, I did add a dark tree limb on the left because I wanted to remember where that point was. This was the same light mix used in the upper right but done with a no. 8 round.

## 2 Construct the Foundation Pattern

At this stage you are only working in the middle-value range. Block in the general shape of the foliage in the upper left using your flat brush and Quinacridone Burnt Orange. Paint a light wash of Carbazole Violet across the far end of the road for the shadow. This links the left with the right. Continue painting with Quinacridone Sienna, leaving whites for the trees, to build a mid-value pattern at the base of the trees. Add a touch of Sap Green for variety. Paint the lower-left corner slightly darker with a wash of Manganese Blue and Quinacridone Rose.

## 3 Connect the Darks

This step provides punch, ties the painting together and gives sparkle to the whites. Using a no. 12 round, begin at the left with some Carbazole Violet and Quinacridone Burnt Orange. Paint the dark shapes of space, defining a few branches as you go. Add Sap Green as you get to the pine boughs above the road. These darks define the shapes of the lighter foliage. Switch to Quinacridone Burnt Orange for the road.

Add a little Carbazole Violet to Quinacridone Burnt Orange for a darker shadow across the road. Apply Sap Green and a little Quinacridone Sienna for the dark tree shapes behind the white. Scrape out a few limbs with a palette knife while this is still wet. Add more darks at the foot of the trees. Carry a lighter shadow across the road, varying its thickness to suggest ruts. With your flat brush, add some darks to the lower left and paint the large shadow across the road in the lower right using Manganese Blue and Quinacridone Rose.

## 4 Add Final Details

Create a mixture of Quinacridone Rose and a little Manganese Blue. Strike in the shadows along the white tree trunks using a no. 8 round. Shadows crossing the trunks and the dark marks define and complete the trunks. Add a few dark branches with a no. 6 round. Add texture to the road by spattering it with a little water, blotting it and then quickly rubbing it with a paper towel. A figure at the end of the road adds scale and a human touch to the center of interest.

A STROLL FOR THE SOUL ▸ Watercolor ▸ 14" × 21" (36cm × 53cm)

### Connect the Darks

Do you remember doing connect-the-dot puzzles as a child? Think of how the picture was revealed after you connected all the dots. Darks in a painting are like that. When they are separated from each other, they fail to show the picture. However, when they are connected, they provide a structural skeleton for the image.

# Activate the format using value patterns

One of the most common problems I see when critiquing paintings is a subject painted too small for the format. This results in a lot of uninvolved space. How many times have you resorted to the cropping method of composition? Where you finish a painting and feel as though much of the space around the subject is not needed, so you crop it. You like the painting better after cropping because the subject involves all the space in the format instead of a small area in the center.

Just think of all the time you have spent painting those areas that end up on the cutting room floor. If you plan that space from the beginning, you won't have to cut it off later. I call this concept "activating" your format.

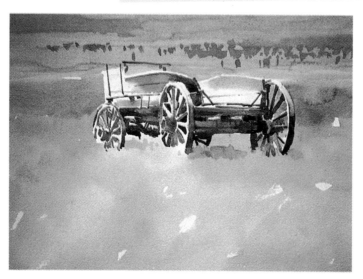

### The "Floating" Subject

Here is a typical presentation of a subject. No matter how well you paint this old wagon, if it floats in the middle of undesigned space, it will suffer from a sense of isolation and loneliness. A psychiatrist might call this separation anxiety.

All the dark values are on the wagon. None touch the edges of the picture. They will never activate the format until they get involved with at least one edge of the paper. Do whatever it takes to connect these darks to the format. Only this will prevent isolation and separation anxiety.

### A Pattern Can Pull It All Together

Use your artist's brain to envision a value pattern that touches the format, embraces the subject and defines the light shapes of the subject with values. Then create a value drawing with the subject and the envisioned pattern. Even though specific objects in this added pattern of values are not defined, you identify what they are just from their context. Remember, detail doesn't do this.

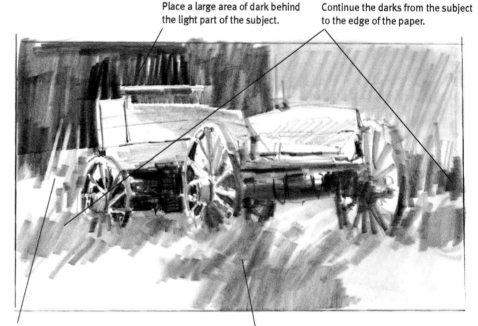

Place a large area of dark behind the light part of the subject.

Continue the darks from the subject to the edge of the paper.

Leave some lights to tie the light of the subject to the space around it.

Create a dark shape with variety in width that will connect the subject to the bottom of the paper.

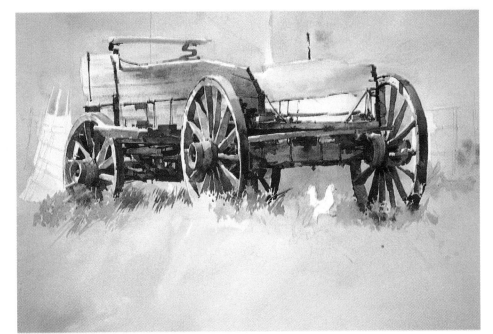

## An Improved Composition, Still in Need of Help

Even when painted larger within the format, the wagon still seems lost and disconnected—decapitated, like a portrait without the neck. It needs to reach the edges of the format.

Keep the detail well within the value range of darks. When you squint, the details should almost disappear.

Flood rich colors into the shadows and avoid flat, ugly darks.

Provide a little value contrast in the sky to define the side of the wagon. Light shapes need darker value to define them.

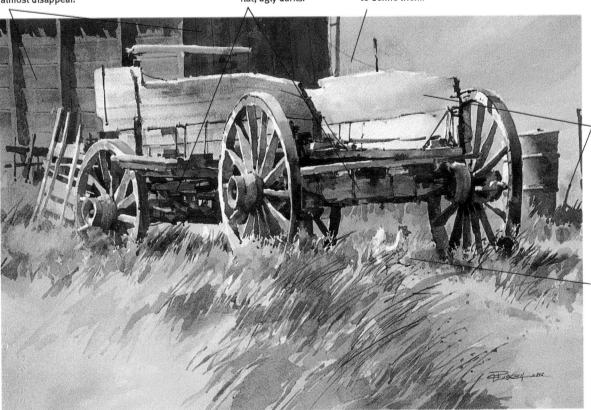

Repeat colors around the format. These spots of blue balance each other. Blue is also found in several areas on the wagon.

The chicken was an afterthought. I had some white there and the idea suggested itself.

## An Activated Format, a Better Composition

Compare this revised painting with the first one in which the subject is isolated. This is better than cropping because it has a sense of having been planned this way from the start. Squint and see how the value pattern activates the format. No isolation and loneliness here. A simple value pattern can reduce the need for detail and simplify the painting process, making the painting stronger.

**No Horse Power** ▸ Watercolor ▸ 14" × 21" (36cm × 53cm)

# Develop your sense of value pattern

Learning to work and think within a format is essential to painting. Some people start painting and keep on painting until they simply run out of canvas or paper. If they end up with a decent composition, it is sheer luck or a miracle.

The following exercises will help you develop the ability to see value patterns for painting. Your goal in these exercises is to create a pattern of darks that:

- Aesthetically divides the format by touching at least three edges
- Interacts with its surrounding space
- Has variety in width

Use pieces of white mat board or watercolor paper cut to about 6" × 8" (15cm × 20cm), a 1-inch (25mm) flat and any tube of dark color.

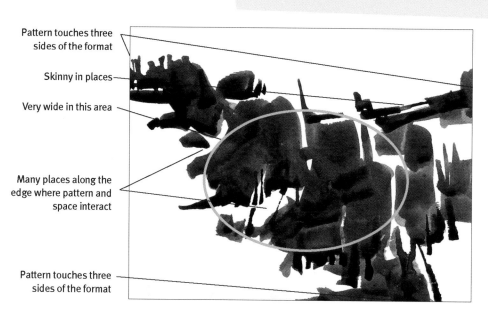

Pattern touches three sides of the format

Skinny in places

Very wide in this area

Many places along the edge where pattern and space interact

Pattern touches three sides of the format

## Paint a Pattern With Variety
Load your brush with a dark color. Keep it neutral rather than a pure bright color so you can focus on the shapes. Begin on one side of the format, but avoid the midpoint. Build a pattern by painting one stroke after another. Keep the strokes clean by resisting the urge to go over each stroke again; just touch the edge of the previous stroke. Connect the shapes until you reach the opposite edge.

Build as much variety as possible into the width of the pattern, from very thin to very wide. (A large flat brush will encourage this more than a smaller one.) After you reach the opposite side, go back to a point near the middle and continue the pattern to the top or bottom.

## Aspects to Avoid
Avoid making a boring pattern like this. Although the strokes are connected and the pattern reaches the edges of the format, notice that each stroke is nearly identical, making the resulting pattern basically the same width throughout. It also divides the format into four equal parts; the four shapes of space are almost identical.

## Play With Different Patterns
Try creating a pattern that touches most or all of one edge of the format.

## Three-Value Pattern
After you have practiced this exercise and have achieved some interesting results, try some with an intermediate value. The previous exercise used two values—dark and light. In this version start with a middle value, limiting the whites to a connected pattern. Then add a pattern of darks. The result will be dark and light patterns on a midtone background.

## Middle-Value Beginning

This three-value pattern began with a gray wash of Manganese Blue, Quinacridone Sienna and a touch of Permanent Rose. I covered the entire paper except for a T-shaped pattern of whites.

## Bring On the Darks

Next, I used a neutral dark to build a pattern that touches three sides of the format. Many of the darks were placed directly beside the whites. This produces a very dramatic pattern.

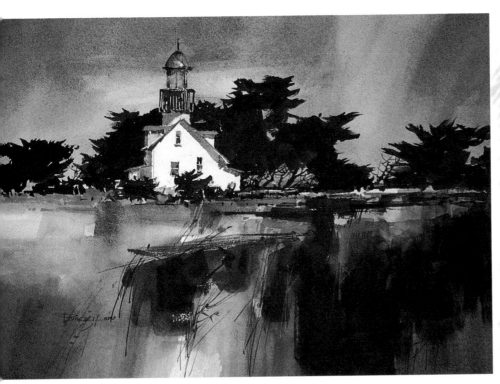

## Find Cheap Paper for Exercises

If you cut your own mats for your paintings, you will have odd pieces of mat board left over. Save them and cut them up. It doesn't matter what color they are, because the back is always white. If you have none, your local frame shop will probably save you the center cuts that are too small for them to work with.

Another option is to use the backs of old paintings that didn't quite make it. If you are like me, you have plenty lying around.

## A Value Pattern Becomes a Painting

Every now and then, one of my random value-pattern exercises begs to be turned into a serious painting. Such was the case with this one. It just seemed to suggest a landscape with its emphasis on the horizontal. The white shape near the center suggested a building. I decided to use this pattern as the basis for a painting, using a drawing I had done of Point Piños on the Monterey, California, peninsula. With just a little adaptation, it produced a dramatic painting.

During the course of these exercises, you too may produce a piece so good that you will want to make a painting of it. If you just use the small exercise as a guide and create a similar pattern, you could simply leave it as an abstract piece. Who knows, it could win a prize at your local art show.

**LIGHTHOUSE** ▸ Watercolor ▸ 14" × 21" (36cm × 53cm)

# Find interesting value patterns in your photos

I take several types of photos with my camera. Some are of interesting shapes that I might use in painting, some are of value patterns, and others are references of details. Then there are the ones my wife, Nan, reminds me to take of the children and grandchildren. All of these photos are good sources for value patterns. When taking them, I am looking at the people and other subjects, never noticing the distribution of darks or lights.

Flip through your latest collection of photos, and squint as you do. You will spot some interesting value patterns. Try looking at the photos upside down, to help you see shapes of value instead of items.

The following exercise trains your eye to see value patterns in everything; however, the results are not something you will frame and display. Follow these instructions:

1. Tape a half sheet of paper to a board and divide it into fourths with strips of 1-inch (25mm) masking tape.

2. Select a photo.

3. Paint the pattern of darks using a 1-inch (25mm) flat loaded with a neutral dark color. A smaller brush will lead you into painting little details rather than large patterns. You may find it helpful to turn the photo upside down so you do not get involved with the images of the things you recognize, only with what the pattern looks like.

4. After painting the dark pattern, use a light version of the same color and paint everything but the lightest lights.

Here are a few examples to show you what you should strive for. Remember, you are not trying to paint the picture. By practicing these types of exercises, seeing value patterns will become a natural way to think.

**Reference Photo**
Can you see the large dark pattern when you squint? It moves up the left side of the picture, crosses over, then touches the top before going to the right side. A part also connects up through the center area. This is our subject, not the child.

**Value Pattern**
Paint the dark pattern, then add the middle values while leaving the whites. Resist the temptation to paint individual features. If you start painting an eye or a hand, your thinking will shift from visual to intellectual and the enemy within will take over. Keep focused on the pattern.

**Reference Photo**

This photo consists of a large dark shape that moves into gray, then into white as it moves up the composition. See how the whites trickle down into the dark? This value interaction is interesting to the eye.

**Value Pattern**

Once again, begin with the dark, then add the middle value and leave the whites. Do it with as few strokes as possible. The interaction of white, gray and dark is pleasing to look at.

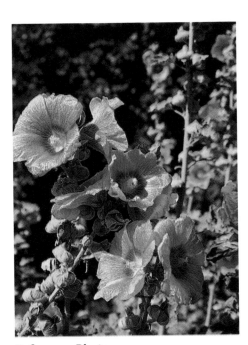

**Reference Photo**

This pattern of darks covers the entire width of the top of the picture, then it cascades downward, becoming progressively narrower until it finally touches the bottom in one spot. Seeing this kind of pattern requires serious squinting.

**Value Pattern**

As you paint this pattern, the tendency to delineate each flower and not see its value is overwhelming. Stay focused on the pattern. Squint to see what the dark value does and paint that.

# Develop found patterns

Have you ever suffered from painter's block, when even drawing doesn't seem to give you any new ideas? This next exercise in seeing value patterns is a good way to break loose with a little abstract painting. Prepare to have some fun with this one.

You will need two L-shaped pieces of mat board to use as a cropping tool, a 6B pencil and a magazine filled with pictures. Turn the magazine upside down. Scan the pages for photos that have shapes of white, a medium value and black, all within the same area. It can be just a very small part of the photo. When you see such an area, place the cropping tool around it, overlapping the L-shaped mat board pieces to form an adjustable rectangle. Adjust the tool until you find a pattern of dark values that activates the format by touching several sides of the cropping tool. Squint your eyes as you do this; it makes seeing the pattern much easier and keeps you from becoming involved with the subject of the photo.

Finding these patterns, even if you choose not to sketch or paint them, increases your conscious awareness of them and fills your subconscious with value pattern possibilities. These possibilities will surface when you need them later. Practice this exercise for a few minutes every day.

On the opposite page, see how you can take this one step further to develop a finished painting from a found pattern.

### Find Patterns in a Photo

With the cropping tool, search for an area on the photo that contains dark, medium and light values. Hold the photo upside down to focus on the patterns rather than the subject. Look at the cropped section shown above until you only see darks and lights. The dark pattern moves across the top of our format and downward, finally touching the bottom just right of center.

### Make a Value Sketch of the Found Pattern

Use a 6B pencil so you can easily achieve the full range of values. Begin with the dark pattern, and then add the medium value. Respond to what is happening in the drawing. The photo is just a jumping-off point, not the desired end. Something quite different, not found in the photo, may suggest itself to you. Be prepared to respond to it; be flexible.

When you finish you should be able to see the relationship between the drawing and the section of the photo, but it should not look like an exact duplication of the photo since you are only drawing the pattern.

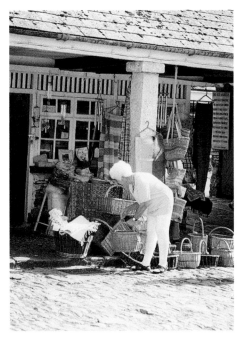

**Reference Photo**
The value pattern we discover in this photo will become a finished painting.

### Find Value Patterns
Crop to a section that has an interesting value pattern. This section has light, medium and dark values that create interesting shapes.

### Draw the Patterns
Make any changes you feel inclined to. Do not make yourself a slave to the photo. Artists are creators, not copyists. After you establish the initial patterns, look at the drawing for inspiration, not at the photo.

**Establish Color Dominance**
Put the photo away and use the drawing as your reference for the painting. Indicate the position of the lights with a pencil drawing. Lay in a varied strip of color across the top quarter of the painting using a mixture of Manganese Blue and Ultramarine Blue and a 2-inch (51mm) flat. This will be the secondary cool color.

Paint the medium values in the lower three quarters of the painting using a combination of Quinacridone Gold and Quinacridone Sienna. Leave the whites. This establishes a warm dominance for the painting.

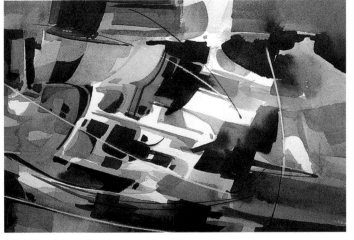

**Add Final Details**
Begin laying in the dark pattern, breaking up the middle values with darker variations of the warm colors. Create the darks with Quinacridone Burnt Orange and Carbazole Violet. Follow your instincts as much as the drawing. Let each stroke suggest the next.

Whenever I start a painting like this, I have no idea what the finished piece will look like. I have only a value pattern as a start, and an exciting journey of discovery ahead. Embrace the fear of not knowing each step ahead of time.

**PRELUDE IN ORANGE** ▸ Watercolor ▸ 10" × 14" (25cm × 36cm)

# Create value patterns through doodles

Have you ever just started scribbling some lines on a piece of paper, then absentmindedly filled in the resulting spaces with alternating dark and gray values? Of course you have. I have never talked with anyone who hasn't admitted to having done some of these doodles while chatting on the phone or enduring a boring lecture.

These doodles can be an avenue for exploring value pattern compositions. Usually, doodling is a random, undirected kind of visual playfulness. You can harness this playfulness to develop your sense of compositional design. Create pages of these doodles. They don't take very long, they're fun and they remind you to think of patterns since there is no subject matter to distract you.

You can doodle anywhere and need no special equipment. A pencil or ballpoint pen and notebook are just as effective as Conté crayon and expensive drawing paper. We all have to attend meetings or wait for appointments. These are excellent opportunities to practice your pattern-making skills. Carry a small pad of paper with you and plan to enjoy your next meeting for a change. You should be able to doodle and listen to what is going on at the same time, since these two activities use the two different hemispheres of the brain.

Remember to let the initial lines act as a guide only. These are meant to help free you from the slavery of copying. Don't let the very lines you create enslave you.

### Divide a Format With Scribbled Lines
Begin by scribbling a dividing line across a small format, about 2" x 3" (5cm x 8cm). Make it dance before it gets to the other side.

### Add a Second Line
Add another line doing roughly the same dance, but overlap the first line.

### Create Interesting Space
Add more lines; some that cross the first lines diagonally and others that build on the first direction. You now have an interesting spatial division with a dominant linear direction.

### Add Values
Add values to the shapes created by the overlapping lines. Watch the value pattern as it emerges and add to it whatever you feel is necessary. Add light gray to some of the large negative shapes. You now have a value pattern broken up with light that touches all four sides of the format.

## Variation 2
Now try this concept again, but make an entire side dark.

## Variation 1
So far you have confined the value pattern to the spaces within the lines we generated. Now try giving yourself some specific directions about the value pattern itself. Begin with a large dark area on the left and let it trickle to a narrow shape as it touches the other side.

## Variation 3
Or, make the entire top dark and gradually decrease its width as it nears the bottom.

## Variation 4
Try confining the pattern within the middle of the format, allowing it to escape just enough to touch an edge or two.

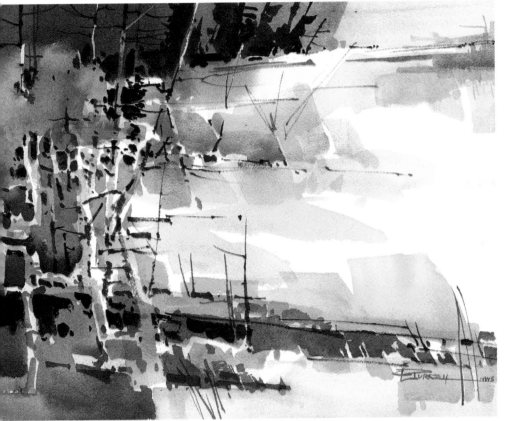

ONE CRISP AUTUMN DAY ▸ Watercolor ▸ 10" × 14" (25cm × 36cm)

## A Doodled Beginning, a Painted Ending
Can you tell that I used the first variation as the basis for this painting? Using your doodles as the basis for paintings will lead to some more daring compositions and possibly an entirely different approach to painting.

# Let value patterns direct visual movement

In the early seventeenth century, Italian artist Michelangelo Merisi da Caravaggio recognized the power of values and their ability to organize visual space. He created emotionally dynamic paintings by using an essentially dark background contrasted with patterns of light that lead the viewer through the composition.

Visual movement around the format is no accident, and must be planned by the artist. It can be accomplished through the use of line and color transitions, but the most compelling method for directing the eye is value juxtapositions. Our eyes move easily from one piece of dark to another connected dark, or from one passage of light to another closely positioned light.

These connected value patterns are your most powerful tool for leading the viewer's eye around the composition. You can use value contrast to plan where you want the viewer's eye to pause, change direction and eventually end up.

Most often your eye enters a painting at the bottom edge. Use patterns of light and dark to lead the viewer's eye from this point in a not-too-direct route to the center of interest. There are no special rules here; just don't make the route so obvious that the viewer is bored or reaches the center of interest too directly.

## Vary Value Pattern Paths

This painting has two patterns of value, one light and one dark. Each leads the viewer's eye by a different route to the center of interest: the barn. The lights move from the lower left in a zigzag route like an "S" back to the center of interest. The darks begin at the bottom center and move diagonally to the left then back to the right, encircling the center of interest.

**SNOWBOUND FARM**
Watercolor
21" × 24" (53cm × 61cm)

## Create a Circular Value Pattern

The visual idea here was a pathway of light leading to the light shape of the lake, which is encircled by a pattern of darks. The foreground darks in the grasses connect to the darks in the rocks, which in turn link up with the darks at the far side of the lake, carrying the viewer's eye across to the tree mass on the right side. This is not the way the scene really looked, but this is how I altered it to make a better painting.

**LITTLE MOLAS LAKE**
Watercolor
14" × 21" (36cm × 53cm)

Spend time planning value patterns for your paintings, and your paintings will be stronger as a result. People may praise them for the details you included, even if there is less detail than you have ever used before. Smile and thank them. Don't try to explain that it is really the value pattern that does the trick. If by chance someone does mention the value pattern, that person will likely be another artist.

The intellect notices details, but the emotional impact of a painting is carried by its value pattern. People will see it without recognizing it, respond to the pattern emotionally without noticing it. Value patterns grab viewers and pull them into the painting. Then their intellect says, "Wow! Look at those pine trees," or "He sure can paint rocks." They literally do not know what hit them. And that's fine; they don't need to. But you, as the artist making the picture, need to know.

## Use S-Shaped Values to Easily Guide the Viewer's Eye

Both the light and the dark patterns lead the viewer's eye in a serpentine or S-shaped movement to the upper central area. The reference photo I took on that cold day in the mountains contained only a couple of rocks in the snow. I grew them into a continuous ledge of rocks.

**EXPOSED LEDGES**
Watercolor
21" × 14" (53cm × 36cm)

# Grab the viewer's attention with value patterns

POINTS TO REMEMBER

▶ Value patterns are the skeletal structure of your paintings.

▶ The viewer's eye tends to move along connected shapes of similar value.

▶ Value patterns can activate the format.

▶ The ability to see value patterns can be developed through exercises.

▶ A simple value pattern reduces the need for detail.

▶ If you can't link a shape to others of similar value, get rid of it.

▶ Details entertain, but value patterns hold a painting together.

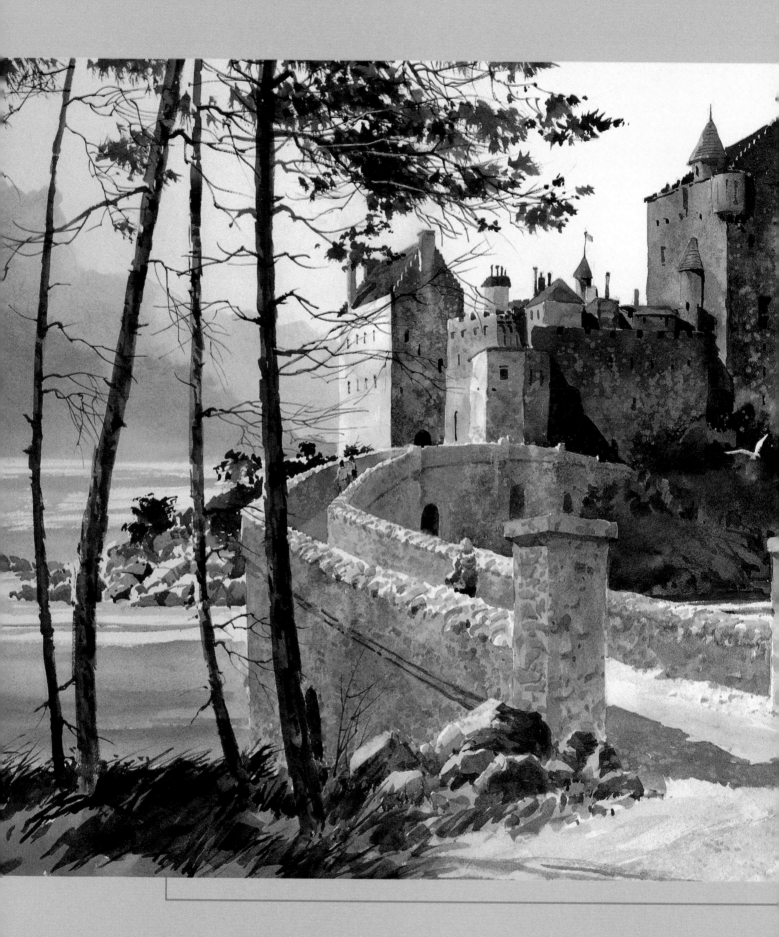

# *ensuring a strong*
# CENTER OF INTEREST

When I was a youngster, my cousins and I used to go out into the hills to play with our bows and arrows. I had a cousin who would never say beforehand what it was he was shooting at. He would wait to see what his arrow hit and then claim that was what he meant to hit. In painting, like target practice, we need to know what we are aiming at.

Ask yourself at the very beginning what you want to say in your painting. Be very specific and phrase it in visual terms. For example, the red shape; the white area surrounded by dark; the dark shape of trees where the river shape meets the base of the hill. This is a crucial step. You cannot design the painting to support the center of interest if there is no center of interest.

**EILEAN DONAN, MONARCH OF SCOTLAND** ► Watercolor ► 22" × 30" (56cm × 76cm)

# Four methods for establishing a center of interest

Some substitute the term "focal point" for "center of interest." The only objection I have to the former term is that it seems to suggest a small point when the center of interest is usually a larger area. Once you have chosen a center of interest, you must decide two things:

1. Where you will place it in the format.

2. The methods you will use to direct attention to it.

Just wanting an area to be the center of interest will not make it happen. There are several tried-and-true methods that artists use to add emphasis to a center of interest. Among these are:

▸ Value contrast

▸ Color contrast

▸ Major lines of motion

▸ Contrast of complexity

More often than not, an artist will use at least three of the four to ensure that the viewer does not miss the point. Study some of your favorite paintings to see if this is not so. In the center of interest you will usually find the darkest and the lightest values placed next to each other, the area of richest color, and the greatest concentration of small shapes.

In addition, you will find that lines of motion in the foreground lead to the center of interest. The outlying areas will be large and simple, painted in grayed or neutral colors with no strong contrast of values and little detail. What you do not include in the supporting areas is just as important as what you do include in the center of interest.

In the next few pages we will examine these methods more closely.

### Modify Subjects to Create a Center of Interest

The dark doorway in this scene caught my eye. I decided that if I pumped its interest level up a few notches, it would make a good center of interest. So, I put a light window shape within the doorway, moved the light-valued shed closer to it, and included a figure as a light shape cutting into the dark. Now you can't miss it!

**MORNING CHORES**
Watercolor
14" × 21"
(36cm × 53cm)

Blue and red on the figure bring additional color to the center of interest.

**Center of interest**
Concentration of smaller shapes and details in this area

The darkest dark surrounds the figure.

These are simple areas of little contrast and very little detail.

Lines of motion lead to the center of interest.

The lightest light is next to the darkest shape.

Of the four methods for establishing a center of interest, value contrast is the most compelling to the viewer's eye. Design your center of interest as either a light shape surrounded by dark or a dark shape surrounded by light. Plan the remaining areas as middle or midtone values. Placing the strongest value contrast in your center of interest elevates it to a position of eye-catching importance.

A light wash over this shape lessens the competition for attention.

Complementary orange brings even more attention here.

**Center of interest**

Dark shapes within the light shape accentuate the center of interest.

This white shape is surrounded by dark values.

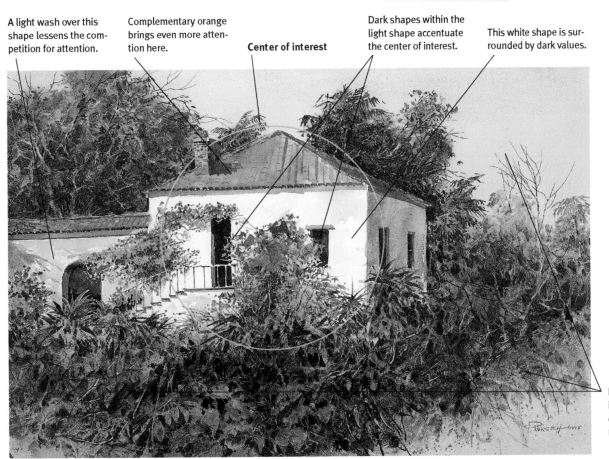

No contrast is included in these areas to avoid competing with the main attraction.

## A Light Against Dark Distinguishes the Center of Interest

The center of interest here is a light area surrounded by darker values. Limit the whites to the façade of the building and you will give greater importance to that area of the painting. The strong contrast of white against dark pulls the viewer's eye to this area. The contrasting orange only adds to it, like an extra nail in the board.

**EL MOLINO VIEJO** ▸ Watercolor and collage ▸ 14" × 21" (36cm × 53cm)

### Think Value First, Then Color

Beginning artists often think the solution to a dull painting is to simply add more vivid colors. But if your values are poorly planned, no amount of beautiful color will fix your painting. Good color is key to the success of any painting, but a well-executed value plan is what will captivate your viewers.

# Engage the viewer with color contrast

Color contrasts are abundant in nature. This is where our ideas about color harmonies originate. Nature provides us with large areas of subdued color (e.g. skies, fields and forests) juxtaposed with small areas of intense, rich color (e.g. flowers, birds and insects). Create color contrasts using all the color properties: warm against cool, intense against muted, and light against dark. Look at a color wheel and notice how complementary colors—those opposite each other—are also opposite in color temperature.

As a rule of thumb, I keep the areas farthest from the center of interest a muted color and reserve the most intense colors for the center of interest. Decide what color is going to dominate the painting, then use the opposite (or complement) in the center of interest.

The value contrast should be most noticeable here: small dark shapes against lights, and light shapes surrounded by darks.

Keep the background simple so the viewer's eye doesn't stay here but rather moves on to the center of interest.

**Center of interest**
Put the strongest colors in this area. This is the place for the complementary color contrast of red and green.

Warm colors in the upper part of the boat contrast with the cool colors in the lower part and in the water.

Connect the boats with a pattern of dark values that also joins them to the edge of the format.

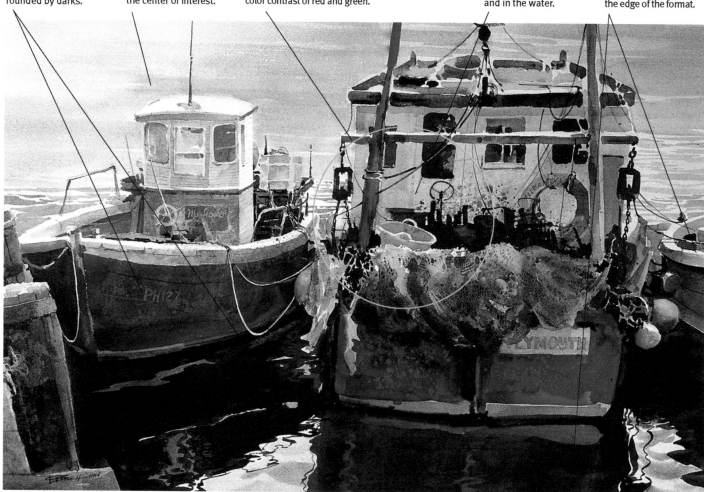

## Enhance a Painting With Color Contrast

The contrast of the red-orange bucket next to the green fishing nets drew me into this scene. The contrast of warm colors against cool colors is very appealing. This is primarily a cool painting, with blue dominating the scene. Most of the warm colors are found around the center of interest. Note the yellow storage box, the warm backlit cabin and the buoys. These provide company for the red-orange bucket, since they are all analogous in color. Color may not be able to build a solid foundation for a painting like value can, but it certainly entertains the viewer's eye.

**At Rest in Plymouth** ▸ Watercolor ▸ 22" × 28" (56cm × 71cm)

Streams, paths and roads are great tools for providing lines of motion leading the viewer's eye to the center of interest. However, use caution with these lines; don't lead the viewer's eye too directly. The shortest possible route may be fine for traveling, but it is not best in a painting.

Construct a more indirect route back to the subject by creating some bends, curves and breaks in the line. The purpose of creating lines of motion is to direct the viewer's eye around the picture plane in a way that allows for exploration, yet keeps leading back to the center of interest. An undeviating movement traps you, and no one likes the feeling of being trapped.

Shapes of shadows, cloud patterns, skylines of distant hills and a myriad of other things with a dominant directional thrust can create lines of motion. Just make sure they are pointing in the direction you want the viewer's eye to go. Choose things to include in your painting based on how they can serve the center of interest. Don't include objects just because they are there. Think of them as actors auditioning for parts in your play. Your job is to create a great production, not provide work for every starving actor. Only use those things necessary for the composition. Send the rest packing.

These bushes were actually growing straight up, but I directed their movement toward the center of interest.

Point the sky toward the center of interest.

A transition in value can provide a line of motion.

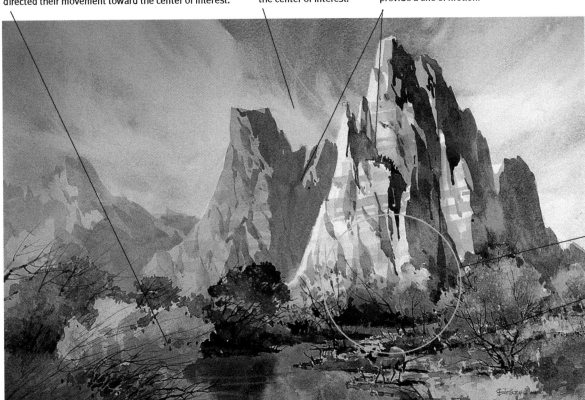

Center of interest
The deer draw the eye to the center of interest.

The edge of the river leads back to the center of interest. Note the many bends and switchbacks along the edge that slow the pace.

## Use Natural Lines to Create a Center of Interest
I decided to create a center of interest at the base of the nearest of these three stone "patriarchs," mainly because the vertical line of the mountain met the horizontal plane there. I had to move the river so it flowed to that area, creating more color intensity and value contrast.

**COURT OF THE PATRIARCHS, ZION CANYON, UTAH** ▸ Watercolor ▸ 14" × 22" (36cm × 56cm)

# Save visual complexity for the center of interest

The fourth method for developing a center of interest is to have a concentration of color and small shapes of light and dark in the focal area while keeping the surrounding areas as simple as possible. The viewer's eye automatically travels to an area of concentrated energy. We naturally gravitate toward complexity of shape and detail.

The challenge is to consciously simplify areas of the painting that do not contain the center of interest. Decide where you want the center of interest, develop it in your drawing and add shapes to the outlying areas carefully, all the time judging their impact on the center of interest. If they start to compete, get rid of them.

This area is broken up into many small shapes, with more detail than anywhere else.

The center of interest has warm-cool contrasts.

**Center of interest**
The strongest value contrasts are located in this area.

Lines of motion direct the viewer's eye to the center of interest.

Gradual transition from warm to cool keeps the attention where you want it. A sudden change here would create a competing area.

Simple areas of rest keep the focus where it should be: on the center of interest.

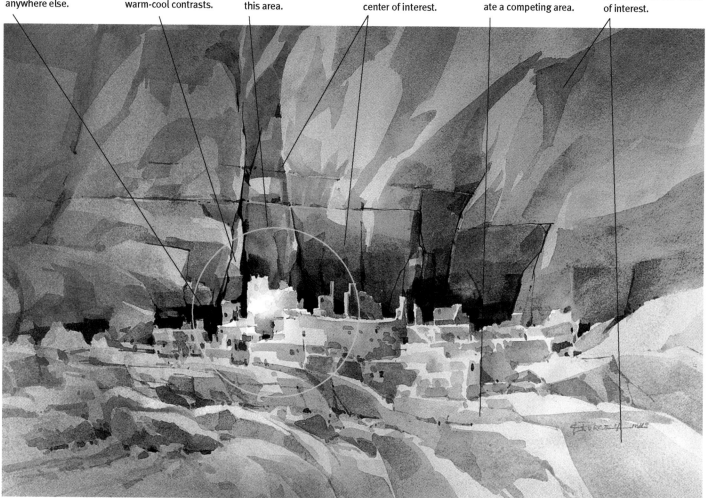

## Use All Four Methods to Create a Center of Interest
This painting utilizes all four methods discussed in this chapter. Lines of motion lead from above, below and from the sides to point toward the ancient dwellings. The principal building is the lightest shape and is placed next to some of the darkest darks. The warm colors terminate in the main building, which is set against the cool purples.

Note that the entire group of ruins constitutes a horizontal band of small, complex shapes sandwiched between two wider bands of relative simplicity. This is the visual concept that guides the painting.

**ANASAZI INDIAN RUINS** ▶ Watercolor ▶ 14" × 21" (36cm × 53cm)

196

# Try a more
## SPONTANEOUS PAINTING APPROACH

### MATERIALS

**PAPER**
Arches 140-lb. (300gsm) rough

**BRUSHES**
No. 8 round

1-inch (25mm) and 2-inch (51mm) flat

**WATERCOLORS**
Carbazole Violet

Manganese Blue

Opera

Quinacridone Gold

Quinacridone Magenta

Quinacridone Rose

Quinacridone Sienna

**OTHER**
6B pencil

Hair dryer

Masking tape

Sponge

*This is the kind of painting I love doing, yet it is the most difficult. I cannot determine exactly what the final painting will look like, only the direction it will take. I depend on the painting to tell me what it needs as it grows. It is an exciting dance, an adrenaline rush. Of course there is the possibility of failure, but in painting you must accept a certain amount of failure as part of the growth process.*

*This painting is based on the forms of a Gothic cathedral. I have always been awed by the graceful arches and the wonderful stonework of this particular style of architecture. More than anything, the whole cathedral seems to be a visual symphony of rhythms. I wanted the painting to be a kind of Gothic hymn.*

*I began with a more passionate approach and no preliminary drawing, and then proceeded to a more methodical approach in which each stroke and each shape inspired the next addition. Toward the end it became a process: paint for five minutes and think for ten. As you will see, as elaborate as the painting is, it still consists entirely of washes and calligraphic brushstrokes.*

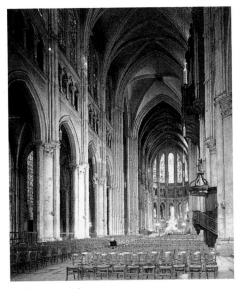

**Reference Photo**

### 1 Lay In the Initial Washes

For this painting, I decided against a smooth transition of graded washes because I wanted patches of color. The idea was to have the overall scene move from warm to cool, but with some interaction. Wet the entire sheet with water and, with a 2-inch (51mm) flat, charge into the wet with Quinacridone Gold, Quinacridone Rose, Quinacridone Sienna, Manganese Blue, Opera and Carbazole Violet, applying them vigorously with full arm movement. Don't create defined shapes of color; allow the colors to flow together. Blow dry these first washes.

## 2 Establish Arches and Gothic Forms

Load a no. 8 round with Quinacridone Gold and begin loosely drawing large Gothic arches. You don't need an exact plan. With each archway it becomes clearer where the painting is going. At this point I consulted a book on Gothic cathedrals and selected some of the most interesting features: a rose window, lancet arches, tracery, sculptural figures, ribbed vaulting and quatrefoil designs. I chose a spot in the upper left for the rose window and drew it with a 6B pencil, adding other features spreading out from that point. This rose window is my personal visual concept, not a copy of any existing one. The same is true of the rest of the forms in the painting.

I added some of the shapes between the ribs in the vaulting on the right using a mixture of Carbazole Violet and Quinacridone Rose with a 1-inch (25mm) flat. I did the same on the left using Quinacridone Gold.

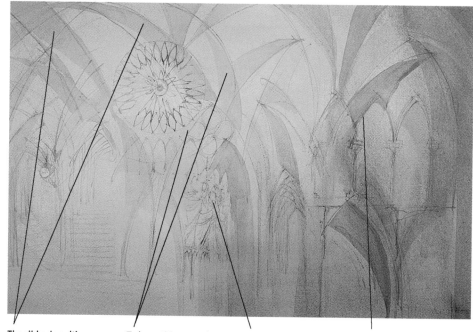

The ribbed vaulting provides additional rhythm, a kind of staccato version of the large arches.

To keep this rose window from being isolated, continue the circular movement with larger lines, to tie it in with the rest.

These figure statuaries, typical of Gothic cathedrals, add rhythm.

These lancet arches bring more rhythm to the right side.

## 3 Develop the Center of Interest

With a mixture of Quinacridone Gold and Quinacridone Rose, begin developing some of the forms in the rose window and the sculptural figures using a no. 8 round. Build arch forms around the figures with a mixture of Carbazole Violet and Quinacridone Magenta using a 1-inch (25mm) flat. Apply light washes of Quinacridone Rose to build more arch forms on the left.

With the center of interest established, you can see how far to go with the rest of the painting. Everything should be measured against the center of interest.

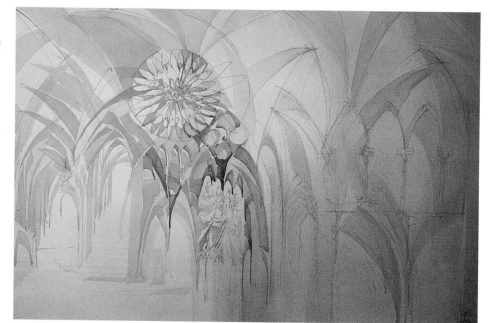

### Develop the Value Pattern

**4** The value pattern will provide a rhythm that holds the painting together. I wanted the pattern of darks to start high on the left and bounce across the paper, much like the series of arches as they move across the painting. Develop this rhythm with darker versions of the same colors.

On the right, I first studied the shadow shapes that were created in lancet arches and used those shapes to develop this area. I included a quatrefoil design just below and to the right of the rose window. To carry this circular rhythm through the rest of the painting, cut circular arcs in wide masking tape and position the tape to reveal only a thin line. Rub out the lines with a clean sponge. These circles are neither complete nor concentric, just repeat motifs.

Each dark adds to the overall value pattern and develops some architectural detail.

The horizontal steps add a counterpoint to the dominant verticals.

Shadow shapes in this area create a quatrefoil.

Unusual cast shadow shapes add to the value pattern while introducing a different kind of arch shape.

### Add Final Details

**5** Add the decorative detail. Pull the painting together by repeating the quatrefoil design in a few places and some tracery in a few of the arches. Notice that the farther away from the center of interest, the less finished the detail. Carry some of the Quinacridone Magenta into the stairs on the left side. The cool right side still seemed a bit separated from the rest of the painting, so I added some warm accents with Quinacridone Rose and Quinacridone Gold to tie it together more.

**GOTHIC SYMPHONY** ▸ Watercolor ▸ 19" × 28" (48cm × 71cm)

# Paint a street scene
## as a GROUP OF SHAPES

### materials

**PAPER**
Arches 140-lb.
(300gsm) rough

**BRUSHES**
Nos. 8 and 12 round
1-inch (25mm) flat

**WATERCOLORS**
Alizarin Crimson
Carbazole Violet
Manganese Blue
Permanent Rose
Quinacridone
Burnt Orange
Quinacridone Sienna
Sap Green

**OTHER**
6B pencil
Sketchbook
Paper towels

*I had been to Buckfast Abbey in Devon, England, a number of times, and so on this occasion I did not bother taking my sketch pad and I left my camera in the car. I was just taking the workshop participants there for a little shopping. As luck would have it, however, I walked past this archway—which I had not previously seen as a painting possibility—as two nuns were walking through it. That made all the difference! Now it was a painting.*

*I quickly returned to the car and grabbed my camera to take a picture of the archway with the wonderful shadow shapes surrounding it, assuming I would just have to remember the nuns. But it was my lucky day. As I got ready to snap the picture, another nun walked through the archway, giving me a reference for my subject.*

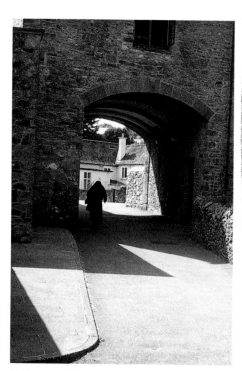

**Reference Photo**
Let's take this photo and make a value sketch, adding, eliminating and changing what we want in order to create a strong composition.

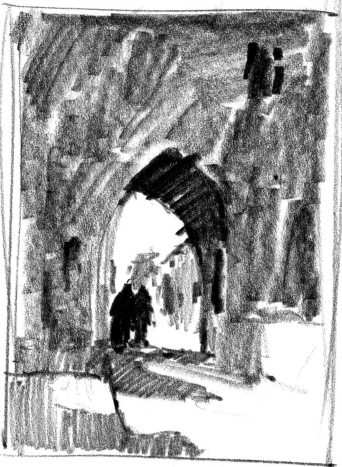

**Value Sketch**
Decide where you will put the lightest lights and the darkest darks and how to get the most effective use of shapes. The shape of the shadow is a definite plus, but I think a Gothic arch is more in keeping with the religious order of the nuns (and I simply liked the shape better). The window above the arch needs to be moved over to the right to balance the black shapes of the nuns. I rearranged the buildings in the background to make a street instead of a courtyard. Finally, I thought the wall needed some decoration to break it up, so I created a little niche with a figure. Now it is ready to paint.

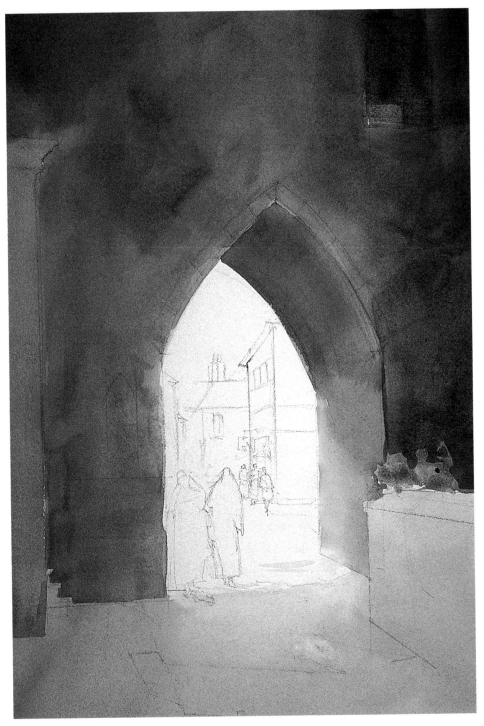

## 1 Lay In the Foundation Washes

Turn the paper upside down. Paint the lower left wall of the arch with a mixture of Quinacridone Sienna and Carbazole Violet, using a 1-inch (25mm) flat. Leave the strip of wall at the far left edge unpainted. While the area is still wet, pick up some Manganese Blue and paint the strip of the far left wall slightly lighter than the first wall. Add some Quinacridone Sienna as you go up. Then continue the first wash and as you near the top of the wall, use pure Quinacridone Sienna for a warm accent.

Drop in some Manganese Blue for the window as you continue the wash across the top of the arch wall, heading right using your flat. Don't paint around the window and come back to it later because it will form a hard edge and will not merge with the wall. This is important because the wall edge is not a center of interest. Continue the arch wall down the right side using Carbazole Violet. Pop in a little Sap Green for the foliage on top of the wall.

Paint the underside of the arch with Quinacridone Burnt Orange, changing to Quinacridone Sienna and lightening the value toward the bottom. Paint the foreground a light wash of Quinacridone Sienna and Permanent Rose.

## Add the Other Large Foundation Shapes

The shadow shape is a mingled wash and must be done in one go, so use a 1-inch (25mm) flat and plenty of water. Begin at the left with Quinacridone Sienna to suggest warm light between the buildings. Add Carbazole Violet at the bottom left. Before the colors dry and give you a hard edge, pull the wash to the right and change to a mixture of Permanent Rose and Manganese Blue.

Add some spots of color for distant figures and flowers. Paint the forms of the background buildings, making shadowed sides face you. Suggest warm, reflected light under the eaves of the nearest building with some Quinacridone Sienna. This and the roof of the adjacent building will repeat the warmth of the foreground wall and help unify the piece.

Add some texture to the old wall. Spatter on some clean water first, then let it sit for a few seconds. Dab it off with a soft paper towel and immediately rub the area with a dry towel to lift off the spots. The harder you rub, the lighter they will be. Dab before wiping so that you will retain the shape of the spatter. Rubbing it immediately will smear the water and you will lift off a different shape.

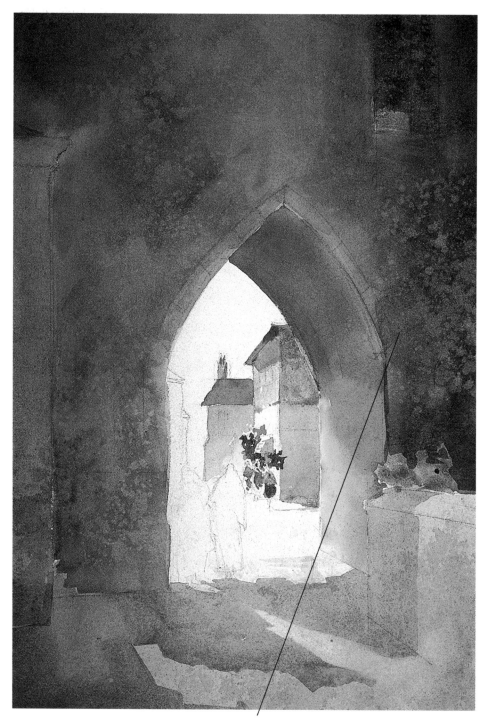

Don't try to distinguish between the wall and the shadow beyond it. Lost edges are part of our visual experience.

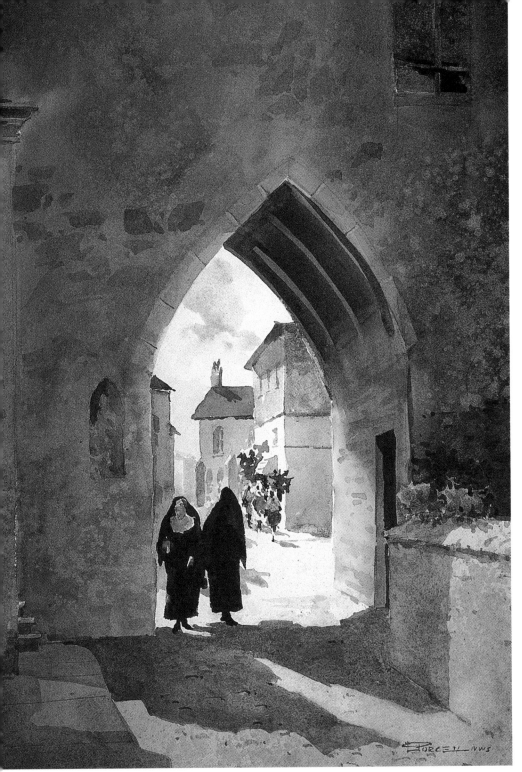

### 3 Add the Main Figures and Finishing Details

The figures in the archway are the center of interest, so reserve the sharpest detail, starkest value contrasts and strongest color for this area. Using a no. 8 round, paint the nuns' habits, but instead of black, which turns flat when dry, use Carbazole Violet, Alizarin Crimson and Quinacridone Burnt Orange. Apply a dab of Quinacridone Sienna for the face and Manganese Blue for the white vestment on the forehead and below the face.

Suggest the detail in the niche with a no. 8 round—just suggest, don't fully complete. With your flat brush, darken the cast shadow with a light wash of Carbazole Violet to define the walkway. Now add a little sky pattern in that beautiful space shape under the arch using your no. 12 round and Manganese Blue. Wet the brush and immediately soften the edges. Suggest the windows in the distant buildings with a no. 8 round.

Finally, using your flat brush, mix some Carbazole Violet and Quinacridone Burnt Orange and darken the underside of the arch, leaving the ribs. Lighten this wash a little as you bring it down the wall and across the doorway. Now add the door with the original dark mixture. With a no. 12 round, drag a few short strokes to indicate larger stones in the wall. Don't go too dark; just use the same color as the wall. The double layer will be dark enough.

**COMING AND GOING AT BUCKFAST ABBEY**
Watercolor
21" × 14" (53cm × 36cm)

## POINTS TO REMEMBER ☞

▸ A center of interest doesn't just appear, it results from planning.

▸ Strong value contrast is the most eye-catching and dramatic method for bringing out a center of interest.

▸ Color contrasts provide wonderful visual entertainment for the center of interest. Reserve your best shots of color for it.

▸ Don't expect the viewers to find their own way through the painting; direct them with lines of motion.

▸ Limit the visual activity of small shapes (details) to the areas of greatest importance. Keep everything else simple.

▸ You are the director; everything out there wants a part in your visual production. Use only the tools that best serve the needs of the painting. Then direct them to do what you want them to.

# Index

## A

Alternation drawing, 90-92
Analysis, of structure, 40
Angles
    finding similar, within shape, 34
    seeing relationships of, 26-27, 32
    using pencil to find, 30

## B

Background, creating own, 89
Birds, 68-69, 90-91
Blending, to render value, 70-71
Brick walls, broad-stroking, 79
Bridging exercise, 107
Broad-stroke, 70-71, 78-81
Brushes, 110-111
    loading, 120
    optimizing, 120-123
    thirsty, 113

Brushstrokes
    lines, 120, 122
    ragged edge, 122
    side-drag, 121, 122
    spattering, 121, 202
    stab, 121
Building, as shape, 129

## C

Center of interest, 191-203
    beginning with, 100
    and color contrast, 194
    developing, 103, 105
    establishing, 198
    lines of motion leading to, 195
    methods for establishing, 192
Circle, subject as, 44-45
Circular value pattern, 188
Color, shapes of, 130

Color contrast
    engaging viewer with, 194
    establishing center of interest with, 192
Color dominance, establishing, 185
Color palette, 111
Complexity
    and center of interest, 196
    contrast of, 192
    in value, 87
Composition, 96
    adjusting subject and space shapes in, 152-155
    and value patterns, 98-99, 174-175, 178-179
    See also Format
Contour line drawing, 50-51
    point-to-point, 52
Contrast. See Color contrast, Value contrast
Contrast of complexity, establishing center
    of interest with, 192
Copyright, 184
Cropping, 178
Crosshatching, to render value, 70-71

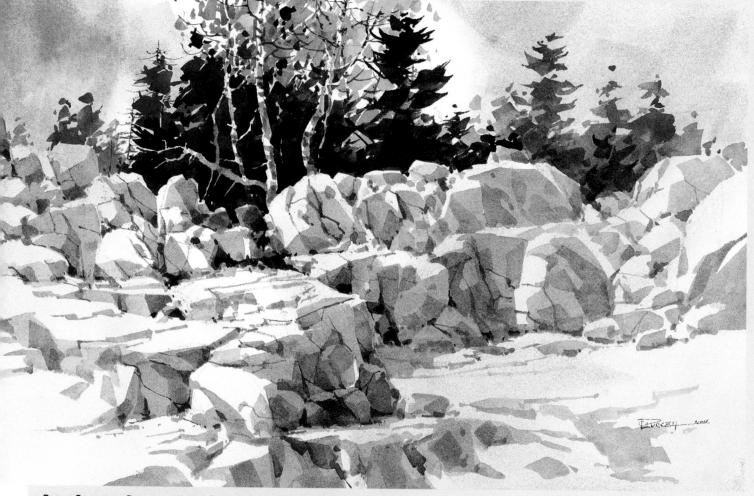

**RIGHT FROM THE ROCKS** ► Watercolor ► 14" × 21" (36cm × 53cm)

**D**

Dark against light, 63
Dark shapes, 158-159
Details, vs. shapes, 23
Doodles, creating value patterns through, 186-187
Drawing
  alternation, 90-92
  compromises in, 15-16
  contour line, 50-51
  as means of discovery, 20
  portrait, 58-59
  problems with, 11-23
Drawing tools, 26-27

**E**

Edges, 88-89
  capturing with contour line, 54-55
  defined, and variations in value, 72-73
  defining, 149-150
  lost, 84, 87, 93, 202
  ragged, 122
  refining, 37
  softening, 118, 203
  See also Angles
Ellipses, 39

**F**

Features, defining with value patterns, 99
Figure
  defined, 84
  See also Human figure
Figure and ground relationships, 83-93
  alternating values in, 87
  constant changes in, 90-91
  and edges, 88-89
  reversing values in, 86
Focal point. See Center of interest
Foreground, building, 47
Foreground/background.
    See Figure and ground relationships
Form, defining through value, 64
Format
  activating with value pattern, 178-181
  adjustable, 106

**G**

Graded washes
  layering, 115
  mastering, 112-114
  See also Underpainting
Grays, 69
  patterns of, 97
  See also Middle values
Ground
  defined, 84
  See also Figure and ground relationships

**H**

Human figure
  alternating values in, 87
  drawing as shapes of space, 143
  and points of reference, 34-35
  shadow shapes in, 74-75
  using line to determine, 56-57

**I**

Intellectual brain, 12-23, 86-87, 127, 134

**L**

Landscape
  adjusting composition, 152-155
  focusing on shapes in, 136-139
  values in, 76-77
  value patterns in, 100-101
Leaves, 148-151
Light against dark, 63
Light shapes
  creating visual paths and bridges with, 162-163
  improving, 164-167
Likeness, achieving, 28-29
Line
  capturing edge with, 54-55
  controlled, 120
  essence of, 50
  pulling, 52
  using to determine figure, 56-57
Lines of motion, 195
  establishing center of interest with, 192

**M**

Middle values, 165, 180-181
Mood, creating with value pattern, 175

**N**

Negative painting, 73
Negative shapes. See Shapes of space

**O**

Onion, 44-45
Outline, 51

**P**

Paint. See Watercolor paints
Painting
  building value patterns in, 174-177
  cropping, 178
  focusing on shapes in, 136-139
  graded washes, 112-115
  materials and studio, 110-111
  negative, 73
  spontaneous approach to, 197-199
  technique for, 109
  wet-into-wet, 115
Paper, for broad-stroke, 81
Patterns. See Value patterns
Pear, 30-33
Pencil, measuring with, 31-33

**Photos**

Photos
  combining, to create ideal shapes, 146-147
  and copyright, 184
  cropping upside-down, 106
  finding value patterns in, 182-183
Pigments, 115
Point-to-point contour, 52
Points of reference, 35
Portrait, 28, 58-59, 92
  seeing shadow shapes in, 74-75
Positions in space
  finding horizontal and vertical alignments, 35
  seeing relationships of, 26-27, 33
Positive/negative. See Figure and ground
    relationships
Positive shapes, 142-143

**R**

Rectangle, subject as, 43
Rocks, 132-133
  broad-stroking, 80
  interesting forms, 126
  as shapes, 128
Rock walls, broad-stroking, 78

**S**

Scene, complex, 104-105
Seascape, 130
Shadows, paying attention to, 22
Shadow shapes, in portrait, 74-75
Shapes, 22-23
  altering, 132-133
  collecting, 135
  of color, 130
  combining photos to create, 146-147
  comparing, to find relationships, 36-37
  defining, 54
  distinguishing interesting from boring, 131
  drawing adjacent, 46-47
  ellipses, 39
  fitting subject into one, 41
  focusing on, in painting, 136-139
  interesting, 126-127
  in landscapes, 76-77
  modifying, 128-129
  multiple, seeing as one similar value, 160-161
  painting mingled washes within, 118
  painting wash around, 113
  placing into visual categories, 130
  positive and negative, 142
  refining, 33
  relationships to angle, size, position, 28-29, 49
  roughing in, 36
  seaside, 130
  seeing, 30, 125
  shadow, seeing in portrait, 74-75
  simplifying then refining, 38-40
  streetscape, 130, 200-203
  of varying value, 68-69
  See also Dark shapes, Light shapes,
      Positive shapes, Value(s)

Shapes of space, 130
  adjusting for stronger composition, 152-155
  darker, defining light subjects with, 148-151
  designing, 142-143
  enhancing subject with, 144-145
  seeing, 141-155
Shapes of value, 130, 157-167
Side-drag stroke, 121
Sighting lines, 33, 37
Silhouette, 51
  using to find interesting shapes, 126
Sizes
  finding similar, 34
  seeing relationships of, 26-27, 31-33
Sketches. *See* Thumbnail sketch, Value sketch,
  Watercolor sketch
Spatial processing. *See* Visual brain
Spattering, 121, 202
Squinting, to see values, 65, 68, 72, 74-75, 87, 89
S-shaped value pattern, 189
Streetscape, painted as shapes, 130, 200-203
Subject(s)
  adjusting for stronger composition, 152-155
  for contour drawings, 53
  enhancing, with shape of space, 144-145
  "floating," 178
  light, defining with darker shapes of space,
    148-151
  modifying, to create center of interest, 192
  as shapes, 41-45
  simplifying, 102-103
Symbols, 17-21, 127
  *See also* Intellectual brain

**T**

Thumbnail sketch, 132, 153
Transitions, in value, 86
Trees, pine, 18, 80
Tree shapes, 154
Triangle, subject as, 41-42

**U**

Underpainting, 116

**V**

Value(s), 28
  adding, 37, 38, 42, 55
  alternating, 85, 87
  defining form through, 64
  how to see, 65
  in landscapes, 76-77
  methods of rendering, 70-71
  middle, 165, 180-181
  rendering shapes of, 68-69
  reversing, 85-86
  shapes of, 130, 157-167
  similar, 160-161
  variations in, and defined edges, 72-73

Value contrast, 61-63, 93
  establishing center of interest with, 192-193
  leading eye with, 193
Value patterns, 169-189
  activating format with, 178-179
  bringing order with, 170
  building in painting, 174-177
  composition with, 98-99
  developing, 199
  developing sense of, 180-181
  directing visual movement through, 188
  doodling, 186-187
  evaluating, 171
  exercises in spotting, 106-107, 182-183
  found, 184-185
  in landscapes, 100-101
  organizing, 95-105
  in photos, 182-183
  reasons to create, 96
  simplifying complexity with, 172-173
Value range, establishing, 75
Value relationships, 66
  and edges, 88-89
  figure/ground, 85, 87
  manipulating, 92-93
  seeing, 26-27
Value scale, 67
Value sketch, 171, 178, 200
  creating bridge with, 164
  of found pattern, 184-185
  simplifying with, 172
  three basic shapes, 136
Visual brain, 12, 14-15, 20, 125
  and categorizing shapes, 130
  painting with, 134
Visual information, ways of processing, 12-13
Visual movement, directed by value patterns, 188
Visual paths and bridges, 162-163

**W**

Walls, broad-stroking, 78-79
Washes, 197, 201
  broken, 121
  graded. *See* Graded washes
  mingled, 117-118
Watercolor, technique for, 109
Watercolor paints, 110
Watercolor paper, 110
Watercolor sketch, 160
Waterscape, 164-167
Wet-into-wet, 115
Whites, limiting, 175, 180

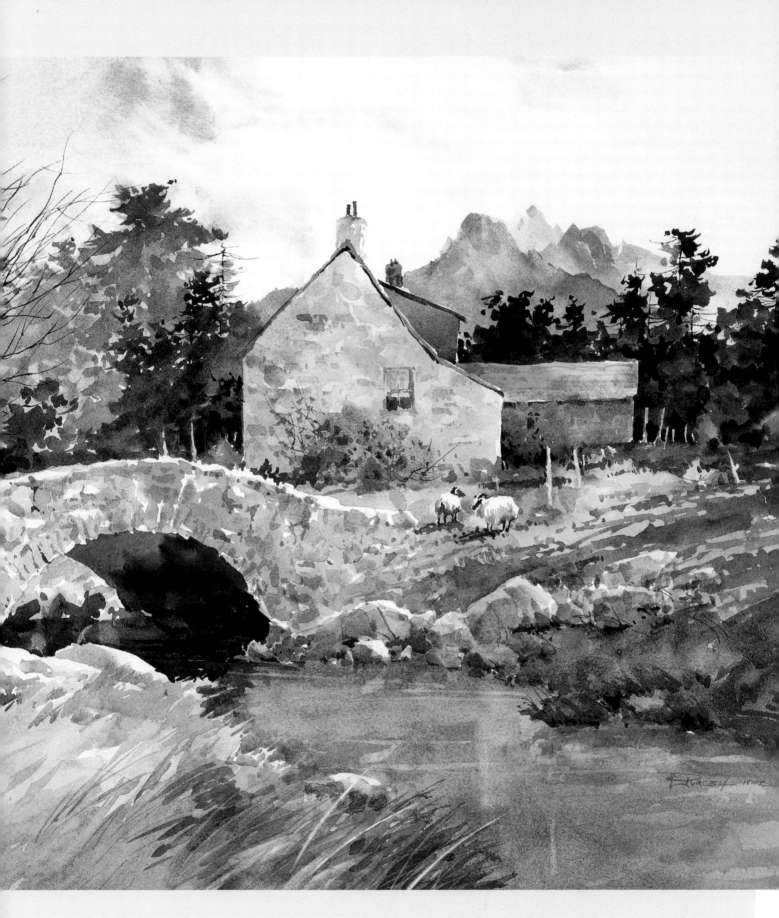

**HIGHLAND CROFT, SCOTLAND** ▸ Watercolor ▸ 28" x 30" (71cm x 76cm)

# IDEaS. INSTRUCTION. INSPIRaTION.

These and other fine North Light products are available at your favorite art and craft retailer, bookstore or online supplier. Visit our websites at www.artistsnetwork.com and www.artistsnetwork.tv.

ISBN-13: 978-1-60061-094-3
Z2003 | book/DVD combo
hardcover with concealed spiral, 128 pages
DVD running time: 60 minutes

Find the latest issue of *The Artist's Magazine* on newsstands, or visit www.artistsnetwork.com.

ISBN-13: 978-1-60061-465-1
Z4266 | DVD running time: 55 minutes

**Visit www.artistsnetwork.com and get Jen's North Light Picks!**

Get free step-by-step demonstrations along with reviews of the latest books, videos and downloads from Jennifer Lepore, Senior Editor at North Light Books and Online Education Manager.